Brooklyn
Museum of Art

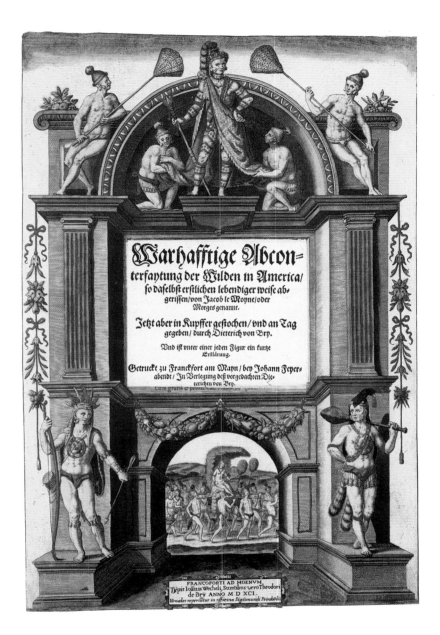

Frontispiece from *Der ander Theyl, der newlich erfundenen Landtschafft Americae . . . Floridam* (Frankfurt am Main: D. von Bry, 1591). Brooklyn Museum of Art Library Collection. This plate is from the German language edition illustrated by Jacques Le Moyne de Morgues documenting an expedition to Florida in 1564. The travel account is the second in a series of books published by Theodor de Bry that served as a major pictorial source for images of Native Americans in North America. The book was collected by Stewart Culin, who was the Museum's founding Curator of Ethnology from 1903 to 1929.

Open to the public by appointment, the Brooklyn Museum of Art Libraries and Archives comprise the fifth-largest art museum library in the United States.

Brooklyn Museum of Art

BROOKLYN MUSEUM OF ART
IN ASSOCIATION WITH
SCALA BOOKS

This publication is made possible in part by Furthermore, the publication program
of the J. M. Kaplan Fund.

The Brooklyn Museum of Art's Centennial/175 Celebration is sponsored by
Philip Morris Companies Inc.

First published by Scala Books
an imprint of Philip Wilson Publishers Limited
143–149 Great Portland Street
London WIN 5FB

All measurements are in inches followed by centimeters;
height precedes width precedes depth.

Designed and typeset by Malcolm Preskett
Produced by Scala Books, an imprint of Philip Wilson Publishers Limited
Printed and bound in Italy by Società Editoriale Libraria per azioni, Trieste

Library of Congress Cataloguing-in-Publication Data

Brooklyn Museum.
Brooklyn Museum of Art.
192 p. 22.9 x 15 cm.
ISBN 0-87273-136-7 (alk. paper)
1. Art—New York (State)—New York—Catalogs.
2. Brooklyn Museum—Catalogs I. Title.
N620.B6B76 1997
708.147'23—dc21
96-40100 CIP

ISBN 0-87273-136-7

Front cover: *Cartonnage of Nespanetjerenpere* (see page 27)

Back cover: Georgia O'Keeffe (American, 1887–1986), *Brooklyn Bridge*, 1948.
Oil on Masonite, 47¹⁵⁄₁₆ x 35⅞ (121.8 x 91.1). 77.11, Bequest of Mary Childs Draper.

Contents

CONSIDERED one of the leading museums of the world, the Brooklyn Museum of Art holds an impressive place in the history of the arts in twentieth-century America through its active exhibition program, excellent comprehensive collection, and commitment to public service. In 1997–98 the Museum celebrates its founding in 1823 and the 1897 dedication of its magnificent Beaux-Arts building. This is a time of renewal and progress for the institution as it evolves from The Brooklyn Museum into the Brooklyn Museum of Art and enters its second century as a local, national, and international cultural resource.

Philip Morris is proud to sponsor the Brooklyn Museum of Art's Centennial/175 Celebration. During this pivotal period, we will honor the Museum's long and prodigious legacy and contribute to its future through support of a myriad of exciting plans and activities. Our company's association with the Brooklyn Museum of Art began in the mid-1970s with the ground-breaking exhibition *Two Centuries of Black American Art*.

Over the last twenty years we have funded six major exhibitions that either originated at or toured to the Brooklyn Museum of Art: an exhibition of Buffalo Bill iconography; Romare Bearden's collages; new art of the American West; the Albert Bierstadt retrospective; the pictographs of Adoph Gottlieb; and more recently, the extraordinary Louise Bourgeois retrospective, which opened at the United States Pavilion at the Venice Biennale in 1994 and toured internationally. We look forward to partnering with the Brooklyn Museum of Art in this special anniversary year and to enjoying a long future association.

Stephanie French
VICE PRESIDENT,
CORPORATE CONTRIBUTIONS AND CULTURAL PROGRAMS
PHILIP MORRIS COMPANIES INC.

Foreword

IN 1997 we celebrate the centennial of the Museum's great McKim, Mead & White landmark building. In 1998 we commemorate the 175th anniversary of the founding of this institution. Such occasions offer ample opportunity to praise the past. More important, they challenge us to prepare for the future. Early in 1889, the Brooklyn Citizens' Committee on Museums of Art and Science heard a stirring address on "The Museum of the Future." The speaker warned supporters of the museum project that, if successful, their work would "never be finished": "When a museum building has been provided, and the nucleus of a collection and an administrative staff are at hand, the work of museum-building begins, and this work, it is to be hoped, will not soon reach an end. A finished museum is a dead museum, and a dead museum is a useless museum." [1]

The measure of the founders' and their successors' achievement is recorded in this volume. The Museum is far from being a static treasure house; nothing, including the building itself, is ever "finished" at the Brooklyn Museum of Art. Change has been the constant. Each collection, each department, has its own story, its own cast of characters, a chain of events—external and internal—that have charted or altered its course over the last century. Each has contributed to the history of the Museum as a whole. Institutional goals have in turn exerted a powerful influence on the growth of collections. The 1889 address closed by observing, "The founders of institutions . . . do not often realize how much they are doing for the future." We salute the founders' achievement in this visitors' handbook of the collections. We also look forward to welcoming new audiences during the twenty-first century.

This handbook was completed with the help of all the curators at the Museum, who selected the objects and wrote the entries: Richard Fazzini, Curator, James Romano, Curator, Donald Spanel, Associate Curator, Egyptian, Classical, and Ancient Middle Eastern Art; Amy

Poster, Curator, Layla Diba, Associate Curator, John Finlay, Assistant Curator, Asian Art; Diana Fane, Curator, William Siegmann, Curator, Judith Ostrowitz, formerly Assistant Curator, Arts of Africa, the Pacific, and the Americas; Kevin Stayton, Curator, Barry Harwood, Associate Curator, Melissa W. M. Seiler, Assistant Curator, Patricia Mears, Assistant Curator, Decorative Arts and Costumes and Textiles; Marilyn S. Kushner, Curator, Barbara Head Millstein, Associate Curator, Prints, Drawings, and Photographs; Sarah Faunce, Curator, Elizabeth Easton, Associate Curator, European Painting and Sculpture; Linda S. Ferber, Curator, Barbara Dayer Gallati, Associate Curator, Teresa A. Carbone, Associate Curator, American Painting and Sculpture; Charlotta Kotik, Curator, Brooke Kamin Rapaport, Associate Curator, Contemporary Painting and Sculpture.

The photography in this volume was organized by Dean Brown, Chief Photographer, and Cheryl Sobas, Exhibitions Manager. We also acknowledge the invaluable assistance of Cathryn Anders, Collections Manager; Elaine Koss, formerly Vice Director for Publications, Lisa Mackie, Copy Editor, Joanna Ekman, Editor; Deirdre E. Lawrence, Principal Librarian; Kenneth Moser, Vice Director for Collections; Terri O'Hara, Associate Registrar; Sallie Stutz, Vice Director for Marketing; and Deborah Wythe, Archivist.

We are grateful to Furthermore, the publication program of the J. M. Kaplan Fund, for its generous support of this publication, and Philip Morris Companies Inc. for its sponsorship of the Centennial/175 Celebration.

<div align="center">

Linda S. Ferber
ACTING DIRECTOR

Roy R. Eddey
ACTING PRESIDENT

</div>

1. George Brown Goode, Assistant Secretary of the Smithsonian Institution, delivered the 1889 address on "The Museum of the Future."

A Brief History

O N Independence Day, 1825, General Lafayette, on a triumphant tour of the United States, boarded one of the Fulton and South Ferry Company's steamboats for the short trip across the East River to the village of Brooklyn. The thriving community—then independent from its sister city on Manhattan Island—is depicted in Francis Guy's painting of 1820 (FIG.1). Accompanied from the Brooklyn ferry landing by a great throng of "citizens, trade societies and Sunday Schools," the hero of the Revolution presided over the laying of the cornerstone of a large brick building, the Brooklyn Apprentices' Library —the ancestor of the Brooklyn Museum of Art—at the intersection of Cranberry and Henry streets in today's Brooklyn Heights.

Two years earlier, in the summer of 1823, a group of public-spirited citizens had met at William Stephenson's tavern to establish the

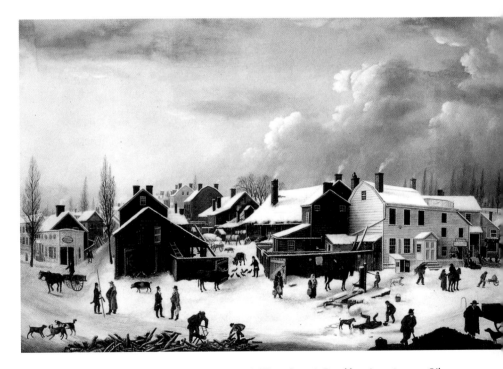

FIG.1. Francis Guy (American, 1760–1820). *Winter Scene in Brooklyn*, circa 1817–20. Oil on canvas, 58¾ x 75 (149.2 x 190.5). 97.13, GIFT OF THE BROOKLYN INSTITUTE OF ARTS AND SCIENCES.

village's first free circulating library. In 1824 these citizens incorporated the Brooklyn Apprentices' Library Association, and by summer of 1825 a home for the book collection was under construction. The red-brick Federal-style building functioned as a center for the village, housing the Library as well as a number of civic functions until the building was sold to the city in 1836.

Sometime during 1838, the Library Association began classes in mechanical, architectural, landscape, and figure drawing in rooms rented in the Brooklyn Lyceum Building on Washington Street. In 1842 Augustus Graham, a prosperous manufacturer of white lead, a founder of the Library, and by then the President, bought the Lyceum's elegant granite Greek Revival building for the Association, thus reestablishing a permanent home for the institution. The popular lecture courses were continued, and the first annual exhibition of paintings was held. Library and Lyceum were consolidated in 1842 as The Brooklyn Institute (FIG.2). The Institute's natural history department was then established with the acquisition of the Lyceum's collection. In 1846 the Institute directors announced their intention of establishing a permanent art collection.

While Augustus Graham was one of a number of Library promoters, his traditional recognition as the founder of the Museum is owing not only to his dedication during his lifetime, but also to his provision for the institution's future. In 1848 Graham paid off the mortgage on the Institute building. When he died in 1851, he left funds to support the library, lectures on secular and religious subjects, classes in drawing, and the work of the department of natural history. Graham also left a sum that marked the formal establishment of a Gallery of Fine Arts. His endowment outlined what would remain the primary intellectual and social commitments of the institution until the mid-1930s, although the Museum's massive collections were not to be formed until the early years of the twentieth century.

Optimism ran high at midcentury about Brooklyn's future. The consolidation act of 1855 had enlarged the boundaries of the city, increasing the population to more than 200,000. By 1860 Brooklyn was the third-largest city in the country. The ultimate harbinger of a glorious destiny for the City of Churches seemed embodied in John A. Roebling's

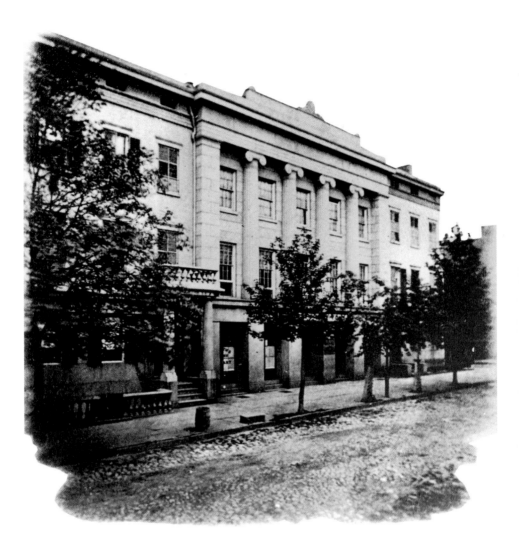

FIG.2. The Brooklyn Institute, 1840s–50s. 182 and 184 Washington Street near Concord Street. Photograph from Wallace Gould Levison, "Reminiscences of The Brooklyn Institute and Some Early Collectors," Brooklyn Museum of Art Library and Archives Collection.

Great East River Bridge, under construction by 1869 and completed in 1883. This spirit galvanized supporters of the Institute to ambitious plans: to establish an amalgam of New York City's recently founded Metropolitan Museum of Art and the American Museum of Natural History. The old Institute, the germ of this grand scheme, was expanded into sixteen departments (which by 1897 had grown to twenty-five) that would through collections and programs explore and present the entire

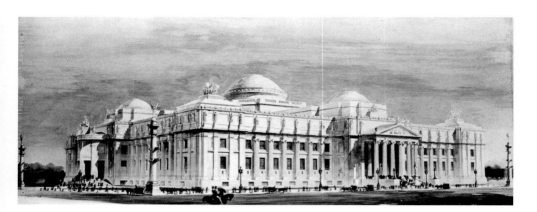

FIG.3. Francis L. V. Hoppin (American, 1867–1941). Architect's Rendering of the Central Museum of The Brooklyn Institute of Arts and Sciences, 1893. Watercolor and pen and ink, 26⅛ x 67¾ (66.4 x 172.1). X737, BROOKLYN MUSEUM OF ART.

spectrum of natural history and human achievement. The Brooklyn Academy of Music, the Brooklyn Botanic Garden, and the Brooklyn Children's Museum were departments of the Institute until the 1970s. Sites for programs were located all over the city of Brooklyn, while the existing collections were still mostly housed in the Institute building on Washington Street, which was inadequate to accommodate this grand design, especially after a fire in 1890.

By 1891, under the energetic leadership of President John B. Woodward (1835–1896), the city of Brooklyn made plans to build a large museum, a complex that would house nearly all departments of the newly incorporated (1890) Brooklyn Institute of Arts and Sciences in a single structure on Prospect Heights just east of Olmsted and Vaux's great park, which had opened in 1866. The architectural firm of McKim, Mead & White was victorious in a competition held to design a master plan for the Institute. The land occupied today by the Brooklyn Museum of Art, the Brooklyn Public Library, and the Brooklyn Botanic Garden was part of a 320-acre tract bisected by Flatbush Avenue that had been set aside earlier in the century as the future site for a public park. In 1866 Frederick Law Olmsted and Calvert Vaux submitted a report to the Brooklyn Park

Commission suggesting that this cultural, educational, and recreational complex be connected to outlying areas of Brooklyn by a system of parkways—a term they coined in 1868—to the south (Ocean Parkway) and to the east (Eastern Parkway.) Their grand urban plan was realized and remains very much intact today.

Francis Hoppin's 1893 rendering of McKim, Mead & White's design for the Institute building presents the original scheme meant to house comprehensive collections of art, natural history, and science, as well as myriad education and research activities (FIG. 3). The plan—if completed—would have been the largest museum structure in the world. The West Wing of the Central Museum was opened in 1897. A year later Brooklyn was incorporated into New York City, and the independent competitive spirit that had fueled the mammoth project was diminished. The central portion of the façade was added in 1905, and in 1907 the East Wing and Grand Staircase were completed. The original building campaign would come to a final halt in 1927, just four years after the Centennial of the Apprentices' Library, with only one-sixth of McKim, Mead & White's original conception realized.

The organization and growth of the collections in the new Museum building were regulated at the turn of the century by three departments, Fine Arts, Ethnology, and Natural History, each presided over by an extraordinary intellectual presence: William Henry Goodyear (1846–1923), Stewart Culin (1858–1929), and Franklin W. Hooper (1851–1914), respectively. The collections grew exponentially in the first three decades of the twentieth century by donation, by purchase, by exchange, and as a result of museum expeditions.

The 1930s were to prove a decade of reevaluation and redefinition. In 1934 the Board adopted a new collections policy, marking a turning point for the Museum. The natural history specimens were distributed to other institutions, laying to rest the nineteenth-century encyclopedic ambitions of the founders by finally abandoning science for art. The collections remaining were eventually organized into seven curatorial units, dividing the holdings of the Department of Ethnology between a Department of American Indian Art and Primitive Cultures and a Department of Oriental Art. The history of Western art was organized

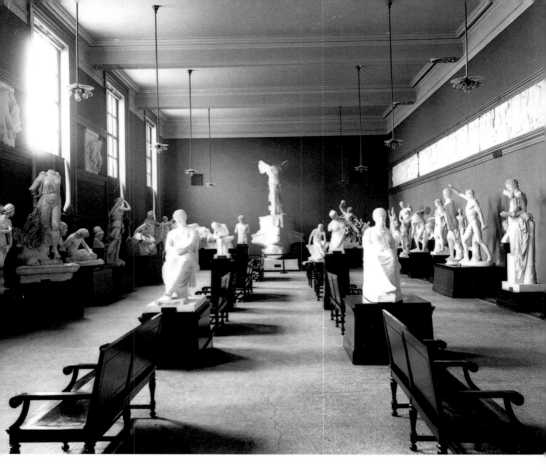

FIG.4. The Hall of Casts, 1898–99, West Wing, third floor.

chronologically in departments of ancient, medieval, Renaissance, and contemporary art—later consolidated as a Department of Painting and Sculpture—while print collections remained a division of the Library. The large collection of plaster casts was discarded (FIG.4). Modern museum administrative and collection care practices were introduced with the appointment of a registrar and the establishment of the Conservation Laboratory. A modern Education Department was formally established in 1930.

Not only were the collections and their uses redefined, but the building was reconfigured as well. The most radical change was the removal in 1934 of the Grand Staircase on the northern façade. While justly criticized today as an ill-conceived violation of the original design of the building, this controversial "improvement" was intended as a socially responsible gesture, to facilitate public access from Eastern Parkway. The collections themselves were then configured into what was then

termed "chronological" order, beginning with the placement of American Indian Art and Primitive Cultures on the first floor and rising to a "gallery of living artists" on the sixth—a floor plan that survives nearly intact today.

Curatorial departments have come and gone as Museum holdings have been repeatedly reorganized in efforts to define collections more accurately. The collections change in response to new scholarship and to changes in mission and curatorial vision, to new audiences, and to the donors and patrons who continue to enrich Museum holdings. Such continual redefinition of Museum holdings is exemplified by the reemergence of extensive Spanish colonial collections in the acclaimed 1996 exhibition *Converging Cultures: Art & Identity in Spanish America*.

The Brooklyn Museum as we know it today is the product of an evolution resulting in a remarkable amassing of more than a million works of art housed in six curatorial departments and displayed in a grand though incomplete structure of 450,000 square feet. In 1986 the Board announced another architectural competition to commission a new plan for the landmark McKim, Mead & White building. The winners— Arata Isozaki & Associates of Tokyo and James Stewart Polshek and Partners of New York— designed a compelling masterplan that looks as sensitively to the past as it does daringly to the future (FIG.5). The Iris and B. Gerald Cantor Auditorium opened in April 1991, and in December 1993 the redesigned West Wing—now the Morris A. and Meyer Schapiro Wing—opened to critical and popular acclaim as the first phase of the Museum's plan.

What is today the Brooklyn Museum of Art began in 1823 as an idea "extending the benefits of knowledge," embodied in a series of collections through 174 years of constant change, and now housed in a century-old landmark structure. The audience changed, Brooklyn changed, the building changed, and the collections changed. The idea, however, has remained constant as the mission that inspired the founding of the Brooklyn Apprentices' Library, The Brooklyn Institute of Arts and Sciences, and the Brooklyn Museum of Art.

This handbook is intended as both a guide for the Museum visitor and as a sampling for art lovers of some of our most treasured artworks.

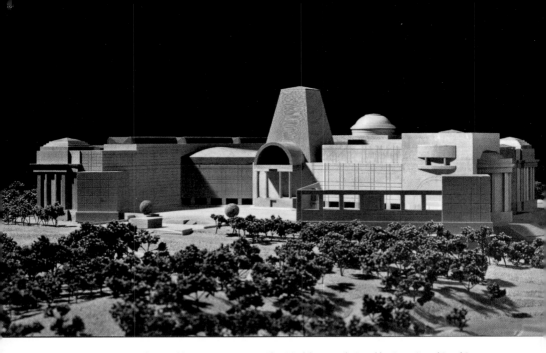

FIG. 5. The Brooklyn Museum Master Plan Model, 1986, designed by Arata Isozaki and James Stewart Polshek. View of south façade from the Brooklyn Botanic Garden.

Many of our most prized pieces—works on paper, costumes and textiles—are by their nature so fragile that they cannot be on view for long periods of time but are represented nonetheless in this volume and appear in the galleries on rotation and in special exhibitions.

Linda S. Ferber

FOR FURTHER READING

Handbook. Brooklyn: The Brooklyn Museum, 1967.

Masterpieces in The Brooklyn Museum. New York: The Brooklyn Museum in association with Harry N. Abrams, 1988.

A New Brooklyn Museum: The Master Plan Competition. New York: The Brooklyn Museum and Rizzoli, 1988.

Egyptian,
Classical, and Ancient
Middle Eastern Art

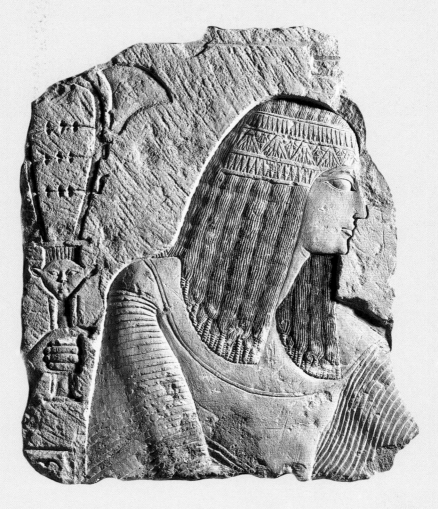

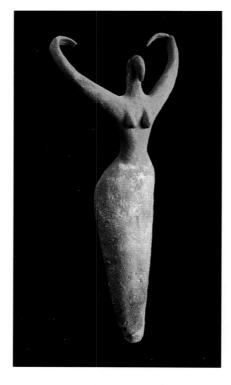

Female Figurine

◄ Egypt, from Maʻmariya
Predynastic Period, Naqada II
(circa 3650–3300 B.C.)
Terracotta, 11½ (29.3) high
07.447.505, MUSEUM COLLECTION FUND

Recurrent throughout the Predynastic Period
(circa 6100–3800 B.C.), the earliest phase of
ancient Egyptian history, are representations
of enigmatic female figures. Their symbolism
and even their nature—human or divine—are
not certain. Known primarily from paintings on
ceramic ware and from ceramic statuettes, the
females are always shown in highly abstracted
form. The hands and the feet are not modeled,
and the legs are not often articulated. Instead,
the legs are shown as a long spike. In the
paintings, the heads of the women are gener-
ally hemispherical and have no modeling. In
the statuettes, the heads have eyes and are
dominated by prominent beaks. This statuette,
one of the oldest objects in the Brooklyn
Museum of Art, is a very rare intact example.
Six other nearly identical statuettes in the
Museum's collection are fragmentary, as are
most parallels in other collections.

Colossal Head of a King

◄ Egypt, exact provenance not known
Old Kingdom, late Dynasty III—early
Dynasty IV (circa 2625–2550 B.C.)
Red granite, 21⅛ (54.5) high
46.167, CHARLES EDWIN WILBOUR FUND

Beginning in Dynasty I, Egyptian religion taught
that the king was a god incarnate, the earthly
manifestation of the sky god Horus. Over time
the Egyptians came to think of their ruler as
more human than divine, but the idea of pharaoh
as a god-on-earth was never completely aban-
doned. This over-life-size head shows a king
wearing the White Crown of southern or Upper
Egypt. Traces of his garment visible behind the
neck indicate that the head once belonged to a
statue representing the pharaoh participating in
the *sed*-festival, a ritual of royal renewal. The
style of the head—including its full, round face,

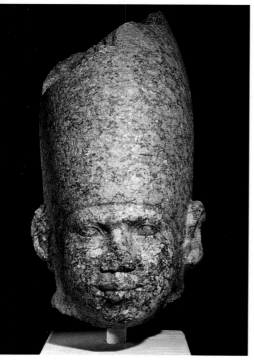

thick neck, and summarily modeled eyes—suggests an early date, perhaps in the second half of Dynasty III. Some Egyptologists, however, have argued that it should date to Dynasty IV and may represent Cheops, builder of the Great Pyramid at Giza.

Three Statues of Metjetji

❚ Egypt, probably from Saqqara
Old Kingdom, late Dynasty V or early
Dynasty VI (circa 2360–2340 B.C.)
Wood, stone, metal, gesso, paint, 27½ (69.9) high; 24¼ (61.5) high; 35⁵⁄₁₆ (88.9) high
53.222, 51.1, 50.77, CHARLES EDWIN WILBOUR FUND

Distributed throughout several collections, the statues of Metjetji from his tomb are remarkable for their diversity. Of his three sculptures in the Brooklyn Museum of Art, two represent him as an athletic, tall man in the prime of life. In both examples his face is bland and idealizing. The third statue renders him as a smaller, perhaps older and wizened, person whose face is inflected by a profound sensitivity and inner life that some regard as an indication of portraiture. Possibly there is a degree of verisimilitude. However, like the idealizing sculptures, which have a symbolic value, conveying one or more aspects of Metjetji's essence (no doubt including his virtuous character) the naturalistic statue may be more expressive of some other aspect, such as piety or intelligence, than realistic. Ironically, the finely wrought facial details were obscured by the plaster and paint surface that has now almost completely fallen away.

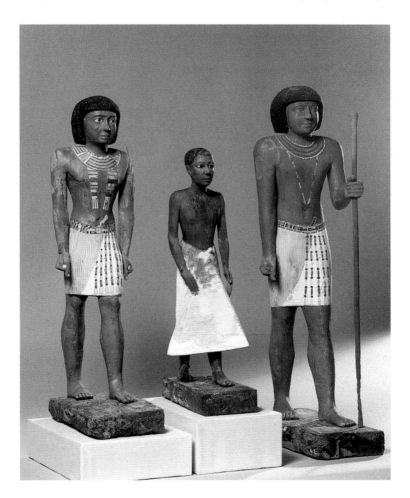

Queen Ankhnes-meryre II and King Pepy II

► Egypt, possibly from the Abydos region, Old Kingdom, Dynasty VI (circa 2245–2157 B.C.)
Egyptian alabaster, 15⁷⁄₁₆ (39.2) high
39.119, CHARLES EDWIN WILBOUR FUND

Pepy II became king while still a child, perhaps no older than five or six. This statue depicts him seated on the lap of his mother, Queen Ankhnes-meryre II. Although Pepy's back is carefully modeled, his mother's is flat, indicating that when the sculpture was placed in its original setting, the queen's figure had her back against a wall or column. Thus Ankhnes-meryre II would have confronted the viewer directly, making her, and not Pepy II, the statue's primary subject. The sculpture seems to celebrate the queen's role as mother of the reigning king and perhaps as regent during her son's minority. Only twelve royal stone sculptures can be dated with certainty to the Sixth Dynasty. Most are small, featuring unnaturally large heads and arms and legs carved fully in the round rather than connected to the rest of the statue by stone "bridges" or supports.

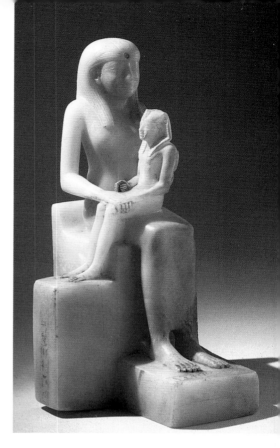

Head of a Queen or Princess

◄ Originally from Egypt, found near Rome, perhaps in Hadrian's Villa at Tivoli Middle Kingdom, mid-Dynasty XII (circa 1917–1882 B.C.)
Chlorite, 15⅜ (38.9) high
56.85, CHARLES EDWIN WILBOUR FUND

This colossal head features a wig that identifies the subject as female, and the miniature

uraeus-cobra on the forehead indicates that she is a queen or princess. Since 1956, when the Brooklyn Museum of Art purchased this head, most historians of Egyptian art have acknowledged it as one of the finest sculptures of a woman to survive from antiquity. Because the end of the wig tails off toward the horizontal, we know that the head originally belonged to a figure of a recumbent sphinx. A second female sphinx depicts Princess Ita, a daughter of the Twelfth Dynasty King Amenemhat II. Its similarity to this head suggests that they were contemporaneous. The head probably once stood in Hadrian's Villa at Tivoli, near Rome. Hadrian surrounded himself with "masterpieces" of Egyptian art, which his agents sent to Tivoli from sites in the Nile Valley.

Statue of Senwosret III

► Egypt, from Hierakonpolis
Middle Kingdom, Dynasty XII,
reign of Senwosret III (circa 1878–
1859 B.C.)
Black granite, 21½ (54.6) high
52.1, Charles Edwin Wilbour Fund

Senwosret III was one of the most powerful kings of the Twelfth Dynasty (circa 1979–1800 B.C.), whose reputation survived in legends told by the Greek historians. Although many Egyptian sculptures, both royal and private, are bland and idealizing, the statues of Senwosret III are highly naturalistic. This seated work bears all the hallmarks of the king's sculptural facial features: heavily lidded eyes, strongly lined and haggard cheeks, tightly pursed mouth, and prominent chin. His expression has been interpreted either as brutal or as careworn and compassionate. The latter opinion is surely correct. Many later kings and private persons copied and elaborated upon the visage of Senwosret III in their sculptures, and they would hardly have perpetuated the memory of a tyrant. The subsuming of identity to the royal visage of Senwosret III no doubt served to allow the individual to share the king's virtuous qualities.

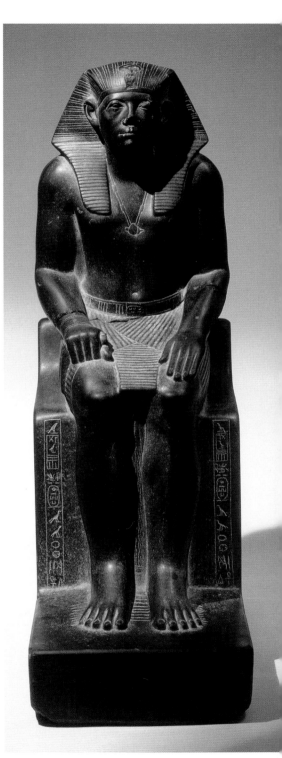

Seated Sculpture of an Unknown Man

❡ Egypt, exact provenance not known
Second Intermediate Period, Dynasty XIII,
(circa 1801–1627/1606 B.C.)
Quartzite, 27¼ (69.8) high

62.77.1, CHARLES EDWIN WILBOUR FUND

Long after the death of Senwosret III, one of the mightiest pharaohs of the Twelfth Dynasty, his facial features were widely copied. This sculpture of an unknown person has been dated to the Thirteenth Dynasty because its mannered abstraction derives from the style popularized by Senwosret III.

Despite the convincing, heavily lidded eyes and the prominent cheekbones, the dramatic muscular tension of the face is gone and the hand is overly large. The Thirteenth Dynasty sculpture is not an inferior work; it reflects a reworking of a popular style. The act of subsuming an individual's features to those of an earlier work illustrates the complexities of portraiture in ancient Egyptian art. Just because a sculpture looks realistic does not necessarily mean that it represents the actual physical features of the particular person. This sculpture is certainly naturalistic, if not realistic, and yet it is clearly patterned after a model.

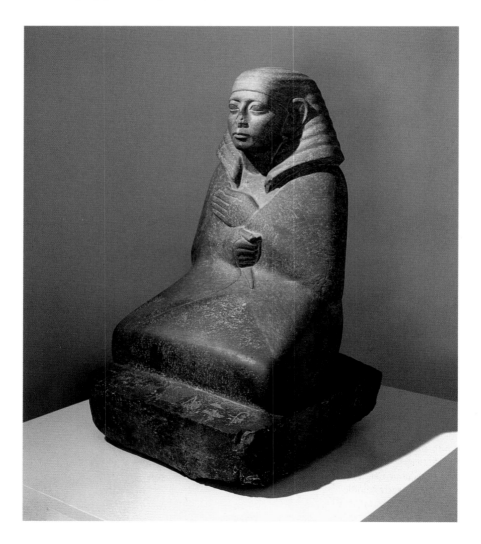

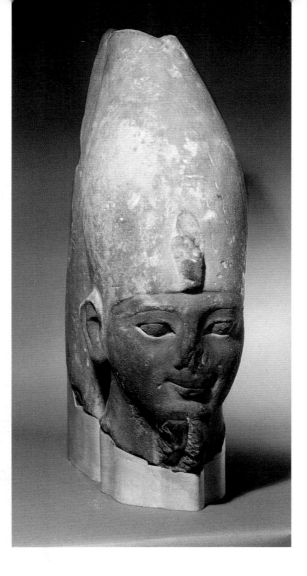

Head of a King

Egypt, exact provenance not known
New Kingdom, Dynasty XVIII (circa
1539–1493 B.C.)
Sandstone, painted, 24¼ (61.8) high
37.38E, CHARLES EDWIN WILBOUR FUND

At the dawn of the Eighteenth Dynasty, Egyptian royal sculptors sought to revive an art form that had largely been dormant during more than a century of foreign occupation. They fashioned statues harking back to the style of the early Middle Kingdom. No doubt these artisans sought to draw a parallel between that remote era, which marked the beginning of a glorious age in Egyptian history, and their own fledgling dynasty. The artistic creations of earliest Dynasty XII and Dynasty XVIII are so similar that this uninscribed head was long attributed to the Middle Kingdom. We now know it to be an Eighteenth Dynasty work. The treatment of the eyes, eyebrows, and mouth deliberately recalls early Middle Kingdom royal sculptures, but its open, ingenuous expression and curious half-smile are characteristic of the beginning of Dynasty XVIII. The head represents one of the first two kings of Dynasty XVIII, Ahmose or Amunhotep I.

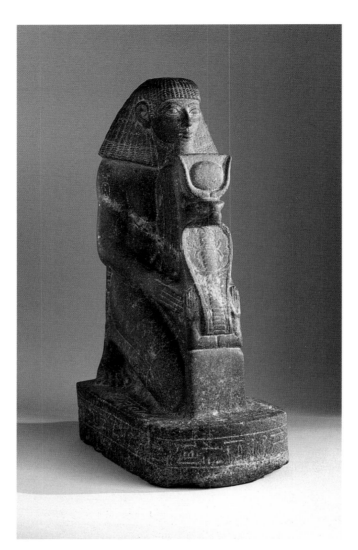

Statue of Senenmut

▌ Egypt, Armant
New Kingdom, Dynasty XVIII, reign of
Hatshepsut (1478/1472–1457 B.C.)
Gray granite, 18¼ (47.2)

67.68, CHARLES EDWIN WILBOUR FUND

Senenmut, a powerful official of the female
pharaoh Hatshepsut, was depicted in a variety
of innovative statue types, including this one:
a private person offering a divine symbol or
image. According to its inscription, this statue
shows Senenmut offering an image of the
harvest and nourishment goddess Renenutet
on behalf of the well-being of his sovereign
and in hopes of eternal blessings for himself.
However, the image he holds is also a rebus
for Maat-ka-Re, Hatshepsut's throne name.
The entire statue can thus be read as a
statement that Senenmut offers the name of
his sovereign; and it can be viewed as a
declaration of, and an appeal for, loyalty to
the controversial female pharaoh, who is
likened to a goddess of nourishment in accord
with the traditional concept of pharaoh as
Egypt's sustainer.

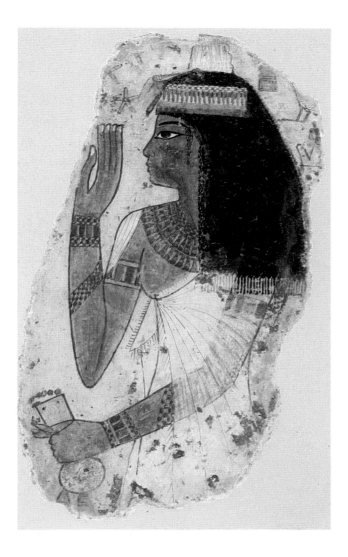

Fragment of Painting of Tjepu

▲ Egypt, from Thebes, Tomb 181
New Kingdom, Dynasty XVIII, reign of
Amunhotep III (circa 1390–1352 B.C.)
Painted plaster, 11⅞ (37.6) high
65.197, CHARLES EDWIN WILBOUR FUND

Although women of the higher social classes may have enjoyed many significant legal and other entitlements in certain periods of ancient Egyptian history, equal representation in Egyptian art was not one of them. The major- ity of Egyptian sculptures, paintings, and reliefs depict men. As well illustrated by this fragment from a tomb wall painting of Tjepu, those works that do represent women are almost always idealizing. Women in Egyptian art are eternally young, slender, and beautiful, surely in conformity to an aesthetic protocol dictated by male artists. Most paintings and reliefs of men are also idealizing, but sculptures of men are often naturalistic or realistic. Tjepu's features, however, cannot be taken seriously; despite her youthful image in this painting, other evidence from the tomb indicates that she was a much older woman.

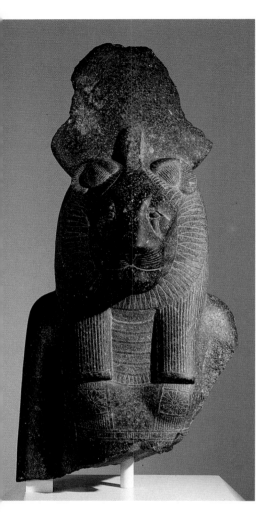

Bust of the Goddess Sakhmet

◄ Egypt, from Thebes
New Kingdom, Dynasty XVIII, reign of
Amunhotep III (circa 1390–1352 B.C.)
Granodiorite, 30 (99) high

1991.311, GIFT OF DR. AND MRS. W. BENSON HARER, JR.,
AND THE CHARLES EDWIN WILBOUR FUND

In this bust from a human-size statue, the god-
dess is crowned with a sun disk and protective
cobra and wears a broad necklace and a sheath
dress whose straps are adorned with a rosette.
The details of Sakhmet's garb and the patterns
on her muzzle, ears, leonine ruff, and wig are
excellent foils for the powerful modeling of her
face and the dramatic curve of her neck and
jaw. Sakhmet means "the Powerful" or "the
Power," and her disk and cobra relate to her
role as the dangerous, mobile eye of the sun
god Re. She was a great protectress of Egypt
and its kingship but, if not placated, might
abandon or attack what she should protect.
This bust is from one of a large number of
Sakhmet statues commissioned by King Amun-
hotep III as a sort of litany in stone to conjure
the goodwill of the goddess.

Relief of Queen Nefertiti

❙ Egypt, Karnak (Amun Precinct)
New Kingdom, Dynasty XVIII (circa
1352–1348 B.C.)
Sandstone, painted, 16⅝ (42.3) wide

78.39, GIFT OF CHRISTOS G. BASTIS IN HONOR OF
BERNARD V. BOTHMER

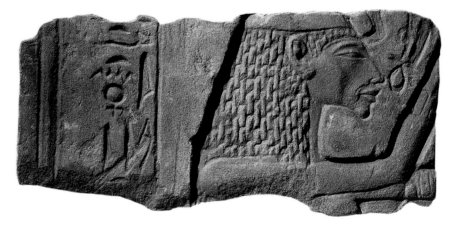

In Year 5 of his reign, Amunhotep IV changed his name to Akhenaten and transferred the capital from Thebes to El Amarna. He encouraged the worship of his personal deity, the Aten, a version of the sun represented by a solar disk. Over time, he and his principal wife, Queen Nefertiti, forbade the worship of all gods except the Aten. Akhenaten's radical changes in religion were paralleled by a startling transformation of the visual arts. Previously, royalty had appeared as "perfect beings" with idealized faces and trim, athletic bodies. Under Akhenaten—particularly in the early years of his kingship—both king and queen were represented with elongated eyes set at an unnatural slant, long straight noses, emaciated cheeks, knobby chins, and attenuated necks. This relief depicts Nefertiti offering to the Aten. The tiny *ankh*-sign (the hieroglyph for "life") before her nose is presented to the queen by one of the Aten's rays.

Relief of a Nobleman

► Egypt, provenance not known, probably from Saqqara
New Kingdom, probably Dynasty XIX (circa 1295–1185 B.C.)
Limestone, 20⅕₆ (51.2) high
36.261, Charles Edwin Wilbour Fund

This fragment must come from a scene of a nobleman bowing and/or offering to one or more deities. Accompanying him was a figure, possibly his wife, holding a flower and playing a looped sistrum. The noble wears an elaborate pleated garment and a fancy wig of a type known from late Dynasty XVIII through the Ramesside Period. His wig is adorned with a band of lotus blossoms and buds: fancy party garb but also symbols of rebirth appropriate to a scene that can only be from a tomb. This relief is a splendid example of the timeless, staid, and formal elegance found in most periods of Egyptian art. A possible Amarna Period legacy is the creation of a sense of depth and volume through the

strong projection of the chin and neck before the wig and through the deeper carving of the rear of the head.

Cartonnage of Nespanetjerenpere

►► Egypt, provenance not known, probably from Thebes
Third Intermediate Period, Dynasty XXII–early Dynasty XXV (circa 945–653 B.C.)
Cartonnage (linen or papyrus mixed with plaster), painted, with eyes and eyebrows inlaid with glass and lapis lazuli, 69¾ (177) high
35.1265, Charles Edwin Wilbour Fund

Everything about the priest Nespanetjerenpere's "mummy case" reflects a desire to associate him with the divine. This is evident, for example, in the image of the winged ram-headed solar deity on the chest and the scene of the gods Horus and Thoth erecting a symbol of enduringness and the god Osiris on the back. More unusual is the decoration of the front panels, which for the most part consists of deities whose accompanying texts identify each one with a specific part of Nespanetjerenpere's body. The priest also appears in human guise in these panels and on the back, where he receives life-giving water twice from

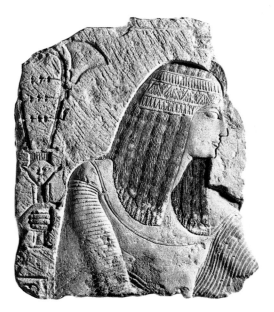

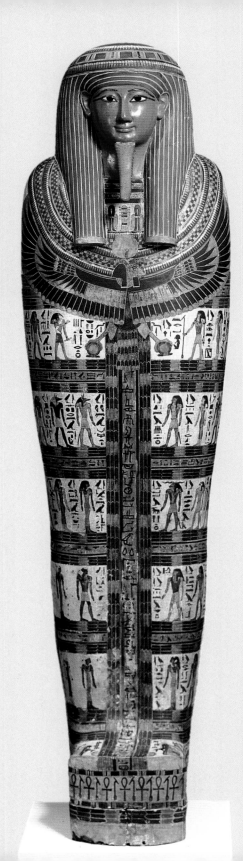

a goddess and then kneels under a flow of life signs. This massing of divine images, propitious symbols, and magical texts in lively colors is characteristic of funerary furnishings of the era in which Nespanetjerenpere lived.

Relief of a High Official

► Egypt, from Thebes
Third Intermediate Period–Late Period, late Dynasty XXV–Dynasty XXVI (circa 670–525 B.C.)
Limestone, 15 (38) high
1996.146.3, BEQUEST OF MRS. CARL L. SELDEN

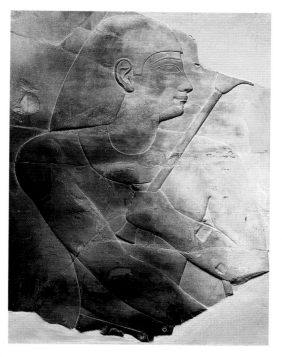

The nobleman in this relief wears a full wig, a broad collar necklace, and a kilt. One hand once held a staff, only a very small portion of which is preserved, while the other held a scepter. The demarcation of the iris of his eye in relief is something that does not occur in all periods of Egyptian art. This relief's style makes it possible to attribute it to one of the palatial tombs of Dynasty XXV and Dynasty XXVI built by great officials such as Montuemhat, governor of Upper Egypt. They are located on the west bank of the Nile at Thebes, in the Asasif, the plain in front of the great bay in the cliffs known as Deir el Bahri. Reliefs in these tombs often display archaizing tendencies, and this relief of a nobleman has an elegance and style reflecting the art of Dynasty XVIII and perhaps even the Middle Kingdom.

Head of Wesirwer, Priest of the God Montu

◄ Egypt, from Karnak
Late Period, Dynasty XXX, (380–342 B.C.)
Schist, 6⅛ (15.56) high
55.175, CHARLES EDWIN WILBOUR FUND

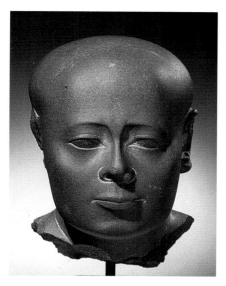

Originally part of a statue now in the Egyptian Museum, Cairo, the head of the priest Wesirwer is one of the greatest sculptures in the Brooklyn Museum of Art's renowned collection of ancient Egyptian art from the Late Period (Dynasty XXVI–Dynasty XXXI, circa 664–332 B.C.). At this time Egyptian sculptors sought to reveal the inner, spiritual life of the subject as never before. As revealed by the head of Wesirwer, many Late Period sculptures are markedly naturalistic, sometimes realistic, and yet they still adhere to the conventional idealizing forms of representation.

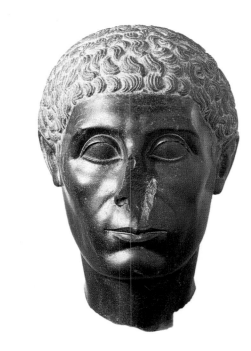

Although certain details such as the egg-shaped head and the treatment of the eyes are traditional, the downward gaze, the high cheekbones, and the small and pursed lips provide a naturalistic look that perhaps reveals a pensive nature.

The Brooklyn Black Head

◂ Egypt, provenance not known, said to be from Memphis
Late Ptolemaic Period, 1st century B.C.
Diorite, 16⅛ (41.4) high
58.30, CHARLES EDWIN WILBOUR FUND

Egyptologists have named a few fine Late Period heads whose subjects are not known after their current location and the color of their stone: hence, this sculpture's title. If the few preserved hieroglyphs behind the head on the upper part of the back pillar do not identify the man depicted, they do demonstrate that the sculpture is Egyptian. Elements of its style, however, such as its hairdo, have made it a focal point in the scholarly debate over whether Late Period Egyptian statuary reflects both pharaonic and Hellenistic influences and, if so, to what extent. It is also a focus in the ongoing discussion on the existence and nature of portraiture in ancient Egypt. Two things, however, are clear: this over-life-size sculpture in a very hard stone, whose significantly asymmetrical face has few parallels elsewhere, is a masterwork of its era and must have represented a very powerful priest or official.

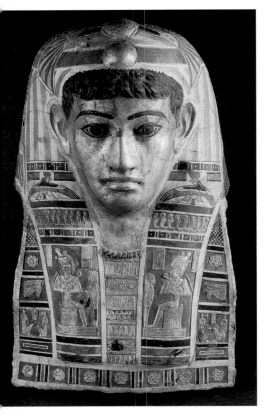

Mummy Mask

◂ Egypt, exact provenance not known
Roman Period, 1st century B.C.–
1st century A.D.
Linen, plaster, pigment, gold leaf, 19⅞ (50.48) high
72.57, CHARLES EDWIN WILBOUR FUND

An inveterate aspect of ancient Egyptian burial equipment, the mummy mask attained its most florid expression during the Roman occupation of Egypt, which began late in the first century B.C. The short, curly locks and the caterpillar-like eyebrows on this mask are of a clearly Roman style. The face seems to be of a generic type; the mask was no doubt a stock-

in-trade item. Symbolizing permanence and immortality, gold and gold leaf had long been used in mummy masks, and their application was mandatory during the Roman Period. At the top of the head is a winged scarab beetle holding a sun disk, a potent image of rebirth. At the bottom are two mirror images of the unknown dead man as a mummy standing before Osiris, lord of the underworld.

Alexander the Great

► Provenance not known, presumably from Egypt
First century B.C.–first century A.D.
Egyptian alabaster, 4⅛ (10.5) high
54.162, CHARLES EDWIN WILBOUR FUND

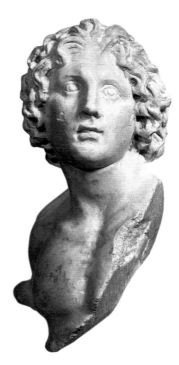

In his brief lifetime (356–323 B.C.), the Macedonian Greek ruler Alexander the Great became sovereign of countries far beyond his homeland. During his lifetime and for centuries thereafter, he was a figure of veneration whose representations could associate or identify him with various deities. In this bust, Alexander's luxuriant head of hair, likened by his contemporaries to a lion's mane, is pierced with holes for the attachment of metal rays (perhaps gold) that associated him with the solar deity Helios. Its head turned sharply to the left and slightly upward, this bust, carved with the delicacy of a cameo, once formed part of a draped figure whose garment was of a different material.

Coptic Openwork Relief

❚ Egypt, perhaps from Ihnasya el Medina (Herakleopolis)
5th–7th century A.D.
Limestone, 14 (35.6) high; 50⁷⁄₁₆ (128.1) long
41.1266, CHARLES EDWIN WILBOUR FUND

Produced at a time when Christianity had become the major religion in Egypt, this fragmentary relief has non-Christian decorative elements, illustrating the problems inherent in interpreting "Coptic" as an exclusively religious designation. Much of what is called "Coptic art" has no explicit Christian or even distinctly Egyptian decoration, as this frieze demonstrates. The garland frieze is a popular classical motif, and the circular frames around each animal are found earlier in various Near Eastern contexts. The frieze was almost certainly an architectural element in a church, monastery, or other religious building, but it is completely lacking in Christian iconography. Similar motifs have been found in Christian contexts throughout Egypt, such as at Alexandria, Saqqara, and Herakleopolis in the Faiyum.

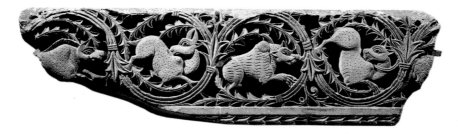

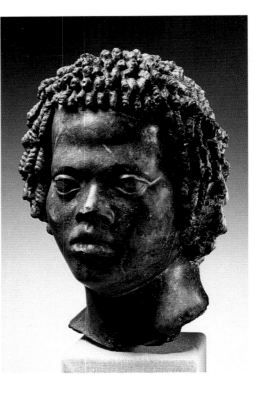

Head of a Black Man

► Provenance not certain
Hellenistic, 2nd–1st century B.C.
Black marble, 11 (27.9) high
70.59, CHARLES EDWIN WILBOUR FUND

Of unknown origin but probably from the Hellenistic Near East, this sculptural fragment is noteworthy for its sensitive representation of a black man, devoid of the unfortunate racial stereotypes sometimes found elsewhere in ancient classical art. Equally uncertain is the identity of the man or his ethnic origin. Various possibilities have been suggested—soldier, administrative official, servant—but none is conclusive. He may have been from Nubia or elsewhere in sub-Saharan Africa. The pensive look and the carefully detailed dreadlocks may suggest that the head is a portrait, but once again there is no definite answer. The representation may have been generic rather than specific.

Minoan Jug

► Found in Egypt, but probably made in Crete
Late Minoan IB, 16th century B.C.
Ceramic and slip, 8⅝ (21.9) high
37.13E, CHARLES EDWIN WILBOUR FUND

Passionate observers of the natural world, the Minoans of Crete translated their observations into some of the most original imagery found in ancient Mediterranean art. Marine life, a favorite visual theme of this seafaring culture, was depicted in wall paintings, reliefs, and on both stone and clay vessels. On this jug five painted nautili float effortlessly above the sea floor among various aquatic creatures. Sinuous tentacles rise up from the shells, counteracting the weight of the vessel's swollen belly. A net motif frames the nautili above, and bands of petal-like decoration adorn the neck. Found in Egypt, this pot may have contained oil or wine

and was probably traded for Egyptian goods. Once owned by Dr. Henry Abbott, the jug was purchased from The New-York Historical Society in 1948. The Abbott acquisitions form the core of Brooklyn's outstanding collection of classical, Egyptian, and ancient Middle Eastern antiquities.

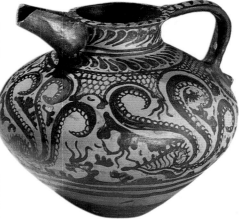

Image of the Sun God

► Syria, exact provenance not known
Circa 1700–1600 B.C.
Bronze, 5¾ (13.5) high

1995.27, Purchased with funds given by Shelby
White, the Ella C. Woodward Memorial Fund, and
the Charles Edwin Wilbour Fund

Because of its location in westernmost Asia
along the eastern coast of the Mediterranean
Sea, ancient Syria maintained extensive trade
connections with Europe, Turkey, Mesopot-
amia (modern Iraq), Iran, and Egypt. These
connections occasionally resulted in works of
art inspired by diverse sources. This bronze
statuette of a god reflects reliance on several
prototypes. The presence of a horned crown
indicates that the subject is divine, and the sun
disk atop his head is paralleled on innumerable
Egyptian images suggesting inspiration from
the Nile Valley. The god depicted here belongs
to the western Asiatic pantheon, however; he
is probably a Syrian version of the Akkadian
sun god Shamash. The modeling of the face—
particularly the nose, mouth, and elaborate
beard—is without parallel among the corpus
of Syrian bronzes and seems to argue for
Mesopotamian influence. The god's thick
fringed cloak, however, is a typical Syrian
garment.

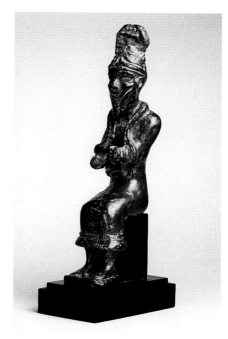

Recumbent Dog

❚ Mesopotamia, perhaps from Babylon
Old Babylonian Period, circa 19th
century B.C.
Aragonite, 8¾ (22.3) long

51.220, Gift of Mr. and Mrs. Alastair B. Martin

A strong tradition of animal sculpture existed
for millennia in ancient Mesopotamia (modern
Iraq). Of the few examples that have survived,

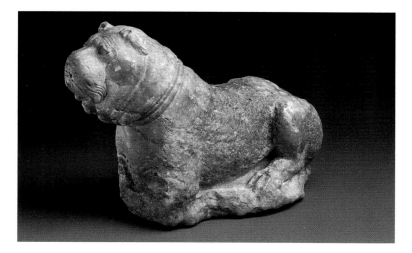

most seem to come from temples and represent animals associated with specific divinities. The dog was sacred to the goddess Gula, consort of the great Babylonian god Ninurta. This image was probably a votive offering left in the temple by a follower of Gula's cult. The statuette may have stood in a sanctuary of that goddess, perhaps in one of the temples of Babylon. This figure reflects the great attention to naturalism characterizing the finest creations of the Old Babylonian Period. The sculptor paid great attention to the dog's wrinkled muzzle, heavy jowls, thick, muscular neck, and stout torso. So faithful was the representation of these details that we can recognize the dog as an early form of the modern mastiff.

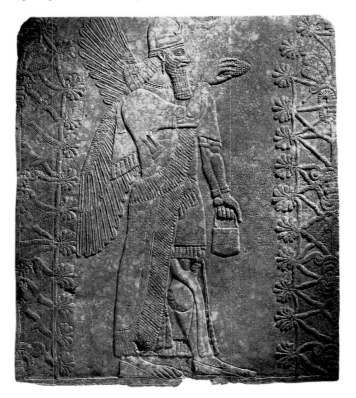

Winged Genie

⬑ Iraq, Nimrud (Assyria), from Room L of the Northwest Palace
Reign of Ashur-nasir-pal II (circa 883–859 B.C.)
Alabaster, 93 (236.2) high

55.147, PURCHASED WITH FUNDS GIVEN BY HAGOP KEVORKIAN AND THE KEVORKIAN FOUNDATION

From their heartland in what is now northern Iraq, the Assyrians established a vast political and military empire extending throughout western Asia into Egypt. Beginning in the ninth century B.C., the Assyrians constructed large palaces featuring walls embellished with monumental alabaster reliefs. These reliefs show the king leading his army into battle, hunting lions, and participating in solemn religious rituals. This slab depicts a great winged genie accompanying the king in one of these rites. He holds a pinecone, which he dips into a pail and uses to sprinkle liquid onto a stylized "Sacred Tree." The long cuneiform inscription running across the slab recounts the major events in the reign of Ashur-nasir-pal II, the self-proclaimed "King of the World". The Museum possesses twelve of the earliest Assyrian palace reliefs. All were removed from Ashur-nasir-pal II's palace in Nimrud in 1853 and came to Brooklyn in 1937.

Asian Art

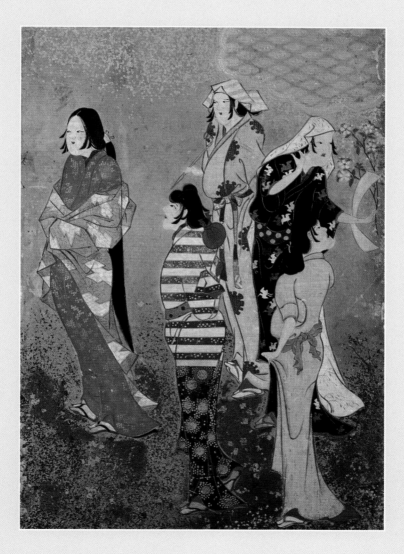

Ritual Wine Vessel *(Guang)*

► China, late Shang Dynasty, 13th–11th century B.C.
Bronze, 8½ x 6½ x 4 (21.6 x 16.5 x 10.2)
72.163A-B, GIFT OF THE GUENNOL COLLECTION

Truly sculptural in its conception, the Shang Dynasty *guang* is the Museum's finest early Chinese ritual bronze. The rituals of the Shang kings were elaborations of banquets that included serving food and wine, and this superbly cast *guang* is a type of wine vessel. Like other bronzes, it is a symbol of authority, and possession of the best artistic products is directly linked to the social, political, and religious prestige of the Shang rulers. The burial of ritual bronzes in Shang tombs, too, indicates the desire to invoke the deceased to continue their vital role in the lives of their descendants. This ritual wine vessel, which combines striking natural and mythological animal imagery with finely cast geometric designs, raises the question of meaning in Shang bronzes. One writer has suggested that the animals represent spirits that possessed Shang shamans during rituals.

Ewer with Phoenix Head

► China, Tang or early Song Dynasty (possibly 10th century)
Qingbai stoneware, translucent glaze, 14⁹⁄₁₆ (37) high; 6⅞ (17.5) diameter
54.7, ELLA C. WOODWARD MEMORIAL FUND AND THE FRANK L. BABBOTT FUND

The Museum's phoenix-headed ewer is a superb example of *qingbai,* or "blue-white," glazed high-fire ceramic. The head is wonderfully carved and modeled and truly ferocious in appearance. The earliest ceramic phoenix-

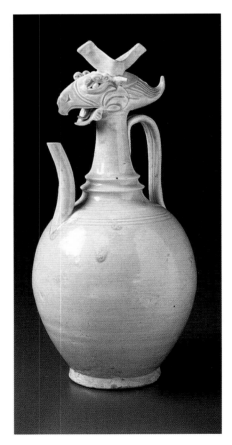

headed ewers, or vaselike pitchers, date from the Tang Dynasty (A.D. 618–907) and were inspired by gold and silver ewers with phoenix heads imported from Sassanian Persia. The ridges around the neck, the tall spout and handle, and the elaborate crown on the bird's head are all vestiges of metal prototypes. It is the skill of the Chinese potter, however, that makes this ewer such a compelling vessel. The quality and color of the glaze, which appears blue-green with opaque white inclusions where it is thickest, link it to archaeologically excavated kiln sites in southern China. Maritime trade between China and Southeast Asia, the Philippines, and the islands of modern Indonesia greatly expanded during the early Song Dynasty in the late tenth century, and many examples of *qingbai* wares from southern Chinese kilns were exported there.

Bodhisattva Guanyin

► China, Yunnan Province, Dali Kingdom, 11th–12th century
Cast bronze, traces of gilding, 18⅞ x 4½ x 3
(48 x 11.4 x 7.6)
1995.48, GIFT OF THE ASIAN ART COUNCIL

The Bodhisattva Avalokitesvara, called Guanyin in Chinese, played a crucial role as the protector of the semi-independent Nanzhao and Dali kingdoms (flourished A.D. 649–1253) in present-day Yunnan Province. The creation of this type of tutelary icon representing Azuoye Guanyin, the Ajaya or All-Victorious Avalokitesvara, is recorded in the mid-tenth-century handscroll *Illustrated History of Nanzhao*, currently in the Fujii Yurinkan in Kyoto, which details the miraculous introduction of Buddhism into Yunnan by an Indian monk, himself believed to be an incarnation of the Bodhisattva. Significantly, the sculpture displays strong stylistic ties to images from Southeast Asia and India. Pallava prototypes of the eighth to ninth century in India and their outgrowths in Southeast Asia, particularly in Srivijaya, are the most suggestive examples. Visible on the back of this Guanyin are two sealed openings, which would have held written prayers or objects of devotion, reinforcing the powers of divine protection provided by the Bodhisattva.

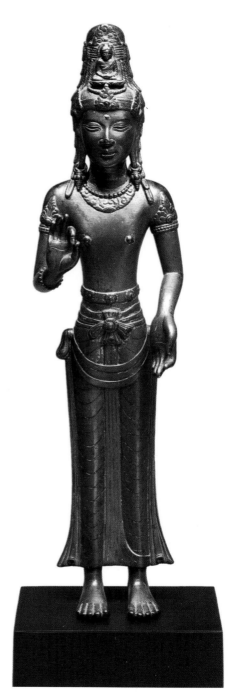

Wine Jar with a Design of Fish and Water Plants

▶ China, Yuan Dynasty (1279–1368)
Jingdezhen porcelain, underglaze cobalt blue decoration, 11¹⁵⁄₁₆ (30.3) high; 13¾ (34.9) diameter
52.87.1, WILLIAM E. HUTCHINS COLLECTION

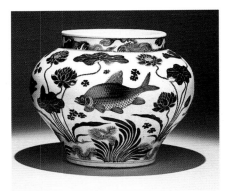

The quality of the deep blue color produced by the cobalt oxide pigment imported into China in the fourteenth century, the strong contours of the jar, and the extraordinary fit of the design of fish and water plants to the form all make this wine jar one of the masterpieces of Chinese porcelain. Unlike the designs on other fourteenth-century ceramics, the jar's decoration of fish swimming among stylized plants fills the entire surface in one unified field, leaving only a small but powerfully drawn band of crashing waves around the neck. Four vivid, naturalistic depictions of fish form the focal points of the design. In addition, the names of the fish form a rebus—a word-play on a four-character phrase meaning "honest and incorruptible"—adding a layer of meaning to the design. While the design might exhort the jar's owner to the upright action, the wine it once contained remained a powerful reminder of life's temptations.

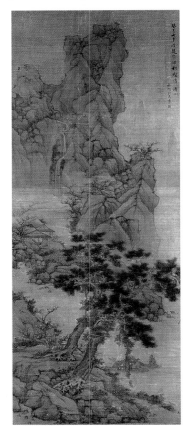

Landscape

◀ Lan Ying (Chinese, after 1585–1664)
China, Qing Dynasty, dated 1653
Hanging scroll, ink and color on silk, 66 x 26½ (167.6 x 67.3)
84.72, GIFT OF STANLEY HERZMAN, BY EXCHANGE, FREDERICK LOESER ART FUND, AND THE DESIGNATED PURCHASE FUND

By the late sixteenth century, traditional Chinese critical writings on the art of painting emphasized the superiority of scholar-amateur artists over professional masters. Lan Ying's life and artistic production, however, bring into question this scholar-professional polarity. While he certainly earned his livelihood as a professional painter, Lan Ying also actively collaborated with many prominent scholar artists. This superb landscape depicts two figures in official robes conversing while boating through an idealized mountain landscape. The painting evokes a leisurely afternoon of elegant conversation and combines the grand scale of a professional hanging scroll in ink and color on silk with subtle references to the canonical scholar styles in the modeling of the mountain forms. It is a major example of Lan Ying's mature style and reminds us that he was skilled in many painting modes, appealing to both popular and scholarly taste.

Ewer

► Korea, Koryo Dynasty, first half
of the 12th century
Porcelain, 9⅞ x 9½ (25.1 x 24.1)
56.138.1, GIFT OF MRS. DARWIN R. JAMES III

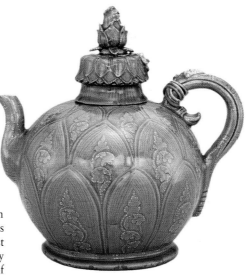

Celadon is the name given to high-fired porcelaneous wares with translucent gray-green glazes, which were developed first in China and then widely imitated. The color of the glaze is a result of iron oxide in a reduction kiln (one with a limited amount of oxygen during firing). Green glazes were introduced to Korea by Chinese potters in the tenth to eleventh century. The glaze on this ewer is the particular type known as kingfisher blue, found on only the best twelfth-century Korean celadons. The body of the ewer is carved with a design of overlapping lotus petals framing leaf sprays. The handle is in the form of a lotus stalk bound at the top with reeds; the lid, in the shape of an upside-down lotus blossom; and the lid knob, in the form of a lotus bud. A butterfly, modeled in relief on the lid, corresponds to a cocoon on the handle. The butterfly and cocoon secured circular rings, now missing, for a chain.

Iron-Painted Dragon Jar

◄ Korea, Yi Dynasty, 17th century
Porcelain, 12⅜ x 14⅝ (31.4 x 37.1)
86.139, GIFT OF THE ASIAN ART COUNCIL

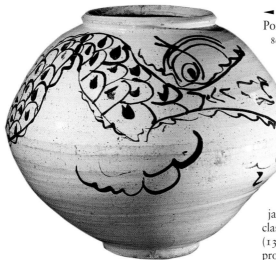

The dragon on this jar seems naive, eccentric, and amusing, yet powerful and mysterious. He acts as the protector from evil spirits for the food inside the jar as well as an attractor of good spirits for the jar's owner. The dragon was painted on the surface of the jar with iron-oxide brown-black pigment prior to the application of the clear glaze. The potters who made these utilitarian storage jars were members of one of the lowest classes in society during the Choson Period (1392–1910). They had to work quickly to produce serviceable pots in large quantities to make a meager living, and the swiftly painted, lively dragon on this jar is the result.

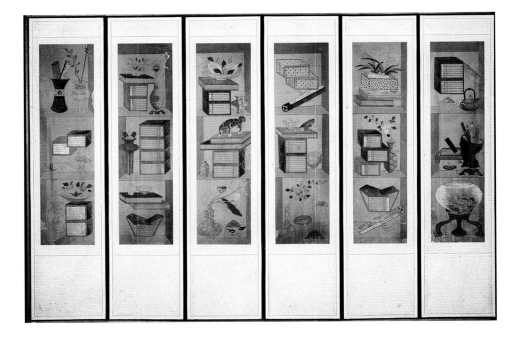

Ch'aekkori Screen
(Books and Scholar's Utensils)

▲ Korea, Choson Period, 1864
Six-panel screen, ink and color on paper,
each 39⅛ x 10⅝ (99.4 x 27)
74.5, GIFT OF HORACE O. HAVEMEYER, BY EXCHANGE

In the Choson Period the scholarly elite followed Confucian rules of governance and philosophy. *Ch'aekkori* screens are still-life paintings of furnishings from an idealized scholar's study meant to convey the Confucian ideals of dignity and a reverence for scholarship. Recent study has revealed that the seal in the middle section of the third panel from the right gives an artist's name and an ink stick in the first panel middle section gives a date, which is accepted as the cyclical year, corresponding to 1864, when the screen was painted. The details in these six panels were meant to enlighten the contemporary viewer who could identify various antique objects and the specific books whose titles are associated with the Confucian classics. Such objects reflect the aspirations of the scholarly elite (*yanban* class). The Brooklyn screens exemplify the detailed composition of multiple perspectives common to a group of *ch'aekkori* paintings, which show the various decorative objects and scholarly paraphernalia in registers from different viewpoints.

Kongo-kai Mandara

❚ Japan, Kamakura Period, 13th century
Hanging scroll, ink and color and cut-gold
leaf on silk, image 46¹¹⁄₁₆ x 38⅞
(118.6 x 98.7); outer fabric 84½ x 47⅜
(214.7 x 120.3)
21.240.1, MUSEUM COLLECTION FUND

This mandala painting is one of a pair in the
Museum of the principal mandalas venerated
in Esoteric Buddhism in Japan, particularly of
the Shingon sect. It demonstrates a pervasive
symmetry of composition, conceptually repre-
senting the theme of Heaven. It is based on

the sutras invoking the manifestations of
Mahavairocana (Dainichi), which were pro-
mulgated in Japan by the monk Kobo Daishi
(794–835) from China. In the composition of
this mandala, as in other versions, the Cosmic
Buddha Dainichi Nyorai occupies the top
center position of nine squares. Each of the
squares is framed by borders containing either
deities seated with their attributes or ritual
symbols, most commonly *vajra* (thunderbolts).
This hieratic framework is also present in the
accompanying Taizo-kai mandara, reflecting
their original placement opposite each other.
Together they form the *Ryogai Mandara*
(*Mandala of the Two Principles*), which are
among the finest early paintings in the
Museum's collection of the mandalas of this
period.

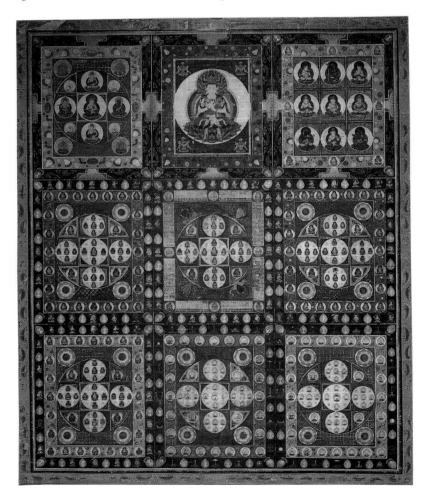

Haniwa Figure of a Shamaness

❚ Japan, Tomb Period, 5th–6th century
Earthenware, 18 x 8¾ (45.7 x 22.2)
79.278.1, GIFT OF MR. AND MRS. STANLEY MARCUS

In the beginning of the fourth century, a group of people calling themselves the Yamato people migrated into Japan from Korea. The Yamato built mound tombs for their important dead, the largest tombs being for emperors. The tomb chambers were filled with luxury goods meant to serve the deceased in the spirit world with artifacts nearly identical to those from Kaya and Silla kingdom tombs in southern Korea. *Haniwa*, however, are unique to Japan. They are large, hollow earthenware cylinders, either plain or shaped like weapons, buildings, animals, or human figures. They were placed in a circle around the tomb mound or on top of it. This *haniwa* represents the Shinto priestesses who presided over the funeral ceremony, which went on for several days, with eating, drinking, and entertainment. The feast was meant to continue indefinitely in the spirit world, with the clay priestess presiding.

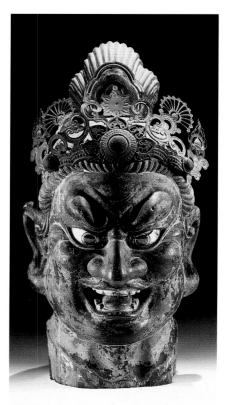

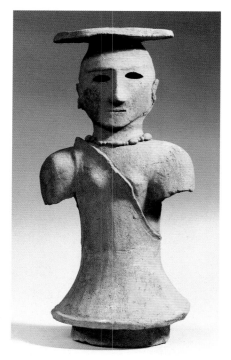

Head of a Guardian

▲ Japan, Kamakura Period, 13th century
Wood with polychrome decoration, inlaid rock-crystal eyes and filigree metal crown, 22¹⁄₁₆ x 10¼ x 13¹⁵⁄₁₆ (56 x 26 x 35.5)
86.21, GIFT OF THE GUENNOL COLLECTION

This head is from the figure of a guardian king of the Kamakura Period in Japan. Acquired in 1954 as part of The Guennol Collection, this head of one of the four guardian kings was at one time owned by the Kofuku-ji temple in Nara and symbolically illustrates the role of Kofuku-ji in the brief but pivotal period in Japan when Nara temples were rebuilt and refurbished, reflecting a renaissance of a naturalistic sculptural style. Sculptors like Unkei, Kaikei, and their followers created portraits and divine images with a new realism that was an amalgam of previous Nara styles. This piece compares in expression and detail to the Shitennō (Four Heavenly

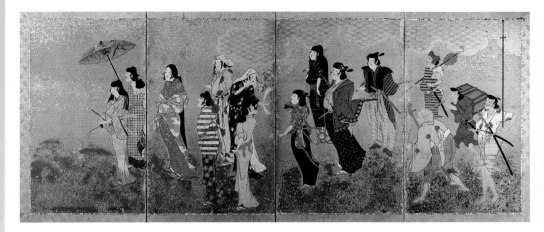

Guardians) that were carved for the Nanendo at Kofuku-ji in 1189 by the renowned artist Kokei. Together, the figure's fiery eyes, furrowed brows, prominent nose, and open mouth present a ferocious mien typical of the Heavenly Guardians, whose role was to protect the temple's sacred precincts.

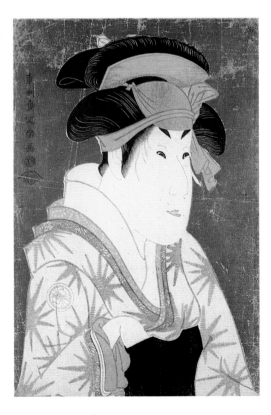

A Cherry Blossom Viewing Picnic

↑ Japan, Edo Period, first half of the 17th century
Folding screen, ink, color and gold on paper, 39⅜ x 105⅞ (100 x 269)
39.87, GIFT OF FREDERIC B. PRATT

Incorporated within this array of figures on a picnic outing in spring are many stories to be told. It is a scene of early Edo society in which women in beautifully variegated kimonos are *yu-jyo* (pleasure girls) playfully carrying a long pipe and decorative swords. The woman in the red *kosode* garment is the most important figure in the composition, and romance is suggested by a woman handing a tree branch with an oblong strip of paper for writing a poem to a man. The screen is one-half of a pair; the other (left) screen, depicting the higher class of pleasure women from the Yoshiwara district seated beneath a cherry tree, is in a private Japanese collection.

The Actor Segawa Kikunojo III in the Role of Oshizu

◂ Tōshusai Sharaku (active 1794–95)
Japan, Edo period, 1794
Woodblock print, 14⅞ x 9¼ (37.8 x 23.5)
42.83, GIFT OF MR. AND MRS. FREDERIC B. PRATT

This print of the actor Segawa Kikunojo III is one of Sharaku's most celebrated portraits of the *onnagata* (male actor in a female role). It portrays the sardonic expression of a character in the Genroku play *Hanaayame Bunroku*

Soga, a drama that tells the true story of the vengeance of ten brothers long after their father's assassination in 1701. The play was performed at the Miyako-za theater in Edo in May 1794, when Kabuki was held at three theaters. The artist was active only from May 1794 to January 1795, in the lunar year, and he produced about 140 actor prints in that ten-month period. It has been said that Sharaku was a Noh actor, Saito Jurobei, who served the Lord of Awa, a province of Shikoku Island near Osaka, but this has not been documented.

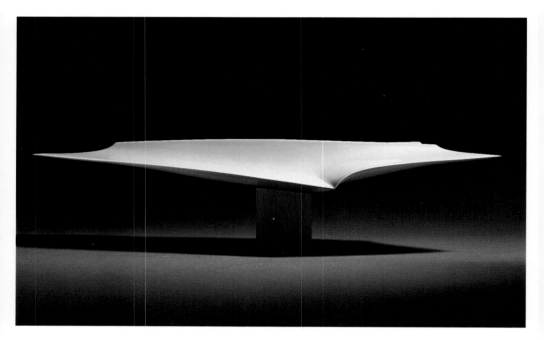

"Shinsho" (Infinity) II

↑ Fukami Sueharu (Japanese, b. 1947)
Japan, 1994
Porcelain with *seihakuji* (blue-green) glaze,
6 x 47⅛ x 9½ (17 x 123 x 26)

1994.146, Purchased with funds given by Alastair B. Martin

This work is an exemplary representation of Japan's contemporary ceramic tradition, which continues to explore the boundary between traditional vessel forms and new sculptural forms. Executed in a white-bodied kaolinite that is poured into a mold under high pressure, the piece has been carved at every edge and rim. A delicate process of glazing followed after initial biscuit firing. The piece was then refired in an electric kiln. As a master of *seihakuji* (blue-green) glaze technique, Fukami produces porcelain work with a strikingly flawless and luminous surface texture. As a sculptor, he has been engaged in expanding forms vertically or horizontally, which has resulted in this soaring winged sculpture. Moreover, extremely delicate ridge lines and sharply beveled edges highlight his aesthetic approach, which earned him international recognition as a leading porcelain artist.

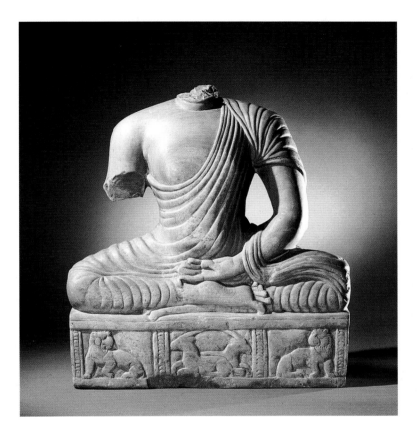

Seated Buddha Torso

▮ India, Andhra Pradesh, Iksvaku Period,
3rd century
Limestone, 16¾ x 15 (42.5 x 38.1)

86.227.24, GIFT OF THE ERNEST ERICKSON FOUNDATION,
INC.

This figure's position, hand gestures, and attributes, and the two deer in the center of the throne indicate that it is part of a scene of the Buddha's First Sermon in the deer park at Sarnath. The image is probably from Nagarjunakonda, in the Guntur district of the modern state of Andhra Pradesh. Nagarjunakonda was one of the greatest art centers in ancient India. The main Buddhist artistic activity at Nagarjunakonda grew through the patronage of the Iksvaku rulers, mostly their queens and princesses, who succeeded the Satavahanas at the end of the second century and ruled until early in the fourth century. The greenish limestone used in this sculpture is typical of the stone sculptures of Nagarjunakonda. This Buddha, head missing, is seated in the *satamaparyanka asana* position, the left hand on his lap forming the *dhyana mudra* (gesture of contemplation); the broken right hand must once have displayed the *abhaya mudra* (gesture of protection). The wheel on the sole of the Buddha's foot refers to the wheel of law, which he set in motion. The two seated lions with their heads turned back that flank the deer on the front of the throne are associated with royal and heroic virtues.

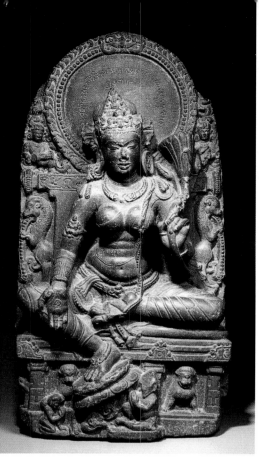

The Goddess Tara

◄ East India, Bihar, Pala Dynasty, 10th century
Black schist, 30¼ x 15½ (76.9 x 39.4)
1995.136, GIFT OF DR. BERTRAM H. SCHAFFNER

This image of a Buddhist divinity reflects the high point of Pala art and is one of the finest representations known outside India. It is carved in the typical polished schist of the Bihar region, and its emphatic volumes and sensuous, rounded forms contrasting with details of jewelry and dress are the hallmarks of the era's artistic production. A counterpart to Avalokitesvara, Tara is the feminine form of the archetypal bodhisattva, one who strives to assist others in the attainment of enlightenment. Seated in *lalitasana* on an elaborate throne, with her right foot supported by a lotus, Tara is flanked by two devotees. Her right hand is extended in *varada mudra*, and her left holds a *nilotpala* (blue lotus). She is surrounded by a circular aureole, with pearl and flame borders, and two *kinnara* (heavenly dwarf musicians) are shown in the upper border among stylized flowers. In this conventional form, the goddess represents the Green Tara, identified by her hand gesture and the closed lotus in her left hand.

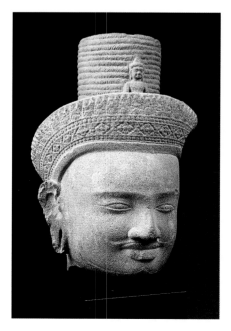

Head of Bodhisattva Avalokitesvara

◄ Cambodia, Koh Ker, 10th century
Gray sandstone, 11½ x 7½ x 7½
(29 x 19 x 19)
1995.180.1, ANONYMOUS GIFT IN HONOR OF DR. BERTRAM H. SCHAFFNER

This head of a male divinity can be identified as the Buddhist deity Bodhisattva Avalokitesvara by the diminutive image of a seated Buddha in the high chignon. The head is typologically grouped with sculpture of the Koh Ker era in Cambodian art, a period when Shaivism, a branch of Hinduism, received great patronage by its rulers, as attested to by the number of extant Shiva images. The almond-shaped eyes, full sensuous lips, earlobe in its stylized shell, and a closely cropped mustache and beard, meticulously carved in local stone, are all characteristics of Koh Ker styles. The hairstyle of the period, a high-tiered

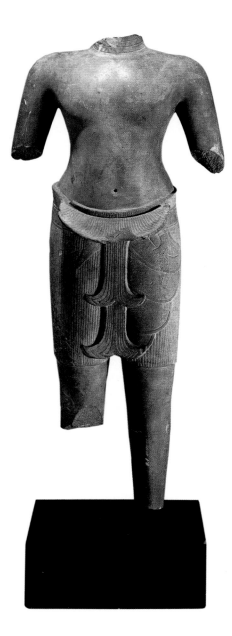

Torso of a Male Divinity

◄ Cambodia, Khmer, Khleang style,
978–1000
Sandstone, 48¾ x 21½ (124 x 54.5)
1991.131, GIFT OF DR. BERTRAM H. SCHAFFNER

The Khmer empire was one of the most power-
ful political and cultural powers of mainland
Southeast Asia from the ninth through the
thirteenth century. The empire was based in
Cambodia and had its capital in Angkor.
Large figures served as major icons of Khmer
temples and often appeared in the cella of a
chapel or in an important wall niche. This
sculpture may have been associated with one
of the hundreds of temples built by the Khmers
throughout this area in the form of symbolic
heavenly mountains. Khmer temple art borrows
many of its forms from Indian prototypes,
especially the royal cult of the *deva-raja* (god-
king), in which the ruler is a representation of
the god. The *deva-raja* is presented as a per-
fected version of the human form, with a
polished surface and geometric proportions.
Although it is difficult to determine its identity
with certainty, it probably represents the two-
armed Hindu god Shiva.

Demon Offering the Weapon Chest to Amir Hamza

►► Folio from the *Hamza-nama*
India, Mughal, circa 1562–77
Opaque watercolor and gold on cotton,
image 26⅝ x 20¹¹⁄₁₆ (67.5 x 52.5); sheet
31⅛ x 24¹³⁄₁₆ (79.1 x 63.3)
24.47, MUSEUM COLLECTION FUND

This painting is a folio from a unique
manuscript produced by the atelier located in
the court of the Mughal Emperor Akbar
(1556–1605): the *Hamza-nama*, otherwise
known as the *Qissa-i Amir Hamza*. It is one of
the earliest Mughal manuscripts, and through-
out history one of the most highly treasured.
The *Hamza-nama* recounts the legendary tales
of magic and miracles that are centered around
Hamza, uncle of the prophet Muhammad, the
hero of these stories. This painting represents
the demon Argan Div bringing a weapon chest
to Hamza. Emerging from the water, rendered
here by frothy, curling waves, he presents a
seemingly ferocious aspect with his spotted

coiffure enhanced by a banded crown tied in
the back with a knot, is also typical. Here, a
vertical third eye in the forehead, an attribute
of Shiva, denotes the divine nature of the
image and, together with the figure in the
headdress, suggests a syncretism of Hinduism
and Buddhism unusual in the period.

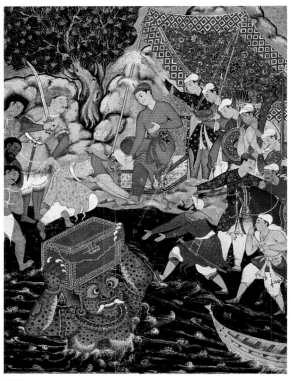

24.47

skin, flaming eyes, and sharp fangs projecting from a mouth with a rather frozen grimace. On the shore is Hamza seated on a throne under a bright canopy. His sovereign status is indicated by the row of attendants on his left, one of whom waves a yak-tail whisk above his head.

Seated Maitreya

❚ Tibet, 12th–13th century
Gilt copper, 9½ x 7½ (24.1 x 19.1)
67.80, CHARLES STEWART SMITH
MEMORIAL FUND

This wonderfully preserved image of Buddha is shown in the gesture of setting in motion the Wheel of the Doctrine. The Buddha is identified as Maitreya (Buddha of the Future) by the *stupa* (ritual object) in his headdress and by the flanking lotus. The artist has emphasized the hieratic pose of the figure and the stereotyped gesture of the

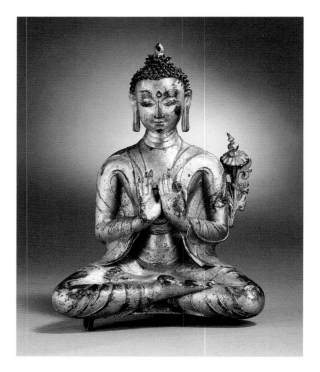

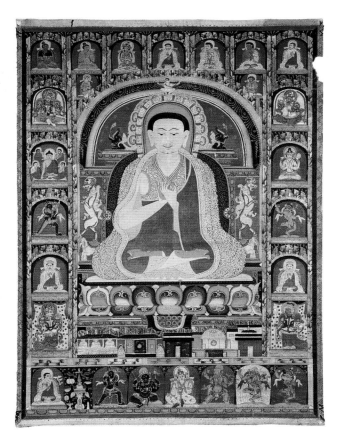

hands while at the same time conveying the Maitreya's authority and withdrawal to meditation. Although the spiked snail curls of this figure are seen in some Buddha images from western Tibet, the abstract patterning of the folds of the monastic garment are more typical of Newari workmanship of Nepal. Although such differences make attribution and dating of the piece difficult, it is known that Newari craftsmen were often employed in Tibet to produce bronze statuary.

Lama Portrait

Tibet, fourth quarter of the 13th century
Opaque watercolor and gold on cotton,
20⅛ x 14⅞ (51.5 x 37.9)
1991.86, Gift of the Asian Art Council

The tradition of Buddhist portraiture in Tibet dates back at least to the eleventh century, based on artistic evidence. The Taglung monas-

tery, founded about 1180–85, was one of central Tibet's seven most important and wealthiest monasteries. Its founder, a leading ascetic monk of the time, Thangpa Chenpo (1142–1210), is here portrayed as the principal figure of this *tangka,* or ritual banner. A register beneath his throne may depict scenes of his life, and the border cartouches contain images of deities, guardians of the faith and four directions, and teachers, marking the lineage of the central figure in this diagrammatic arrangement. The images are defined by an assured flowing line augmented by colors, with a solid red background isolating most of the figures. This style is based on the eastern Indian, Pala Dynasty Buddhist tradition, whereas a Central Asian influence is seen in the abstract treatment of the elements of the landscape. These combined regional styles became the hallmark of the Karma Kagyu school of painting, named for one of the Tibetan Buddhist sects.

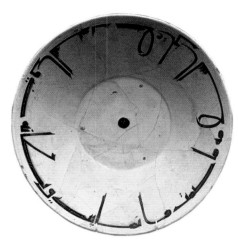

Nishapur Bowl

▌ Northeastern Iran or Transoxiana,
9th–10th century
Ceramic, transparent colorless glaze, black
slip, white engobe, buff earthenware body,
4⁹⁄₁₆ x 14 (11.5 x 35.5)
86.227.19, GIFT OF THE ERNEST ERICKSON FOUNDATION,
INC.

This bowl belongs to a large group of "black-
and-white" ceramic wares excavated in the
1930s at the Samanid (815–1005) site of Nish-
apur. Among those with epigraphic deco-
ration, this bowl is an outstanding example of
the clarity of design achieved by the use of a
white slip, covering the pink or buff earthen-
ware body, on which decoration was painted
in metallic pigments mixed with slip. The dark
brown design is in slight relief and embellished
with incising. The inscription is in Arabic,
expressing a pithy sentiment: "Peace is that
which is silent and only his speech will reveal
the (?) man with faults." The different types
of embellished kufic script in epigraphic wares
of this period vary in style from angular, like
this one, to a freer brushstroke, and in color
from a light brown to black, suggesting that
more than one workshop was in operation for
the production of these wares. Presumably,
each of the Samanid cities had kilns of its own
where ceramics similar to this one were
produced.

Hanging Ornament

▌ Turkey, Iznik, second half of the 16th
century
Ceramic, transparent colorless glaze,
painted in blue, red, and emerald green
underglaze, off-white body, 12 (30.3)
diameter
43.24.8, GIFT OF MR. AND MRS. FREDERIC B. PRATT

This hanging ornament was manufactured
during the Ottoman Empire. In this period,
the potters at Iznik attained a technical and
aesthetic superiority that was without
precedent in the Islamic world—partly as a
result of their desire to emulate the qualities of
Chinese porcelain. Iznik potters and tilemakers
created decorative elements for Ottoman
buildings and palaces as well as ceramic
wares, which were commissioned by the courts
and the Ottoman elite. These Iznik wares also
became very popular in Europe from the late
sixteenth century onward, as attested to by the
copies of Iznik wares in Italian majolica.
Hanging ornaments of this type were used in
mosques as well as Armenian churches, where
they were hung, along with similarly decorated
lamps. Only six globes of this size are extant,
making this type of Iznik ware much rarer
than other forms. This may have been because
they were specially commissioned for a short
period—in the mid- to late sixteenth century—
for a unique decorative purpose.

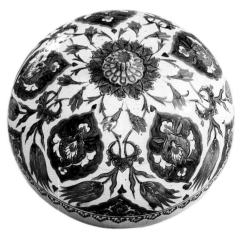

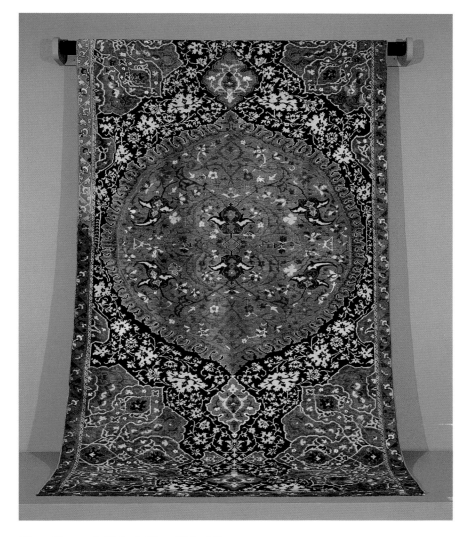

Blue-Ground "Medallion Ushak" Carpet

▲ Western Turkey, Ushak region, mid-16th century
Wool pile on wool foundation, symmetrical knots, 73 x 160 (185.4 x 406.4)
43.24.2, GIFT OF MR. AND MRS. FREDERIC B. PRATT

This Ottoman carpet, datable to the mid-sixteenth century, exhibits a majestic field design of medallions. The indigo-blue ground is embellished with cream-colored peony scrolls in Chinese style and framed by a narrow border of angular scrollwork and guard stripes. Sixteenth-century northwest Persian medallion carpets have been suggested as prototypes for these medallion carpets. This example clearly shows how these designs were adapted to Turkish carpet-weaving traditions. While Persian carpets featured single central medallions, sometimes with inclusions of partial corner medallions, Ushak carpets used the medallion design as part of an endless repeat pattern. Additionally, medallion Ushak carpets use simplified, bold designs in large patterns, in contrast to the complex decorative patterns of vine scrolls and arabesques intermingled with animal and figural designs found in Persian medallion carpets.

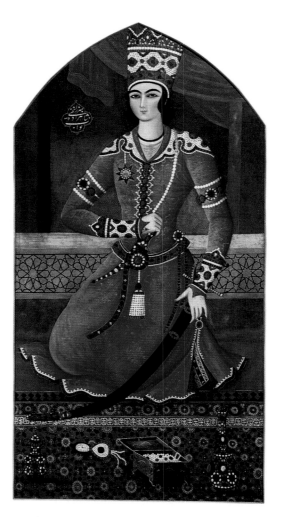

Portrait of Prince Yahya

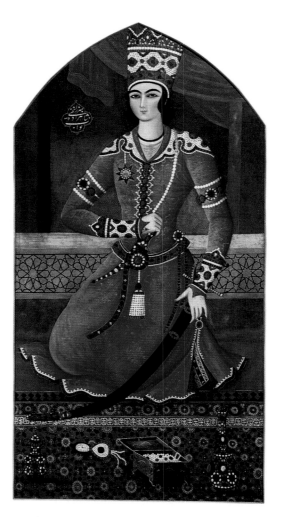 Iran, first half of the 19th century
Oil on canvas and gesso, 66⅗ x 35
(169 x 89)
Inscribed, in Persian, nasta'liq script within
cartouche, upper left corner: "Shahzdeh
Navvab Yahya Mirza (His Highness Prince
Yahya Mirza)"

Persian life-size portraiture reached its height
during the Qajar Dynasty (1779–1924). The
young prince—shown beardless and identified
by an inscription—is rendered frontally,
regally posed "à l'Orientale" on a patterned
carpet against a wooden balustrade. The
beauty of the prince's features, his delicately
arched brows, and his rosy cheeks indicate
that the artist was painting a generic image
of a beautiful youth, rather than an indi-
vidualized portrait. The prince's identity and
station are conveyed not by his features or
stance, but rather by the decorative details, the
inscription, and the diplomatic order that he
wears. This portrait most closely resembles
the work of Muhammad Hasan, in both the
decorative details and the delicate quality of
the facial rendition. This portrait exemplifies
the emphasis on surface decoration and
idealized beauty that the court painter used to
convey the magnificence of the court. This
aesthetic approach is traditionally associated
with the high point of manuscript painting in
the fifteenth and sixteenth centuries. Here it
is applied to large-scale painting with few
perceptible changes.

African Art

Double Bell (Egogo)

► Nigeria, Royal Court of Benin; Edo people, early 16th century
Ivory, 14⅛ x 3¾ x 2¼ (35.9 x 9.5 x 5.7)
58.160, A. AUGUSTUS HEALY FUND AND THE FRANK L. BABBOTT FUND

Only five examples of decorated ivory clapperless bells from Benin are known to exist. All five are closely related in iconography and carving style, and illustrate the peak of the artistic achievement in ivory that marked the florescence of the Benin Kingdom in the sixteenth century. For five hundred years the *obas* ruled as divine kings. The *oba* is depicted here with his hand ceremonially supported by two retainers, the Ezomo and the Edaiken. They

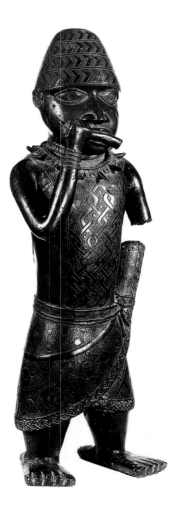

are the supreme military commander and the *oba's* heir respectively and actually supported the *oba* in this manner on the most important ceremonial occasions. The bell would have been struck with an ivory rod on the occasion of the Emobo ceremony in which the *oba* annually purifies and strengthens the nation by driving off malevolent spirits. Also present are the motifs of mudfish, which are royal emblems associated with Olokun, the god of the sea and riches, on either side of the *oba's* skirt; and a hand, a symbol of success and accomplishment, in upright position clenched in the jaws of a crocodile, a symbol of physical power.

Figure of a Hornblower

◄ Nigeria, Royal Court of Benin; Edo people, 16th or 17th century
Metal, 24½ x 8½ x 6 (62.2 x 21.6 x 15.2)
55.87, GIFT OF MR. AND MRS. ALASTAIR B. MARTIN

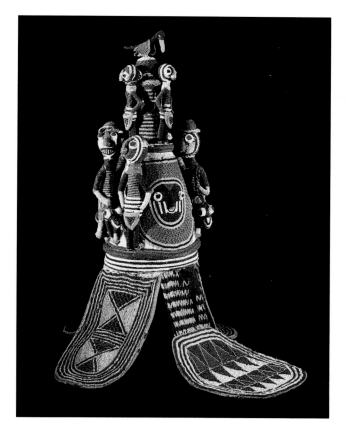

This freestanding representation of a courtier playing a side-blown horn would have originally been placed on an altar dedicated to one of the ancestors of the *oba*, or king, of Benin. Oral tradition tells that brass casting was introduced from the neighboring kingdom of Ife about the end of the fourteenth century. Brass casting was a royal prerogative, for only the *oba* could commission objects from the casters. The circle with four projecting leaves decorating the hornblower's costume refers to leaves associated with Olokun, the Edo god of the waters, and also to the four cardinal directions. This quatrefoil design may have been adapted from European or Islamic designs. Other design motifs on the skirt include representations of Portuguese, who were the principal trading partners of the Benin Kingdom during this period, and the heads of leopards, associated with the *oba* because each was a king in his respective domain.

Beaded Crown *(Ade)*

▮ Nigeria; Yoruba people, late 19th century
Basketry, beads, cloth, 36½ x 32½ (92.7 x 82.6)

70.109.1, CAROLINE A. L. PRATT FUND, FREDERICK LOESER ART FUND, AND THE CARLL H. DE SILVER FUND

The ultimate symbol of Yoruba kingship is the bead-embroidered crown. Each *oba*, or king, may have one or more crowns, and each crown has its own distinctive design elements. All crowns, however, are surmounted by *okin*, the royal bird, and all represent on a front panel the face of Oduduwa, the creator-god who became the first king of Ife, the ancient capital. The representations of the two horsemen and attendant figures symbolize the king's status and quite likely his military prowess, but the horse can also represent spirituality in Yoruba thought. The beaded veil that covers the face of the wearer serves a dual purpose: it

depersonalizes the *oba* while emphasizing his office, and it protects onlookers from the danger of casting their eyes directly on the awesome radiance of a divine king. Though it is often hard to date African art objects, this crown is almost certainly by the same artist as a presentation piece made for the *oba* of Ikere-Ekete in 1924.

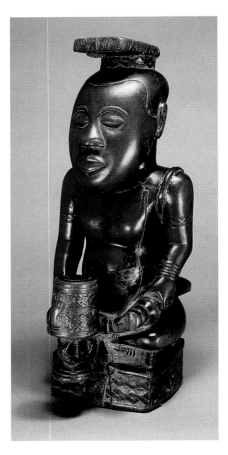

Ndop Portrait of King Mishe miShyaang maMbul

► Zaire; Kuba people, 18th century
Wood, 19⁷⁄₁₆ high (49.4)

61.33, PURCHASED WITH FUNDS GIVEN BY MR. AND MRS. ALASTAIR B. MARTIN, MRS. DONALD M. OENSLAGER, MR. AND MRS. ROBERT E. BLUM, AND THE MRS. FLORENCE A. BLUM FUND

Ndop figures are conventionalized portraits of individual Kuba paramount rulers, or *nyim*. This is one of five *ndop* figures dating from the eighteenth century and is probably the earliest dating from about 1760. This *ndop* represents the *nyim* Mishe miShyaang maMbul, who reigned at the beginning of the eighteenth century. The symbol of his reign is the drum with the severed hand prominently displayed in front of the seated monarch. As in other *ndop* figures, the ruler is portrayed seated cross-legged on a raised platform. The large head displays a countenance suggesting both aloofness and composure. The short sword in the left hand and the belts, armbands, bracelets, shoulder ornaments, and projecting royal headdress are all elements of the royal regalia. The figure was believed to represent and honor the spirit of the *nyim* and served as a point of contact with his spirit.

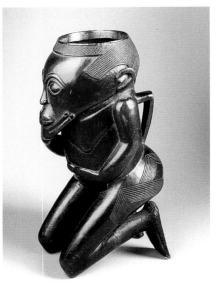

Palm-Wine Cup *(Mbwoongntey)*

► Zaire; Kuba people, 19th century
Wood, 8½ x 4½ (21.6 x 11.4)

56.6.37, GIFT OF ARTURO AND PAUL PERALTA-RAMOS

Palm wine made from the sap of a particular type of palm tree is a commonly consumed beverage throughout much of Africa. Among the Kuba, drinking vessels are often very personal items reflecting the owner's status. Those of higher status may have beautifully carved cups with elaborate geometric designs

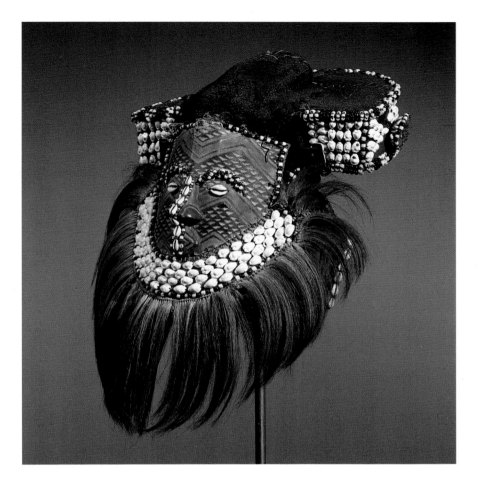

or, more rarely, with heads or even full human figures. Figural cups emphasize the head with a short neck, abbreviated torso, legs, and feet. This exceptional cup shows a full figure crouching with his hand on his chin. The hairstyle of titled Kuba men, as visible here, is delineated by shaving the hairline straight across the top of the forehead except for a sharp angle at the temples.

Mask (Moshambwooy)

▌ Zaire; Kuba people, late 19th or early 20th century
Bark cloth, leather, pigment, shell, hair, beads, fabric, 19⁹⁄₁₆ x 14⁹⁄₁₆ (49.1 x 37)

22.1582, MUSEUM EXPEDITION 1922, ROBERT B. WOODWARD MEMORIAL FUND

Moshambwooy masks are the most important masks in the Kuba culture. They are above all a symbol for Woot, the founder of the Kuba. The white beard of the mask represents the beard of a wise old man rich in experience as well. Such masks are worn by the Kuba king, or *nyim*, as well as by prominent chiefs, when they are receiving homage from subordinates to symbolize their wisdom, experience, and right through descent from founding lineages to rule. Normally chiefs were also buried wearing such masks. This strikingly dramatic example is highly unusual in having a face made of painted hide rather than cloth or fur. The ears, mouth, and nose are made of wood and are attached to the hide face and cloth piece that forms the back of the head. The elaborate geometric painting on the face reflects the emphasis on geometric designs common to all Kuba art.

Grave Marker (*Bitumba* or *Mintadi*)

❙ Zaire; Kongo (Boma) people, 19th century
Steatite, pigment, 23 x 5⅞ (58.4 x 14.9)
22.1203, MUSEUM EXPEDITION 1922, ROBERT B.
WOODWARD MEMORIAL FUND

Stone is used infrequently as a medium for sculpture in sub-Saharan Africa. This figure, carved from steatite, or soapstone, with some painted details belongs to a group of sculptures known as *mintadi*. They were made to adorn the graves of important deceased members of

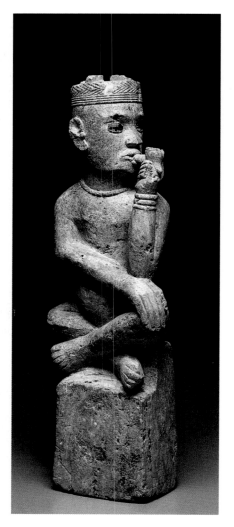

the community. The figure is presumed to represent a chief since it wears a *mpu* cap, a woven tight-fitting hat adorned with the claws and teeth of leopards and reserved for chiefs. Another unusual feature of this piece is the asymmetrical and active pose. The posture has been interpreted as a chief distancing himself from the noise of the mundane world in order to concentrate on important matters.

Mother with Child (*Luphinga Lua Limpe*)

► Zaire; Lulua people, 19th century
Wood, 14 x 3⅜ (35.6 x 8.6)
50.124, MUSEUM COLLECTION FUND

African maternity figures reflect a deep concern with the continuity of the family and the group. A woman's primary responsibility is to ensure that continuity through childbearing. In an environment where childbirth is often difficult and infant mortality high, there is particular concern for the mother and child. Sculptures such as this Lulua figure may be carried by a woman during pregnancy or placed next to her during delivery to ensure a successful birth. If a woman has encountered difficulties with miscarriages or if her child died in infancy, she might appeal to the Buanga Bua Cibola cult. A figure is then carved for her, and she keeps it with her until her delivery to ward off evil. The elaborate scarification and coiffure show a woman of high status. The unusual limp pose of the child has been said to suggest that the child is dead, but there are no references in the literature to figures showing dead children. This piece has a pointed end, which could be tucked into a woman's belt or loincloth.

Power Figure (*Nkisi Nkondi*)

► Zaire or Republic of the Congo; Kongo (Yombe) people, 19th century
Wood, iron, glass mirror, resin, pigment, 33⅞ x 13¾ (86 x 34.9)
22.1421, MUSEUM EXPEDITION 1922, ROBERT B.
WOODWARD MEMORIAL FUND

The pose of this *nkisi nkondi* figure with its hands on hips, head held high, and chest thrust forward, conveys the sense that it is at atten-

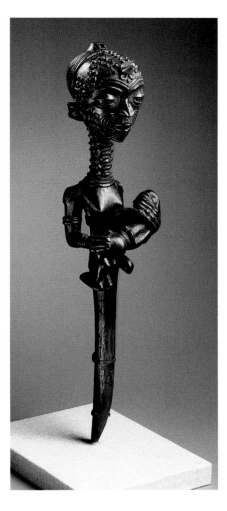

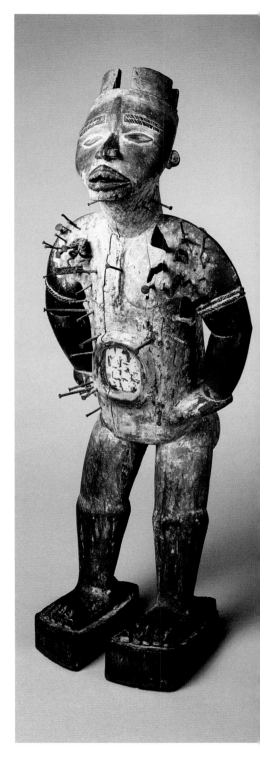

tion and ready to act to defend a righteous person and destroy an enemy. An *nkisi* is a powerful figure endowed with healing powers, which protect the community through its ability to hunt down criminals, witches, and other malefactors who attempt to undermine the social structure. Oaths are sworn, trials held, and contracts made in the presence of these figures and are sealed by driving a blade or nail into the figure. The medicines that give the figure its powers are sealed behind the mirror-covered cavity just above the navel and in another cavity on the back. The top of the head was once covered with a resin cap that marked the "navel of the head," which facilitated the passing of supernatural secrets to the *nkisi's* spirit.

Mask

► Gabon or Republic of the Congo;
Mahongwe or Mboko people, late 19th
century
Wood, 14 x 6 (35.6 x 15.2)
52.160, FRANK L. BABBOTT FUND

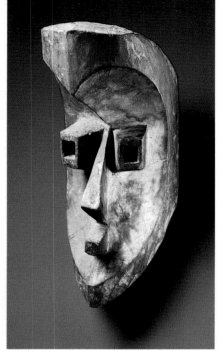

This classic of African art is believed to be
from the upper Likuala River area of the
Republic of the Congo, but virtually nothing is
known about its use or even which of three
ethnic groups in the region might have made it.
The geometric abstraction of this mask,
however, has made it an icon of African art for

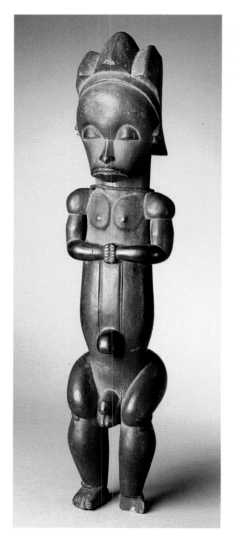

Western audiences. The geometry of the forms
has been reinforced by the asymmetrical use of
three pigments. There is no paint on the right
side of the face except for a few traces of black
on the forehead, eyes, and mouth. The left side
has been rubbed with white clay. The flat
planes of the nose and mouth are red, and
there are traces of red around the right eye and
a band of red on the ridge of the brow.

Reliquary Guardian Figure
(Nlo Byeri)

◄ Gabon; Fang (Mvai) people,
19th century
Wood, 23 x 5⅞ (58.4 x 14.9)
51.3, FRANK L. BABBOTT FUND

The Fang preserve the skulls, femurs, and
vertebrae of revered ancestors in bark boxes
that are protected by carved heads or figures
known as *nlo byeri*, which are placed on top of
these boxes to ward off malevolent individuals
or spirits. This figure is carved in the Mvai
substyle, characterized by a massive head with
a helmetlike coiffure consisting of three broad
tresses sweeping down the back of the head
and standing out from the nape of the neck.
The elegant, carefully modeled face has a high

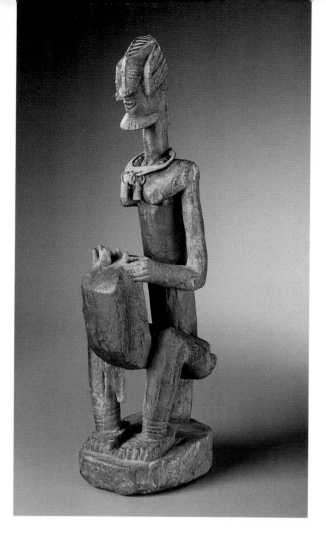

forehead, high cheekbones, a pouting mouth, and large downcast eyes. The passive, inscrutable face is balanced by a body held in muscular tension. The figure would have been placed on top of the reliquary box with its feet dangling over the edge.

Figure of a Seated Musician

Mali, Bandiagara region; Dogon people, late 18th century
Wood, iron, 22 x 7 x 4¼ (55.9 x 17.8 x 10.8)
61.2, FRANK L. BABBOTT FUND

At least three other examples are known in Dogon sculpture of representations of a musician playing a *kora*, or "harp-lute." The *kora* has multiple meanings in Dogon mythology, all tied to the creation of the world and the primordial beings who gave life and sustenance to humans. The instrument is shown being played upright rather than horizontally as it is in life. It has been suggested that the position of the *kora* is upright to enable the figure to receive offerings of millet porridge, oil, or animal blood made to release life-giving energy. Such sculptures were found on various types of ancestral altars as well as on individual and family shrines. The strong jaw, projecting mouth, and small oval eyes are characteristic of this style, which is more naturalistic than most styles of Dogon sculpture and probably originates in the central-northern region of the Bandiagara plateau. The necklace is suggestive of those worn by *hogons* (priests) in Dogon villages.

Figure of a Female *(Nyeleni)*

❚ Mali; Bamana people, 19th or 20th century

Wood, metal, 22½ x 6⅛ (57.2 x 15.6)

76.20.1, GIFT OF MR. AND MRS. JOHN A. FRIEDE

The slender torso, swelling abdomen, large firm breasts, and full buttocks of this figure allude to the childbearing capacities of an ideal wife. The lightly incised designs on the torso refer to the scarification patterns acquired by young women in the initiation

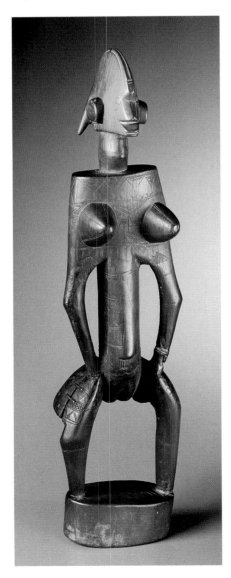

ceremonies preparing them for marriage. The complete figure represents the ideal qualities of a marriageable young woman. These figures are carried by groups of newly initiated young men when they tour neighboring villages entertaining with songs and dances learned during their prolonged initiation seclusion. In return, they receive gifts and have the opportunity to meet prospective brides and their families. By displaying such figures, the initiates in effect advertise their desire to meet eligible brides.

Dance Headdresses *(Chi Wara)*

► Mali, Minianka District; Bamana people, late 19th or early 20th century

Wood, metal, 36⅜ x 14¼ (92.4 x 36.2); 31¾ x 13½ (80.7 x 34.3)

77.245.1, .2, GIFT OF MR. AND MRS. GEORGE LOIS

The rich, warm patina of this pair of antelope headdresses is indicative of the care and long use that these sculptures have received. *Chi wara* headdresses are worn by male dancers, who perform in pairs representing the male and female roan antelope, one of the most important animals in Bamana philosophy. The antelope is a metaphor for the successful farmer who tills his fields tirelessly. The *chi wara* society that uses the headdresses is devoted to agricultural cultivation and fertility, and the figures reflect this in many ways. The horns represent ears of millet, while the penis represents the plant's roots. The zigzag design of the mane represents the course of the sun. The female figure is portrayed with a child on the back in much the same way that human mothers carry their own children.

Mask

► Liberia or Ivory Coast; Dan people, late 19th or early 20th century

Wood, 9½ (24.1) high

80.244, GIFT OF EVELYN K. KOSSAK

The high, curved forehead, pointed chin, and semiclosed eyes of this sleek face mask are all ideals of human beauty for the Dan. The vertical ridge on the forehead is a tattoo thought of as a mark of civilization. While the mask portrays these human ideals, it actually is meant to embody an otherwise nonmaterial

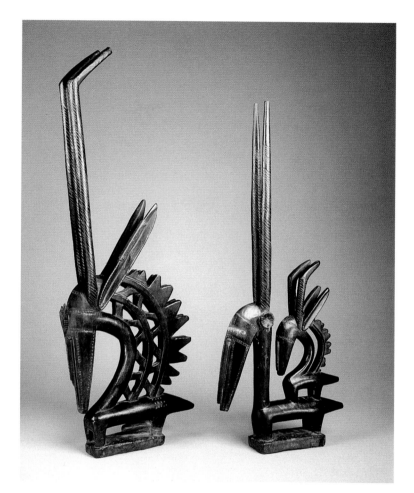

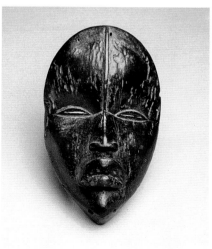

spirit. The Dan believe in a wide pantheon of such spirits, each of which is personalized. Once individual masks are removed from their village contexts, their specific functions and personalities are impossible to determine; nevertheless, the benign features of this face are of a type usually associated with spirits that serve to "calm" a village. They may relieve tensions by entertaining through songs or dance, by serving as intermediaries between boys segregated in the initiation camps of the men's societies and their mothers in the town, or even as peacemakers in disputes.

Mask (Banda)

▌ Guinea; Nalu or Baga people,
20th century
Wood, metal, pigment, 61½ x 15¾ x 15⅜
(156.2 x 40 x 39.1)

58.7, Caroline A. L. Pratt Fund

This large horizontal mask combines features of a human face with those of a crocodile or shark with teeth bared, the tail of a chameleon, and the horns and ears of an antelope, as well as features of less identifiable animals. The combination of these features reflects the interaction between members of the community and their natural environment, an area of coastal lowlands cut by bays and estuaries. Worn on top of the head, the multicolored mask is attached to a long, dense skirt made of vegetal fibers that covers the body of the wearer. *Banda* masks are the property of the Simo society, a secret men's association that regulates fertility and initiation ceremonies. The masks are used at initiations, harvest celebrations, and various other auspicious festivities.

Staff with Female Figure (Udlwedlwe)

► South Africa; Zulu people, 19th century
Polished wood, beads, leather, fiber, 40½ x 12¾ x 3
(102.9 x 32.4 x 7.6)
x968, Brooklyn Museum of Art Collection

This elegant staff is a rare example of southern African figurative carving. Figurative staffs, and, more commonly, nonfigurative staffs were produced throughout southeastern Africa in the nineteenth and early twentieth centuries for use by both men and women as walking sticks or prestige staffs. Many were apparently made by Tsonga-speaking groups as tribute, which they were forced to supply to the Zulu king Shaka and his successors. Most staffs were evidently made for the use of chiefs, but apparently the Tsonga also produced staffs for a nonindigenous market. The elaboration of this piece, the detailed carving of such features as the knees, the fluidity of its form, and especially the treatment of the outstretched arms, all suggest that this piece may not have been intended for traditional use. The addition of the beadwork ornaments, while characteristic of Zulu women's attire, is also highly unusual on such staffs.

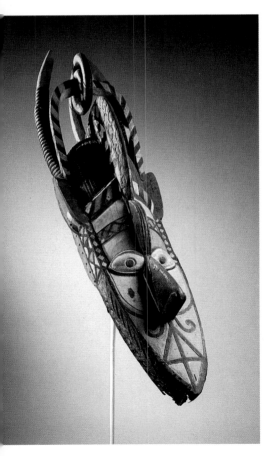

Art of the Pacific

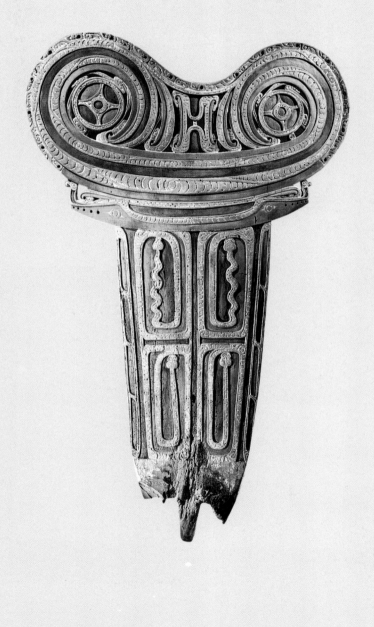

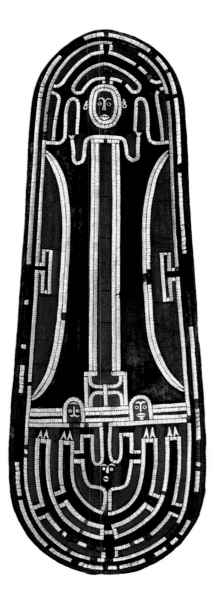

Ceremonial Shield

← Melanesia, Solomon Islands, Santa
Isabel Island, before 1852
Basketry, nautilus shell inlay, resin base,
32¹¹⁄₁₆ x 9¼ (83 x 23.5)

59.63, FRANK L. BABBOTT FUND AND THE CARLL H. DE
SILVER FUND

The unparalleled virtuosity of the Solomon
Islanders in the art of shell inlay is clearly
demonstrated by this rare and richly embel-
lished war shield collected before 1852 by
Surgeon Captain James Booth of the British
Royal Navy. There are only about twenty of
these shields extant today, and all are believed
to have been made before 1840. Shell-inlaid
shields were based on the more common ellip-
tical wicker shields made on Guadalcanal and
traded to Santa Isabel Islanders, who decorated
the shield by covering it with red and black
resins and setting in abstract linear designs
created with small pieces of nautilus shell.
This shield, which bears a characteristic design
format dominated by an anthropomorphic
figure with upraised arms, is distinguished by
two detached heads and a face below, as well as
a set of four double-arrowlike points. These
shields were too fragile for use and were
designed as prestige items.

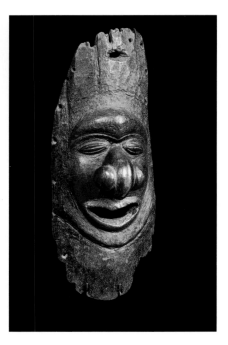

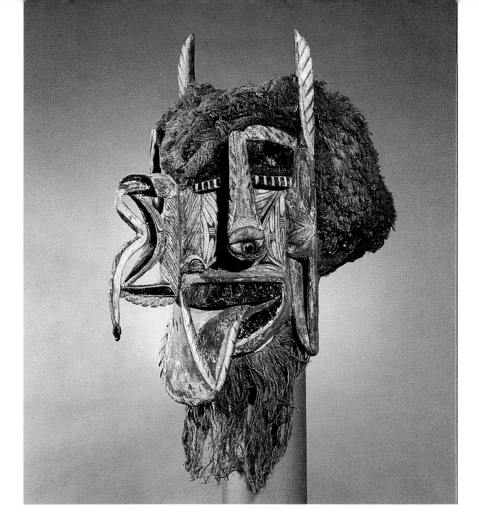

Mask *(Pwemwe)*

◄ Melanesia, New Caledonia (northern area), 19th or early 20th century
Wood, 10⅞ x 4⅜ x 3⅜ (27.6 x 11.1 x 8.6)
42.243.19, BROOKLYN MUSEUM OF ART, BY EXCHANGE

This striking mask with its grimacing mouth, bean-shaped eyes, and bulbous hooked nose was made in the northern part of New Caledonia. The thick, shiny patina of this piece is evidence of its age and considerable use. The holes around the perimeter were used to affix the beard and wig of human hair, a hat, feather, and other elements of a costume that completely draped, to the knees, the dancer who wore it. Little is known about the function of these *pwemwe* masks, although it is usually said that the masks represent the spirits of ancestors returning to the village. It is also said

that they may have been associated with now-extinct secret men's associations or used for social control.

Mask *(Kepong)*

▮ Melanesia, New Ireland (northern area), 19th century
Wood, fiber, sea-snail opercula, pigment, 18⅞ x 9¾ (47.9 x 24.8)
84.58, GIFT OF FRIEDA AND MILTON F. ROSENTHAL

This powerful mask probably represents a *ges* spirit, a powerful and, in this case, probably a destructive spirit force that dwells in the bush. They are said to be spirit doubles of living individuals that sometimes attacked humans who inadvertently saw them. The protrusion from the mouth of this mask is said

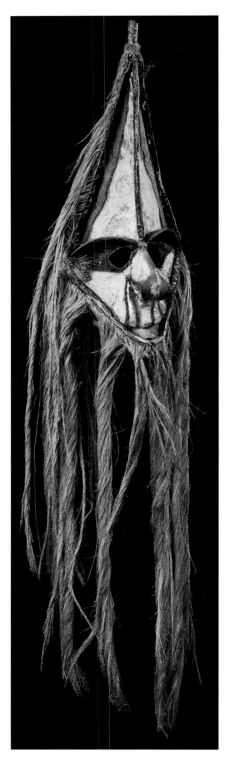

to represent the liver of a *ges* victim. Another interpretation, however, describes it as the protruding tongue warning of the danger that would befall anyone who sought to copy the design of the mask. The nosepiece is a subtle and highly abstract version of the theme of bird and snake in struggle, one of the most common themes in New Ireland sculpture and dance performance. The bird represents the spirit world and the snake, the world of mortals. These two worlds are thought of as locked in an eternal cosmic struggle.

Mask *(Rom)*

◄ Melanesia, Vanuatu, Ambrym Island,
19th century
Palm spathe, bamboo, coconut fiber, hemp,
pigment, 18 x 8½ (45.7 x 21.6)
86.229.5, Gift of Mr. and Mrs. John A. Friede and Mrs. Melville W. Hall

The prismatic form of this striking mask is characteristic of *rom* masks from Ambrym Island in Vanuatu. It is made of fiber and cane thickly plastered with a vegetable paste and painted in the bright and unusual color combinations characteristic of these islands. Long fiber "hair" is fixed to the sides and base of the mask. Such masks are part of an elaborate system of masks and hats that are worn by members of the secret men's organizations that regulate almost all aspects of social life in Vanuatu. Each grade or rank within these societies has its own mask type. When they are in use, the masks are believed to provide a temporary resting place for the spirits of immediate ancestors, most specifically, the grandfather.

Dance Ornament

► Melanesia, New Ireland (northern area),
19th or 20th century
Wood, sea-snail opercula, pigment,
7½ x 14 x 6½ (19.1 x 35.6 x 16.5)
84.109, Helen Babbott Saunders Fund

The *malagan* is a funerary festival honoring a deceased individual that is held several months or years after a person's death. Its purpose is to free the living from the spirit of the dead and to enable the spirit of the deceased to acclimate

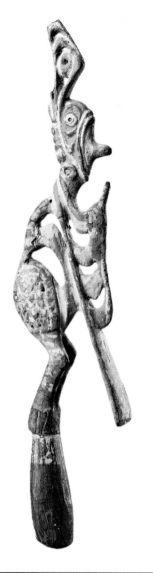

itself to the world of the dead. Birds were the most common motif for *malagan* dance ornaments, but many other types of creatures, either real or imaginary, are found. Though the symbolism of these creatures is usually known only to the carver and dancer, the bird generally represents the spirit world. The small, flat bit behind the bird on this mouth ornament was held between the dancer's teeth as he performed in imitation of the movements of a bird. The dances in which these mouth-pieces are used are part of the concluding rite of the *malagan* ceremonies.

Stopper for a Flute in the Form of a Bird

◄ Melanesia, Papua New Guinea, Sepik River, 19th century
Wood, pigment, 14¼ x 2¾ (36.2 x 6.9)
51.197.1, Gift of Mr. and Mrs. Alastair B. Martin

This bird figure may have served either as a spatula for a ceremonial lime container used by young initiates to men's cults or as a stopper for a ceremonial flute. Lime was taken out of bamboo containers with spatulas to ingest along with betel nuts as a stimulant. Long transverse bamboo flutes are usually played by pairs of men in ritual contexts. The most important rituals are accompanied by flute melodies, which represent the voices of mythical birds and, through them, incarnations of ancestors. The flutes are decorated at the top with carved stoppers that often represent these birds and are ornamented with colored leaves and feathers.

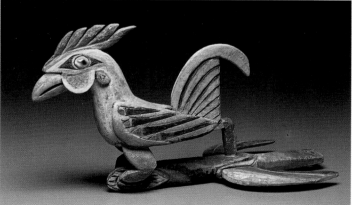

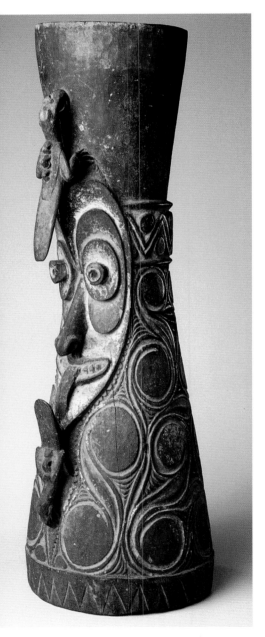

Drum

◄ Melanesia, Papua New Guinea, Sepik
River region; Iatmul people, early 20th
century
Wood, shell, pigment, 26½ x 8¾ (67.3 x 22.2)
87.218.70, GIFT OF MR. JOHN A. FRIEDE AND MRS.
MELVILLE W. HALL

The lower portion of this drum is decorated
with relief carvings of spirals and concentric
arcs that were originally painted white and
red. The large face with its projecting tongue is
meant to be threatening, symbolizing the
power of the clan that owned it. Above and
below the face are two cassowary birds. This
drum is closely related to three other published
examples that may all be by the same artist.
They were collected at the beginning of the
century. The design is reportedly that of a
Chambri drum that was captured by the
Iatmul people, who then used it to celebrate
their victory. This drum, which originally had
a membrane covering the top, is of a type used
to provide accompaniment for clan songs that
were sung on ceremonial occasions such as
funerals, the launching of new canoes, or the
completion of a clan house.

Male Figure *(Bioma)*

► Melanesia, Papua New Guinea, Koiravi
Village, early 20th century
Wood, pigment, 26½ x 9 (67.3 x 22.9)
51.118.9, GIFT OF JOHN W. VANDERCOOK

This highly animated figure is the work of a
gifted artist from the Wapo-Era area of the
gulf province of Papua New Guinea. Small
silhouette figures of this type, called *bioma*, are
usually placed near the floor within the men's
ceremonial house in proximity to trophy skulls
of pigs and crocodiles. Characteristically, *bioma*
figures from this area are flat with two sets of
limbs, one upraised, one lowered, with ridged

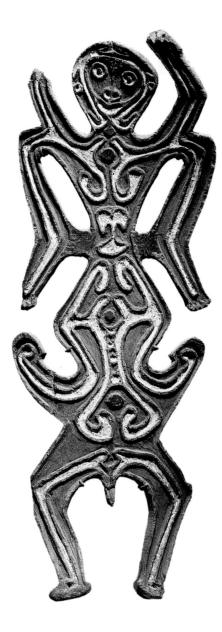

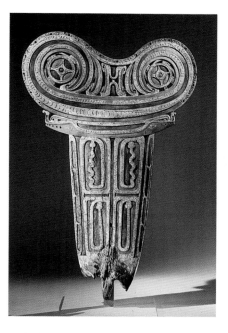

Splashboard *(Rajim)*

↑ Melanesia, New Guinea, Papua New Guinea, Massim Region/Marshall Bennett Islands, Yanaba, 20th century
Wood, pigment, 52⅜ x 32⅝ (133 x 82.2)
80.2, Gift of Frieda and Milton F. Rosenthal

The Massim culture area of southeastern New Guinea is famous for its seagoing outrigger canoes used in the interisland network of ceremonial gift exchange known as *kula*. These canoes are the object of elaborate ritual and ornamentation. The double-lobed canoe splashboard *(rajim)* is set transversely across the prow, closing the end of the well of the vessel to deflect the spray of the waves. More important than its practical purpose, however, is its use as a medium for supernatural powers, activated by magical spells cast when it is set in place, which protect the occupants and speed their journey. In this way the canoe

edges along the outer sides. The extraordinary vitality of this figure is a result of its having been cut from a curved slab of wood that was probably part of an old canoe. The piece was collected in 1929 by John W. Vandercook, one of the most famous traveler-adventurers and writers of his day.

breakwater or splashboard is assigned the dual purpose of protecting its owners and giving them power over their *kula* trade partners. This splashboard comes from the island of Yanaba in the Egum Atol. Supporting the curvilinear patterns of the upturned scroll are two frigate birds symbolizing flight and success. Two pairs of snakes appear on the lower portion of the board.

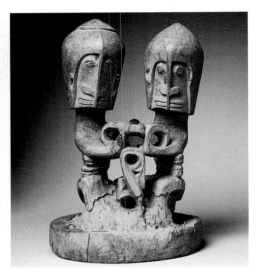

Mortuary Figure *(Korwar)*

▌ Republic of Indonesia, Irian Jaya, Northwest Coast, Cenderawasih Bay, 19th century
Wood, 9¼ x 5¾ (23.5 x 14.6)
62.18.2, FRANK L. BABBOTT FUND

Korwar figures serve to keep surviving relatives in contact with their deceased ancestors and, thus, to secure always their powerful blessings. They also function as a medium of communication between the living and the dead. *Korwars* may be standing or squatting figures. The heads are large in relationship to the highly abstract bodies. The chin is usually straight, horizontal, and broad, and the nose is the most prominent facial feature. This highly unusual double figure holds a shield, now partially eroded. The shield's design may have been inspired by a snake, which in turn represents the idea of rejuvenation and regeneration, a key idea in the religion of the people of Cenderawasih Bay.

Figure

▐ Island Southeast Asia, Nicobar Islands, 19th century
Wood, shell, 28⅜ x 8¹¹⁄₁₆ x 52½
(72.1 x 22.1 x 133.4)
63.57, ELLA C. WOODWARD MEMORIAL FUND AND THE MUSEUM COLLECTION FUND

Wood carvings from the Nicobar Islands are very rare and only two other examples are known of this type, characterized as a heavy-bodied crouching figure with a turtle carapace on the back. Its extraordinarily long arms, set in sockets, stretch forward horizontally. The face is anthropomorphic; the mouth opens to reveal the tongue. The eyes are pointed ovals of shell, and the mouth, with its characteristic square-cut teeth, was painted bright red; traces of the paint remain on the teeth, tongue, and lips. The figure wears a chin-strap helmet, pointed at the top in the Malayan manner. It suggests that the style derives from some part of the Malay Peninsula, where related dialects are spoken. The only recorded use of wood sculptures in this area were forms of *henta-koi*, or "scare devils," intended to keep malevolent spirits at bay.

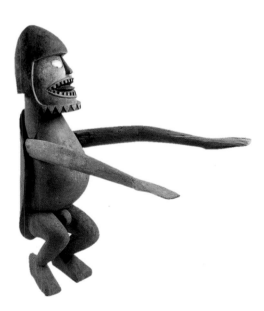

Art of the Americas

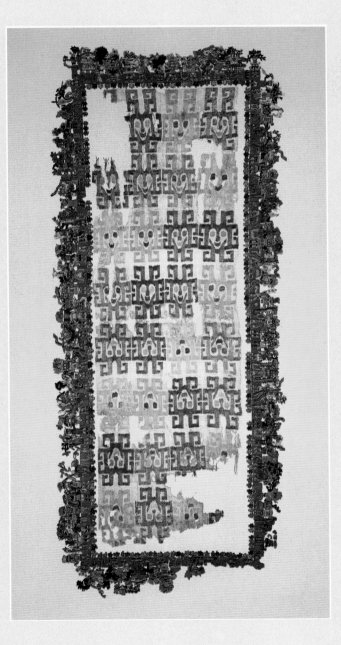

House Post

► Canada, British Columbia, Bella Bella;
Heiltsuk (Bella Bella), 19th century
Cedar, 98 x 35¼ x 17½ (248.9 x 89.5 x 44.5)

11.700.1, Museum Expedition 1911, Museum
Collection Fund

One of a set of four house posts, all of them in
the collection of the Brooklyn Museum of Art,
this carving was made to support the huge
beams of a great Northwest Coast plank house.
The iconographic complex on these posts
displays the ancestral crest prerogatives of the
house owners. Although we do not know the
legendary history associated with these images,
we may identify some elements that are carved
and incised on its surface. The humanoid face
with curved beak may be a hawk or perhaps a
salmon, whose nose becomes elongated and
curved at the end of its life cycle when it
returns to the river where it was born. This
being holds a flat shield-shaped plaque to its
chest, the conventionalized posture for the
chiefly display of a copper, the status object
par excellence in Northwest Coast cultures.
These were sometimes worth thousands of
dollars even at the turn of the century. In front
of the copper is a small human figure, perhaps
a slave, another valuable commodity.
Alternatively, it may represent a rival chief,
whom the house owner wished to diminish in
both size and reputation.

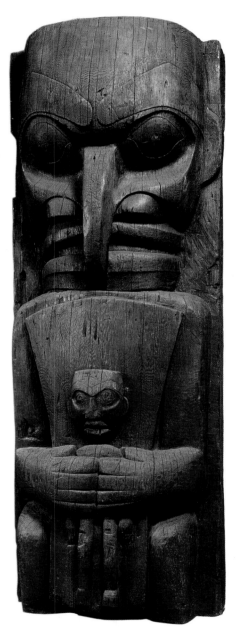

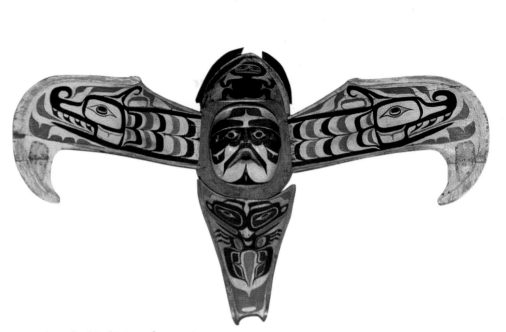

Thunderbird Transformation Mask

↑ ► Canada, British Columbia, Alert Bay; Kwakwaka'wakw (Kwakiutl), 19th century
Cedar, pigment, leather, nails, metal plate, closed: 17 x 29½ x 12½ (43.2 x 74.9 x 31.8); open: 17 x 29½ x 71 (43.2 x 74.9 x 180.3)
08.491.8902, MUSEUM EXPEDITION 1908, MUSEUM COLLECTION FUND

This carved transformation mask in the form of the hook-beaked mythological creature called a Thunderbird is constructed with hinged sections that may be flung open by pulling rigged cords to reveal a second, human face. The Thunderbird appears in many stories on the Northwest Coast, but according to Charles Newcombe, who collected this mask from the Gigilgam lineage of the Nimpkish people of Alert Bay, British Columbia, this particular carving may be traced to their family history. A Thunderbird assisted their ancestor in raising the massive roof beams of a great house and then threw back its head and removed its Thunderbird coat to reveal a human appearance, indicating its supernatural nature. At a potlatch a skillful dancer would circle the fire and intermittently open this mask to reveal its inner face for one section of the audience at a time. When the mask is opened, the carved face is encircled by the four

08.491.8902, CLOSED

segments that have been divided from this creature's huge beak. The pieces on the right and left are painted on the interior with the image of *sisiyutl*, the double-headed snake often associated with Thunderbirds in myth. The piece on top of the face is painted with a crouching human figure, and the piece below reveals the stylized features of a bird with outstretched talons.

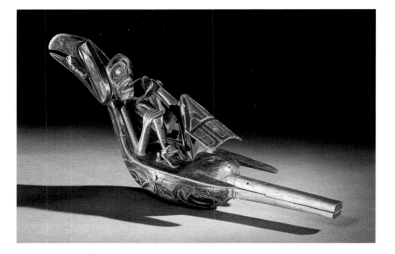

Raven Rattle

▲ Canada, British Columbia, Bella Bella;
Heiltsuk (Bella Bella), 19th century
Wood, pigment, rattles, cotton twine,
5½ x 14 x 4 (14 x 35.6 x 10.2)
05.588.7292, MUSEUM EXPEDITION 1905, MUSEUM
COLLECTION FUND

Said to originate in the north, perhaps among
the Tsimshian, the raven rattle is now found as
an item of traditional regalia throughout the
Northwest Coast. Chiefs dress in a specific com-
plex of costume elements for the "Feather" or
"Peace" dance, including a carved frontlet in-
laid with abalone shell and hung with ermine
pelts, a woven Chilkat robe or button blanket,
and a raven rattle like this one, held with its
beak pointing downward. The intricate com-
bination of carved animal and human forms
that ride on the back of Raven, the trickster-
creator of Northwest Coast legend, varies, but
certain combinations are well known. A reclin-
ing human figure often bears a frog upon its
chest; they are connected by one shared
tongue, a configuration probably referring to the
acquisition of shamanic power. This example is
unusual, however, because it includes additional
frogs, one at each foot of the figure and another
in the beak of Raven himself. Usually Raven
holds a small box in his mouth that alludes to
the mythological origin of daylight. The head
of the bird between the human figure's feet is
that of a kingfisher, and the face carved in
relief on Raven's stomach on the underside of
the rattle is usually interpreted as a hawk.

Kneeling Prisoner Effigy Pipe

▼ Southeastern United States; Palquemine
Mississippian culture, 1400–1500
Stone, 4¾ x 6⅝ x 3⅜ (12.2 x 17 x 8.5)
37.2802, HENRY L. BATTERMAN FUND AND THE FRANK
SHERMAN BENSON FUND

This compactly carved pipe bowl provides
insights into the ritual aspects of warfare
among the chiefly societies that dominated
what is now the southeastern United States
during the fourteenth and fifteenth centuries.
A youthful male is represented in an attitude of
submission, with his head straining forward.
The elaborate hairdo and multiple strands of
beads indicate that he once enjoyed high
status. As an image of defeat, the sculpture
gains power from the insertion of the pipe stem
directly into the prisoner's back.

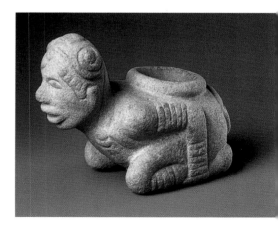

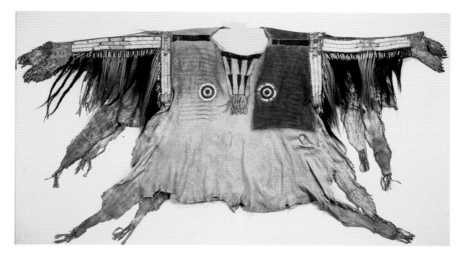

Chief's Shirt and Leggings

▲▼ United States, Plains; Sioux
(Yanktonai?), early 19th century
Emulsion-cured skin, paint, stain, fur, glass
beads, porcupine and bird quills,
[maidenhair?] fern stems, human- and
horsehair, feathers, shirt 44 (111.8) long;
each legging 44 (111.8) long

50.67.1A,B,C, Frank Sherman Benson Fund and Henry
L. Batterman Fund

The various media—beads, quillwork, paint,
and hair-lock attachments—that richly
decorate this chief's shirt and leggings
combine to suggest the high station of the
former wearer and most likely record some of
his most heroic deeds. Linear designs are
superimposed on smudged, stained fields.
These drawings are probably a tally related to
war exploits. The upper left quadrant on the
front of the shirt is stained brown, and sixteen
objects, which are probably stylized rifles,
have been stacked as a type of index, one
above the other. On the right, in the area
partially stained red, are seventeen bifur-
cated lines, and these may represent horse
quirts. Geometric forms on the back of the
shirt almost certainly represent people, and
additional designs on the lower right sleeve, as
well as the right shoulder on the reverse side,
are decorated with marks that are probably
horse tracks.

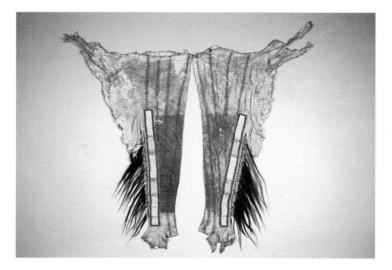

Two-Faced Pipe Bowl

► United States, Plains; Sioux (Sisseton), early 19th century
Catlinite or red pipestone, lead inlay, 5¼ (13.3) long
50.67.104, FRANK SHERMAN BENSON FUND AND THE HENRY L. BATTERMAN FUND

This thick-set catlinite pipe bowl is carved so that the actual bowl section, where tobacco would be inserted, is provided with two roundly modeled human faces—one placed facing the smoker and the other at the back of the bowl. Beyond the extraordinary sculptural qualities of the pipe, some evidence suggests that this may be the oldest Indian effigy pipe whose creator is known by name. Letters and other documents refer to the carver known as Running Cloud. He may have given the collector, a Dr. Jarvis who was stationed at Fort Snelling, Minnesota, from 1833 to 1836, a two-headed pipe as a gift in gratitude for some medical attention. This sculptural configuration may be connected with the Sioux image of the Heyoka, an "anti-natural god." This being is said to groan when he is full of joy and laugh when he is in distress.

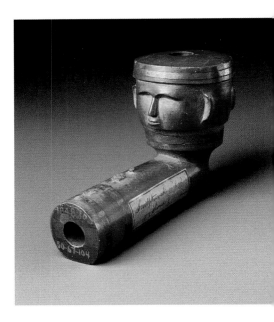

Ceremonial Belt

❚ United States, California; Maidu, circa 1855
Native hemp and commercial cotton cordage, mallard-duck and acorn-woodpecker-scalp feathers, white glass beads, 67 x 6 (170.2 x 15.2)
08.491.8925, MUSEUM EXPEDITION 1908, MUSEUM COLLECTION FUND

Feather belts were the supreme Maidu representation of wealth. Women were given belts by their grooms at marriage, though men wore them as well. Used principally during the cycle of world-renewal dances in the winter months, they were wrapped twice around the waist of the dancer. Belt-making, practiced by male specialists, was a laborious craft; all the feathers were individually inserted into interlaced weaving strands, completely covering the surface of the fiber structure. For the red sections of this belt, the scalps of about twenty-five woodpeckers were needed. The motifs

were similar to those used on baskets. In 1908 native experts interpreted the designs on this belt as follows: the triangular red elements stood for wild grape leaves; the two narrow green bands, for the tongs used to remove hot stones from the cooking fire; and the green rectangle, for a large grasshopper. Few feather-belts have survived, owing to their fragility and the Maidu practice of destroying personal property at death.

Girl's Puberty Basket

► Mrs. Sam Hughes
United States, California; Northern Pomo, late 19th–early 20th century
Sedge, dyed bulrush, willow, black quail topknots and red woodpecker crest feathers, clamshell beads, 7 x 14½ (17.8 x 36.8)
07.467.8308, MUSEUM EXPEDITION 1907, MUSEUM COLLECTION FUND

Combining utility and beauty, baskets permeated Pomo life from fishing and acorn-processing to birth, marriage, and death rites. All women wove their own baskets, though some were acclaimed for their skill and expertise. This coiled basket is clearly the work of a master: the sewing is tight and precise, the

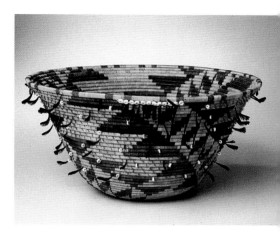

form regular and elegant, and the design laid out on the surface with imagination and balance. The use of feathers and shell beads signifies that this was a ceremonial basket. Made by Mrs. Sam Hughes of Potter Valley, California, it was part of a set of four used by a girl at her puberty ceremony. Women continued to use these baskets during adulthood and often handed them down to their daughters when they came of age.

Water Jar

◄ United States, New Mexico; Zuni, 1825–50
Ceramic, slip, 12¾ x 12¾ (32.4 x 32.4)
03.325.4723, MUSEUM EXPEDITION 1903, MUSEUM COLLECTION FUND

The large globular jar for carrying and storing water was ubiquitous in pueblo villages during the nineteenth century. Each village developed its own repertory of designs and shapes for water vessels; this finely painted jar is a rare example of the early nineteenth-century Zuni style. Distinct features are the high, flat shoulder and the ridge at the bottom, which isolate the mid-body of the vessel as a field for painted designs. Here the artist has created a striking pattern of architectural forms that alternately enclose and support a stylized butterfly. The fine-line hatching within the dark borders of the stepped design has its roots in the prehistoric painting tradition and is also found on the more spherical water jars that characterize Zuni production after 1850.

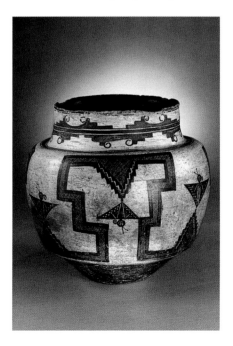

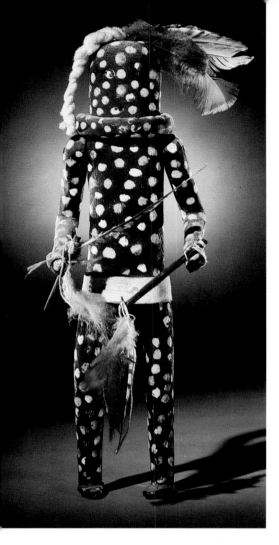

Kachina Doll

◄ United States, New Mexico; Zuni, early 20th century
Wood, feathers, wool, cotton, hide, silk, 17¾ x 6 (45.1 x 15.2)
03.325.4651, MUSEUM EXPEDITION 1903, MUSEUM COLLECTION FUND

Kachina dolls represent in miniature the masked and costumed personages who appear in Zuni dances and ceremonies. The black body paint with multicolored spots identifies this figure as the Fire-God Impersonator. On his head he wears a helmet mask topped by feathers and cotton cords. The Fire-God is an important participant in Shalako, an annual cycle of ceremonies that culminates in a public festival in the early part of December. Kachina dolls such as this one introduced Zuni children to the complex pantheon of supernaturals that regulated village life. This example is one of a large group of Zuni dolls that the Museum acquired in the early part of this century. They all have articulated limbs and wear actual costume elements, traits that distinguish them from contemporary Hopi dolls that are carved from a single piece of wood and have costumes represented in paint.

Bowl in the Shape of a Melon

◄ Helen Shupla (d. 1986)
United States, New Mexico, Santa Clara Pueblo
Ceramic, slip, 8 x 16 (20.3 x 40.6)
87.63, GIFT OF THE ROEBLING SOCIETY

Potters in the pueblo of Santa Clara are heirs to a three-century-old tradition of polished blackware that served both utilitarian and decorative purposes. The clay is collected locally and the hand-built vessels are fired in an outdoor kiln. The lustrous black surface is achieved by smothering the flames during the last stages of firing. Helen Shupla was one of the best-known modern masters of the craft. While many potters in Santa Clara were experimenting with new shapes and designs, she chose to develop the traditional melon bowl as an art form. Shupla's bowls are distinguished by the deep sculptured squash ribs that can be felt on the inside as well as the outside of the vessel. This is one of the largest and finest of her works.

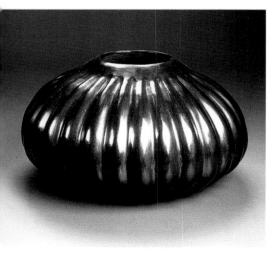

Figure Emerging from a Waterlily

◄ Mexico, Campeche;
Maya Jaina style,
600–900
Ceramic, paint,
8¼ x 1⅞ (21 x 4.3)
70.31, DICK S. RAMSAY FUND

This extraordinary combination of man and flower has been modeled with such sensitivity and grace that the form appears to be entirely natural. Hundreds of figurines in this style, mold-made as well as hand-modeled, have been found on the island of Jaina, just off the Campeche coast of Mexico, a place that is presumed to have functioned as a necropolis for the Maya of the the Late Classic Period (600–900). Human figures emerging from flowers comprise a special class of Jaina figurines. In this example a slender youthful male rises in an attitude of calm authority from a waterlily pod. Because the waterlily is associated with the Underworld in Maya cosmology, this figurine may symbolize the renewal of life after death.

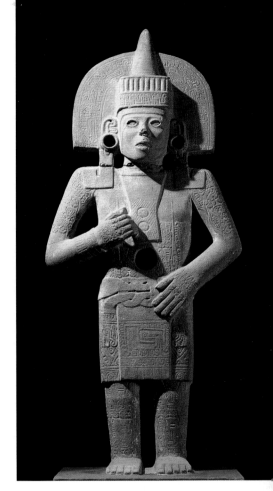

Life-Death Figure

► Mexico, Veracruz; Huastec, 900–1250
Stone, 62½ x 26⅜ (158.1 x 67)
37.2897PA, HENRY L. BATTERMAN FUND AND THE FRANK
SHERMAN BENSON FUND

The dualism that permeates ancient Mexican art is perfectly exemplified by this great Huastec carving from northern Veracruz. A youthful male is represented wearing a conical hat, large circular ear ornaments, a pendant, and a cloth knotted around his waist. Parts of his chest and arms are covered with a dense pattern resembling the designs painted on Huastec pottery. Compressed within the youth's broad back is a skeletal figure wearing a similar conical hat and cloth. While his hands are relatively realistic, his feet are clawed. The significance of this remarkable juxtaposition of life and death is not known. It has been variously interpreted as a cult statue of the god Quetzalcoatl or as a representation of a Huastec ruler. Although other Huastec life-death figures exist, this is undoubtedly the most complete and the finest depiction of the theme.

Jaguar

►► Mexico; Aztec, 1440–1521
Stone, 4¹⁵⁄₁₆ x 5¹¹⁄₁₆ x 11 (12.5 x 14.5 x 28)
38.45, CARLL H. DE SILVER FUND

This jaguar is an excellent example of Aztec naturalistic sculpture. Every part of the animal is carefully delineated, including the underside where the paw pads are carved in low relief.

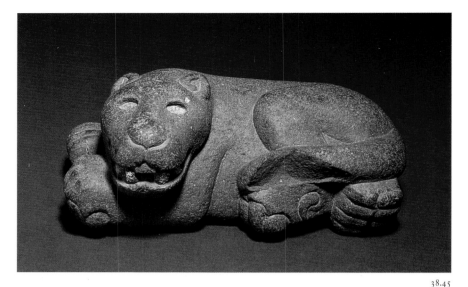

The emphasis on the head and claws expresses the jaguar's latent energy and destructive power. As the most feared and powerful predator in Mexico, the jaguar was closely identified with the ruler; it also symbolized the earth and the realm of darkness. Altlhough the provenance of this carving is unknown, it is in the metropolitan style and must have been made in one of the major cities in the basin of Mexico in the fifty years preceding the Spanish Conquest.

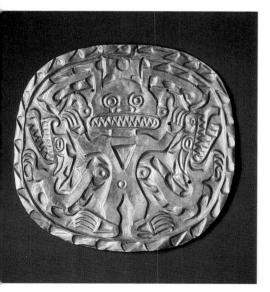

Plaque

▌ Panama, Coclé Province, Sitio Conte, 700–1100
Gold, 9 x 8½ (22.9 x 21.6)
33.448.12, MUSEUM EXPEDITION 1931, MUSEUM COLLECTION FUND

This plaque of hammered gold came from one of the largest and most lavishly furnished graves at the site of Sitio Conte. Nested with another nearly identical plaque, it had been placed near the head of the body of what must have been an important local chief. The frontal reptilian-human figure on the plaque appears on painted pottery and cast goldwork as well as on plaques of various shapes. The creature is usually flanked by reptilian profile heads attached to a belt or streamers emanating from the figure itself. In the literature this figure is often referred to as a "crocodile god," but recently scholars have interpreted it as a mythical warrior or culture hero.

Hat

► Peru; Huari, 500–1000
Cloth, reed, feathers, 6¹¹⁄₁₆ x 5½ x 5½ (17 x 14 x 14)
41.228, A. AUGUSTUS HEALY FUND

Square hats are characteristic of the Huari culture, but they are usually made of wool. On this hat feathers have been attached to a cloth

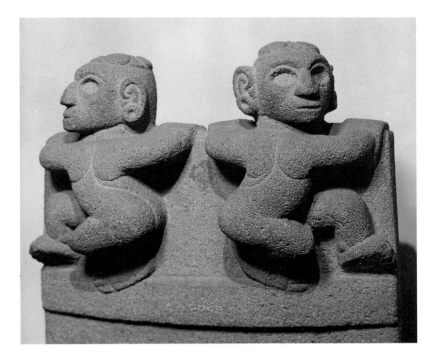

and reed foundation and cut to create a head-dress of exceptional brilliance and beauty. The motifs are similar to those found on wool hats and on fine Huari tapestry shirts. Profile feline heads alternate with a four-part design composed of squares and triangles on all four sides of the hat. In keeping with the geometri-cization of natural forms in Huari art, the felines' heads and snouts have been squared off. Representations of men wearing four-cornered hats on Huari ceramics suggest that this distinctive form of headgear was associated with warriors.

Stela

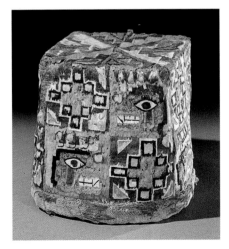

⬆ Costa Rica, Central Highlands–Atlantic Watershed, site of Las Mercedes,
1200–1500
Stone, 22 1/16 x 16 (56 x 40.5)
34.5094, ALFRED W. JENKINS FUND

Although Costa Rica's stone carvings are not as well known as its gold ornaments (the abundance of which gave the country its name "rich coast"), they are artistically and technically just as interesting. A rare type found in the Central Highlands–Atlantic Watershed region is an upright slab carved with figures on the top, presumed to have been used as a grave marker. This example is unusual in the simplicity of the slab and the lively posture of the figures. Precariously balanced on a raised band, the twin figures grasp the upper edge of the slab and look back over their shoulders. Each wears round ear ornaments and has a circular pattern carved on the crown of the head representing a hairdo or headdress.

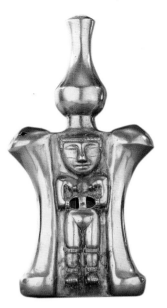

"FEMALE" SIDE

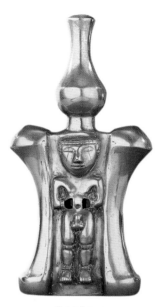

"MALE" SIDE

Lime Container

▎ Colombia, Middle Cauca
Valley; Quimbaya, 500–1000
Tumbaga (gold and copper alloy),
8 x 4⅛ (20.3 x 10.5)

35.507, ALFRED W. JENKINS FUND

Cast by the lost-wax technique, this lime container has a male figure on one side and a female figure on the other. Their hands, which were cast separately and attached through the holes at the wrist, are now missing. Male and female have the same broad face and serene expression. This idealized human countenance is found on Quimbaya pottery as well as on gold flasks and ornaments. Lime containers were used in coca-chewing rituals. A spatula or pin would have been required to reach the lime through the bottle's narrow neck. The lime would then have been mixed with a quid of coca leaves and chewed. Some gold containers have been found with the lime still inside.

Mantle, known as the Paracas Textile

► Peru, South Coast; Paracas/Nasca,
300 B.C.–A.D.200
Cotton and wool, 58¼ x 24½ (149.2 x 62.2)

38.121, JOHN T. UNDERWOOD MEMORIAL FUND

The most famous piece in the Museum's Andean collection is undoubtedly this small rectangular mantle known as the Paracas Textile. It was made about two thousand years ago on Peru's South Coast, where two great civilizations, the Paracas and the Nasca, developed. The extraordinary quantity and quality of finely decorated cloth from Paracas and Nasca archaeological sites demonstrate that textiles were the preeminent arts in these societies. The border of this mantle, consisting of more than ninety individual figures created by needle-knitting, is uniquely varied and detailed. Included are elaborately dressed humans, gesturing animals, fantastic figures, and vegetation in various stages of growth. With its emphasis on activity and the descriptive clarity of the individual figures, the border vividly illustrates the way in which the early cultures of Peru's South Coast envisioned the relationships among man, nature, and the supernatural.

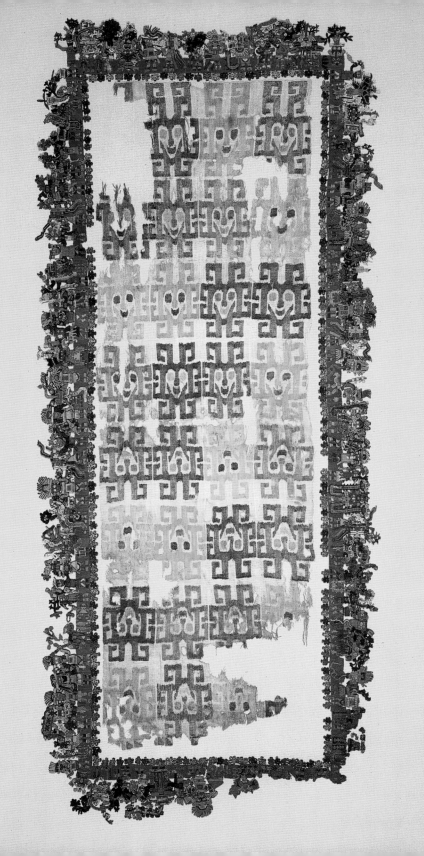

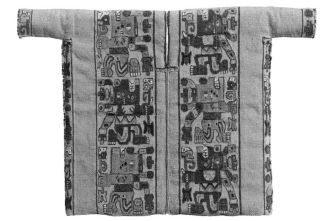

Miniature Shirt

Peru; Huari, circa A.D. 800
Tapestry weave: cotton warp and wool
weft, 8¹¹⁄₁₆ x 12³⁄₁₆ (22.1 x 31)
71.180, GIFT OF MR. AND MRS. ALASTAIR B. MARTIN

Huari tapestry tunics are technically and artistically among the finest textiles produced by ancient Andean weavers. Although the center of production of these garments seems to have been at or near the site of Huari in the South-Central Highlands of Peru, the imagery woven into the shirts is similar to that on the monumental stone sculpture of the sungate at the site of Tiahuanaco in Bolivia. The main deity

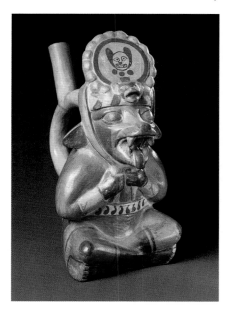

on the sungate is flanked by rows of profile attendants carrying staffs in their hands. Clearly depicted staff bearers appear in vertical rows on this tunic; their heads face upward and elaborate streamers flow down their backs. This miniature garment may have been made as a symbolic offering in place of a full-size tunic or to dress a votive figure.

Effigy Vessel

◄ Peru, North Coast; Moche,
200 B.C.–A.D. 200
Ceramic, slip, 10¾ x 5¾ x 8⅞
(27.3 x 14.6 x 22.5)
36.332, GIFT FROM THE COLLECTION OF EUGENE
SCHAEFER

Moche artists of Peru's North Coast have left a vivid record of their perceptions of the natural and supernatural world on finely painted and modeled ceramics. This stirrup-spout vessel represents an anthropomorphic fox in the process of securing an elaborate headdress in place; with ears pressed back and mouth open, he appears to be ready for action. The distinctive turbanlike headdress surmounted by a disk is associated with ritual runners in Moche art. In narrative scenes, animal and human-headed runners wearing this headdress are depicted racing through a desert landscape carrying small bags in their hands. Often beans such as the ones that appear on the fox's belt are included in these scenes. Some scholars have interpreted the beans as a form of writing and suggested that the runners are messengers in the service of the ruling elite.

Spanish Colonial Art

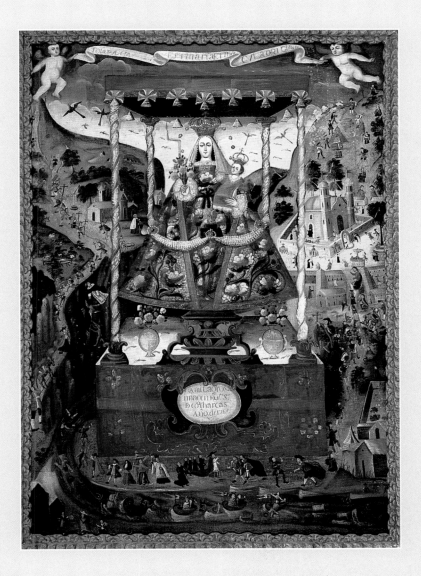

Tapestry

❚ Peru, Cajamarca, 17th–18th century
Tapestry with single interlocking and
dovetailing joins; camelid-wool tapestry
weave, 77¼ x 67¾ (197.5 x 172.1)
46.133.1, MUSEUM COLLECTION FUND

Textiles were a prized commodity in the pre-
Spanish Inca world, and consequently the
textile arts were developed to a level that
astonished Europeans. This tapestry reveals
the union of that ancient local art form
with European-influenced design. Using local
camelid wools and natural dyes, the Peruvian
weaver based the piece on a woven bedcover
from Alpujarra in Granada, Spain, but in the
central field added typically Andean animals
and birds surrounding a mermaid, a popular
motif in the Spanish colonies. Although this
Peruvian tapestry is made differently from its
Spanish model, it imitates its prototype in
unusual ways. For instance, the Alpujarra
covers often have a scalloped edge and ball
fringe, a feature that has been woven into this
tapestry in trompe l'oeil. This tapestry is just
one example of a superb collection of Spanish
colonial textiles in the Brooklyn Museum
of Art.

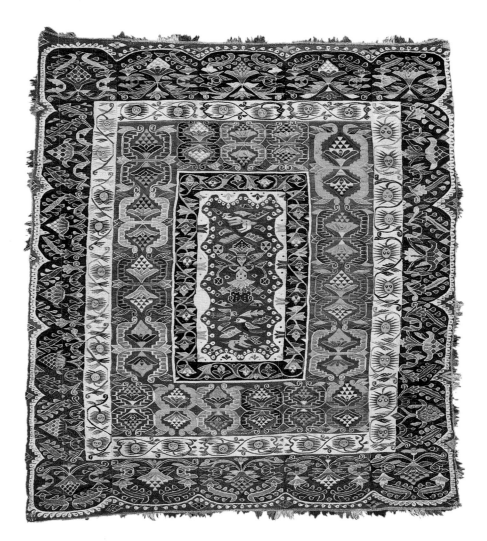

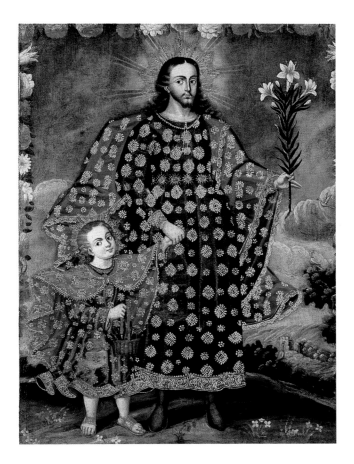

Saint Joseph and the Christ Child

▲ Peru, Cuzco school, late 17th–18th century
Oil on canvas, 43 x 32⅛ (109.2 x 81.6)

41.1275.191, MUSEUM EXPEDITION 1941, FRANK L. BABBOTT FUND

Among the finest paintings of the Cuzco school, this tender depiction of Saint Joseph and the Christ Child reveals the ways in which Peruvian artists adapted the models of the European Renaissance. The distant view in the background relies heavily on imported landscapes of the Northern Renaissance. The figures in the foreground, however, are treated in a way unique to painters of the Cuzco school. The elaborate gold stamping in the robes of the figures serves to flatten them to the surface, denying European conceptions of "realistic" pictorial space and suggesting a different, more abstract, vision of the world.

The painting is further localized by the Inca sandals worn by the Christ Child. Saint Joseph and the Christ Child was a particularly popular subject in Peru, where Joseph is usually depicted as a handsome young man rather than the old and infirm one seen in earlier European iconography.

Kero Cup

►► Peru, late 17th–18th century
Wood and pigment inlay, 7⅞ x 6⅛ (20 x 15.6)

42.149, A. AUGUSTUS HEALY FUND

Wooden cups known as *keros* constitute one of the most characteristic forms in colonial Andean art. Although their shape is similar to that of a European beaker, they derive from Precolumbian prototypes going back to A.D. 500. It was only after the Conquest, however,

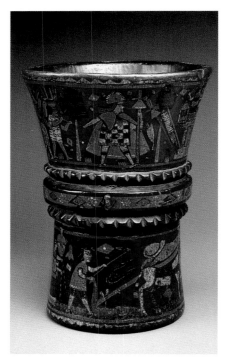

42.149

that these cups began to be decorated with pictorial scenes rather than geometric designs. The technique of inlaying pigments in wood also appears to date to the colonial period. Here it has been used to portray an Inca battle scene on the top register and an agricultural scene on the lower register. Ritual battles that reenacted Inca conquests took place before the harvest season and were related symbolically to agriculture and fertility. This cup makes the connection between battles and agriculture explicit by the juxtaposition of the two scenes.

Our Lady of Cocharcas under the Baldachin

❙ Peru, Cuzco school, inscribed 1765
Oil on canvas, 78¼ x 56½ (198.8 x 143.5)
57.144, BEQUEST OF MARY T. COCKCROFT

Illustrating a rich cross section of colonial life in the Andes, this painting represents the statue of the Virgin of Cocharcas outside her church and under a baldachin on a feast day. The use of religious images as cult objects originated in Europe, but it dovetailed with native belief in the power of certain objects called *huacas*. Andean paintings often depict the statues at the center of such local cults. In the case of the Virgin of Cocharcas, Sebastián Quimichi, a young Indian from Cocharcas, traveled to Copacabana in the late sixteenth century to pray before the famous statue of the Virgin there to heal his injured hand. When he was cured, he had a copy of the statue carved, in gratitude, by the native-born Tito Yupanqui, and after he returned to Cocharcas, his statue, too, became a source of miracles and devotion. In the upper right of this painting, Quimichi arrives at Cocharcas with the statue in a bundle on his back, accompanied by an angel. On the hillside below is the church dedicated to the Virgin of Cocharcas in 1623, the focus of a procession of pilgrims from near and far.

Tupac Yupanqui

Peru, mid-18th century
Oil on canvas, 23⅛ x 21¼ (58.7 x 54)

1995.29.11, DICK S. RAMSAY FUND, MARY SMITH
DORWARD FUND, MARIE BERNICE BITZER FUND, FRANK L.
BABBOTT FUND, AND GIFT OF THE ROEBLING SOCIETY,
THE AMERICAN ART COUNCIL, ANONYMOUS, MAUREEN
AND MARSHALL COGAN, KAREN B. COHEN, GEORGIA
AND MICHAEL DE HAVENON, HARRY KAHN, ALASTAIR B.
MARTIN, TED AND CONNIE ROOSEVELT, FRIEDA AND
MILTON F. ROSENTHAL, SOL SCHREIBER IN MEMORY OF
ANN SCHREIBER, JOANNE WITTY AND EUGENE KEILIN,
THOMAS L. PULLING, ROY J. ZUCKERBERG, KITTY AND
HERBERT GLANTZ, ELLEN AND LEONARD L. MILBERG,
PAUL AND THERESE BERNBACH, EMMA AND J. A. LEWIS,
FLORENCE R. KINGDON

Although the Incas had no system of portraiture before the arrival of the Spanish, they quickly adopted the portrayal of royal ancestors in the early colonial era. This portrait, one of thirteen in the Brooklyn Museum of Art's series of Inca kings, reflects the conventions of European portraiture while preserving the traditional attributes of the native rulers. These images are ultimately derived from paintings of Inca kings sent to Spain in the late sixteenth or early seventeenth century, portrayals that themselves became the models for an engraved frontispiece in Antonio de Herrera's *Historia general de los Hechos de los Castellanos*, first published in 1615 and reissued in 1726–30. It was probably the latter edition that served as the direct model for this series. Throughout the colonial period, portraits of the Incas were prized by colonial Indian nobility as evidence of their aristocratic forebears; however, after a series of rebellions shook the confidence of Peru's Spanish rulers in the late eighteenth century, such representations were banned. Although many Inca king portraits were probably destroyed at that time, this portrait of the eleventh Inca king happily survived the purge, along with the other kings in the series.

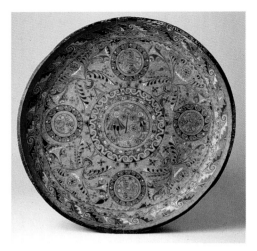

Batea

◄ Mexico, Michoacan, 17th or 18th century
Wood, inlaid lacquer, 4½ x 41 (11.4 x 104.1)
41.227, A. AUGUSTUS HEALY FUND

This unusually large *batea* (tray) was probably made in Periban, the center of production of inlaid lacquerware in Mexico during the colonial period. Although the cursive drawing style and the costumes of the central figures reflect European influence, the stepped-fret border is a common Precolumbian motif found on ceramics and stonework, and in manuscript painting. Several aspects of the central scene also relate to native iconographic traditions. The man and the woman flank a flowering staff, which at one end is enclosed by a U-shaped form, similar to the Aztec glyph for the earth, and at the other is topped by a large bird, symbolic of the sky. The staff could be interpreted as a version of the cosmic tree, a concept that was widespread before the Conquest and continues to have religious and political significance in many native communities today.

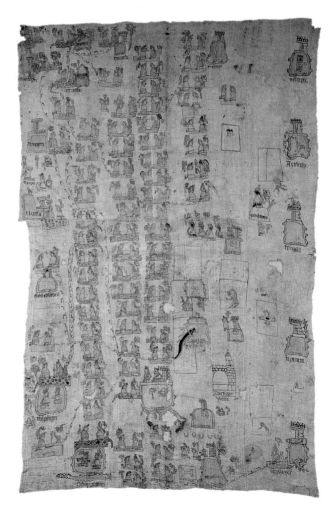

Lienzo of Ihuitlan

◄ Mexico, western Oaxaca, mid-16th century
Nine four-selvaged cotton plain-weave panels; dye pigments and inks,
97¾ x 62 (248.2 x 157.4)
42.160, CARLL H. DE SILVER FUND

Although most Precolumbian native manuscripts were destroyed in the iconoclasm of the Conquest, the painting tradition continued and even developed under Spanish rule. This detailed and delicately drawn *lienzo* (a Spanish word meaning "linen" or "canvas") from the native community of Ihuitlan located in the modern state of Oaxaca presents the

genealogies of the rulers of Ihuitlan and several neighboring towns in a cartographic context. Probably made for a court of law to validate local land claims, the document combines traditional place and name glyphs with newly introduced written inscriptions and symbols such as the church drawn in the lower right-hand corner, labeled as Santiago Ihuitlan. The pre-Hispanic glyph for the town appears just above and to the left. Within Ihuitlan, this *lienzo* served as a tangible record of communal identity throughout the colonial period.

Don Juan Joachín Gutiérrez Altamirano Velasco, circa 1752

► Miguel Cabrera (Mexican, 1695–1768)
Oil on canvas, 81⁵⁄₁₆ x 53½ (206.2 x 135.9)
52.166.1, Museum Collection Fund and the Dick S. Ramsay Fund

The descendant of an ennobled conquistador, two viceroys of New Spain, and a cousin of Hernán Cortés, Don Juan Joachín Gutiérrez Altamirano Velasco was a member of the most powerful—and richest—element of society in colonial Mexico. At this level of society, the Mexican elite saw themselves as European aristocrats in the Americas and made every attempt to maintain a standard of living that both reflected and supported that position, looking to both Spain and the Bourbon court for inspiration. In this portrait by the premier Mexican artist of the eighteenth century, Don Juan is depicted in coat, waistcoat, and knee breeches, and he carries a tricorn hat, all heavily ornamented, richly embroidered, and extremely expensive. Don Juan's status and position, more than his personality, are the subjects of this portrait. Further recognition of the sitter's heritage is provided by the coat-of-arms at the upper left and the cartouche below it, which gives Don Juan's full name and lists the titles he held, including Count of Santiago Calimaya, Marquis of Salinas de Rio Pisuerga, and High Governor for Life of the Philippines.

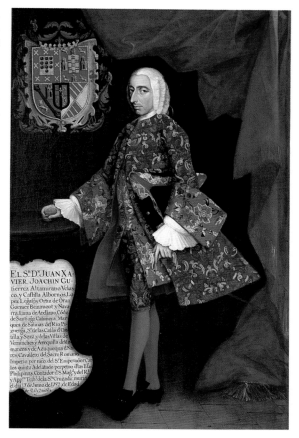

The All-Powerful Hand

►► Mexico, 19th century
Oil on metal (possibly tin-plated iron), 13⅞ x 10¹⁄₁₆ (35.2 x 25.6)
44.195.24, Museum Expedition 1944, Purchased with funds given by the Estate of Warren S. M. Mead

The tradition of painting religious images on tin plate originated in Mexico by the 1820s and remained based in the north-central region of the country. The vivid colors and crisp lines of this work make it a prime example of this popular art form. The All Powerful Hand is a highly symbolic image, which includes references to the Eucharist in the bleeding hand and to Revelations in the seven lambs that drink of its blood. The nail wound is also meant to recall the wounds that Christ received on the cross. The extended family of Christ is represented by individual figures on each of the five fingers of the hand with Christ at the center.

Festival Hat

▌ Bolivia, Potosí(?), 18th
century
Repoussé silver plaques on
velvet, glass beads, wire,
4¹⁵/₁₆ x 13¼ (12.5 x 33.7)
diameter

41.1275.274C, MUSEUM EXPEDITION
1941, FRANK L. BABBOTT FUND

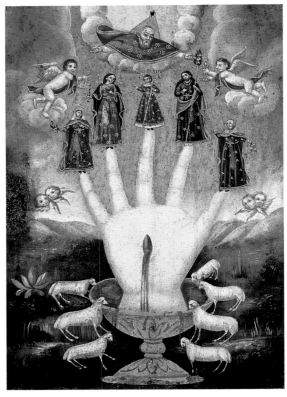

44.195.24

An example of South American
viceregal silverwork at its
finest, this hat is encrusted with
motifs that are encountered
repeatedly in Peruvian colonial
art of all media. It consists of
many separate repoussé silver
plaques sewn onto a velvet-
covered form with rounded
crown and flat, circular brim.
The motifs on the brim include
curvilinear floral vines emerging
from vases and intertwined
with birds and cornucopia.
Flowers and vines continue
onto the crown, surrounding,
on one side, a triangular motif,
possibly representing the Cerro
de Potosí, the mountain from
which silver was mined, with
two llamas at its summit. On the other side are
a pair of mermaids playing *charangos* or
guitars. Birds, elephants, a lion, a crescent
moon, and the sun are among the motifs that
fill out the space. This type of hat, worn by
dancers at festivals that were derived from
indigenous, pre-Conquest ceremonies and
were held in the silver mining regions of
Bolivia, often augmented costumes similarly
ornamented with silver.

Decorative Arts

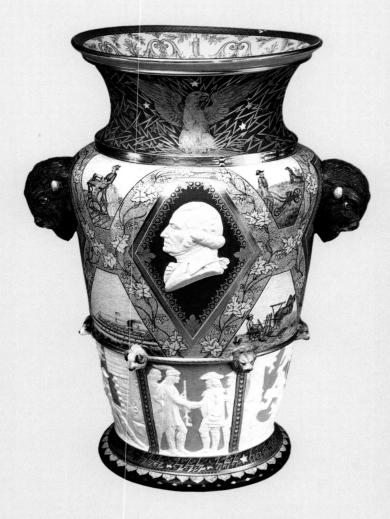

North Room, The Jan Martense Schenck House

▌ Mill Island, Brooklyn,
built circa 1675
18½ x 21½ feet (5.64 x 6.68 m)
50.192, GIFT OF THE ATLANTIC GULF AND PACIFIC
COMPANY

When Jan Martense Schenck built his house on Mill Island in the town of Flatland (now a part of Brooklyn) about 1675, New York had only recently passed from Dutch rule to the English. Schenck himself was Dutch born, and the two-room house he built is in the Dutch vernacular tradition of the seventeenth century. Shown here is the North Room, which served as a parlor, dining area, and sleeping room. The fireplace is of the Dutch type, with a projecting mantelpiece and no jambs, or sides. The triangular knee braces of the exposed post-and-beam construction are also a Dutch feature, as are the built-in bed boxes against the wall

opposite the fireplace. Since Schenck was a relatively affluent citizen, the room is furnished to reflect a comfortable standard of living. The table is covered with a "Turkey carpet," in turn covered by a linen cloth for protection, and the chairs surrounding the table are upholstered in "Turkey work" in imitation of the carpet. The room also includes an extraordinary Dutch *kas* and a number of pieces of ceramics, both Dutch Delft and Asian.

Hall, The Cupola House

► Edenton, North Carolina, 1757–59
19½ x 15½ feet (5.95 x 4.73 m)
18.170, ROBERT B. WOODWARD MEMORIAL FUND

The largest and most impressive house in Edenton, North Carolina, was the Cupola House, whose original ground floor comprised a hall, parlor, chamber, pantry, and stair passage. This fully paneled hall was the

most elaborate room in the house, and it was the primary public space. "Hall" is a medieval term that refers to a room used for dining, but not exclusively so. Many and varied functions took place in the hall, but in this photograph it is set up as if the family were expecting guests for a party. Colonial Americans followed English customs and styles rather closely, and the elaborate woodwork in this room, especially that of the mantel, seems to be based on a plate from William Salmon's *Palladio Londonesis* (London, 1748). The rich Prussian blue color of the woodwork was the most expensive one available in the eighteenth century, and together with ceramics from England and China, imported glassware, English silver, and handsome American-made furniture, it gives the room an air of substantial comfort, even luxury. The marbleized floorcloth—a piece of canvas painted to imitate costly inlaid stone floors—provides a further note of richness.

Moorish Smoking Room, The John D. Rockefeller House

►► New York, built circa 1864–65; remodeled circa 1883
17½ x 15½ feet (5.33 x 4.76 m)
46.43, Gift of John D. Rockefeller, Jr., and John D. Rockefeller III

Inspired by Moorish art, the decoration of this room made it particularly appropriate, in the eyes of the late nineteenth-century viewer, to its function as a gentleman's smoking room. In the nineteenth century, the use of specific rooms for particular functions was a practice on the rise among the elite, whose homes became symbols of their social and cultural standing. Likewise, the range of historical and exotic styles to choose from expanded, and it was important that ornament be symbolically appropriate to function. To assist with this complicated proliferation of styles and rooms, the profession of the interior decorator was

born. This room comes from a house at 4 West Fifty-fourth Street in New York that was purchased by John D. Rockefeller in 1884. When he bought it from Arabella Worsham, who had lived there since 1877, however, it was already fully decorated. During the last years of her residence, she had hired interior decorators such as George Schastey and Pottier & Stymus to create rooms in which all elements of the design—from curtains and wall treatments to stained glass and furniture—were integrated into a coherent aesthetic statement. The Moorish Smoking Room is thus a testament to the complexities and beauty of the Aesthetic Movement in America.

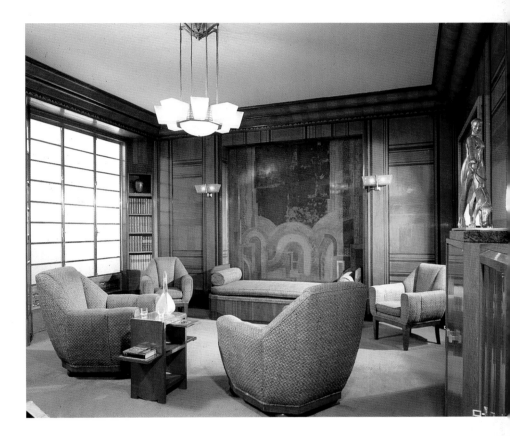

Worgelt Study

↑ Alavoine of Paris and New York
New York, 1928, with additions of 1930
10 x 16¾ x 14½ feet (13.02 x 5.12 x 4.48 m)
70.23.4, 70.96MN, GIFT OF RAYMOND WORGELT

The Worgelt Study is the Museum's only twentieth-century period room on exhibition. Originally installed in the Park Avenue apartment of Mr. and Mrs. Milton Weil, the room was designed by Alavoine, a Parisian decorating firm that specialized in high-style French historical design. The Worgelt Study was one of Alavoine's few modern rooms and reflects the urbanity and sophistication of French Art Deco interiors of the 1920s. The room is paneled in a geometric design of palisander and olive wood veneers and incorporates a large abstract painted lacquer mural designed by Henri Redard and executed by Jean Dunand. (Redard also designed a small walk-in bar with etched glass panels depicting landmarks of Paris that, because of prohibition, was hidden discreetly behind a door that blended into the wall decoration.) The room was completed by the addition of glass by René Lalique and sculptures by Raymond Rivoire and Jan and Joel Martel.

Chest of Drawers

| Massachusetts, 1680–1700
Oak and pine, 36 x 40 x 21½
(91.5 x 101.6 x 54.6)

49.190.2, BEQUEST OF MRS. WILLIAM STERLING PETERS, BY EXCHANGE

Furniture made in New England in the seventeenth century reflects the English heritage of the early settlers of that area. This chest of drawers, which descended in the Hancock family of Bradford, Massachusetts, is in the tradition of English seventeenth-century furniture. The façade of the piece is divided into a vigorous series of geometric compartments that give the piece visual strength and rhythm. The total effect of the surface pattern was originally enhanced by vivid color; strong traces of red paint remain in the panels of the center drawers, which are decorated with facing pairs of birds. The panels of the larger drawers are ornamented with black fleurs-de-lis, and the applied moldings were originally painted black as well. Those areas of the façade that were originally unpainted were covered with an overall pattern of undulating black lines. Such a survival of original paint on a seventeenth-century object is unusual and helps us understand the strong sense of vivid color that dominated the decoration of the period.

Side Chairs

► Wethersfield, Connecticut, circa 1740–50
Cherry and maple, 41 x 19½ x 17½
(104.1 x 49.5 x 44.5) each

14.708 AND 14.709, HENRY L. BATTERMAN FUND

The sculptural beauty and attenuated elegance of these chairs exemplify the restraint typical of the finest furniture produced in America during the Queen Anne–style period. Made in Wethersfield, Connecticut, near Hartford, the chairs are fashioned in cherry, the local wood most common in Connecticut furniture. The needlework upholstery on the slip seats is a reproduction of the surviving original upholstery, which was no doubt worked by an early owner of the chairs. The chairs originally belonged to Dr. Ezekiel Porter (1707–1775), a noted Wethersfield surgeon, or to his son-in-law, Thomas Belden (1732–1782). Once part of a larger set, they remained in the Porter-Belden-Bidwell House in Wethersfield until 1914, when the Museum acquired them, along with other furniture from the house. Three years later, in 1917, the Museum acquired two downstairs rooms from the house as well. Thus, the chairs can now be seen installed in the parlor of the house in which they have resided since the eighteenth century.

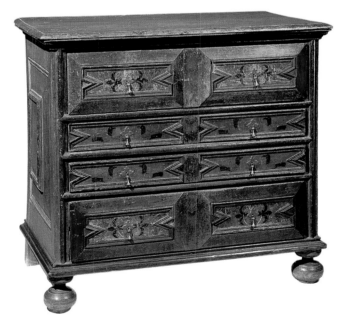

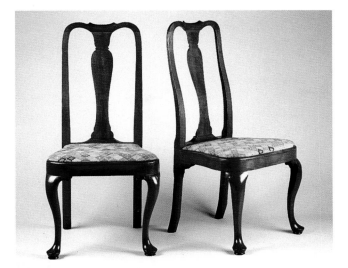

Pier Table

❚ Charles-Honoré Lannuier (active
1779–1819)
New York, circa 1815
White marble top supported by rosewood
veneer frame with applied ormolu and gesso,
36 x 55⅞ x 21¼ (91.4 x 141.9 x 54.6)
41.1, Gift of the Pierrepont Family

After the first decade of the nineteenth century,
the Neoclassical style in America became more
robust and began to reflect French taste more
strongly than ever. During
the War of 1812, France
was an ally and England
the enemy. It is therefore
not surprising that the
finest furniture of the
period, such as this pier
table, reflects the style
popularized by Napoleon
and the designers he
favored. Men like Charles
Percier, Pierre Fontaine,
and Pierre de la Mésan-
gère published Neo-
classical designs that were
disseminated throughout
Europe. In turn, English
designers such as Thomas
Hope and George Smith
published books that were
influential in transferring
the style to America. This pier table, which
belonged to the Pierrepont family of Brook-
lyn, is attributed to Charles-Honoré Lannuier,
a French cabinetmaker who emigrated to
New York in 1803 and became one of the
premier proponents of the late Neoclassical
style in America. Designed to be placed
against a wall, or pier, between two windows,
the table is a superb example of the
adaptation of classical details—columns, dol-
phins, and winged caryatids—to a nineteenth-
century form.

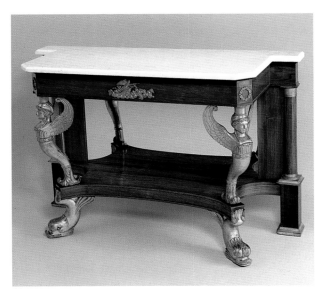

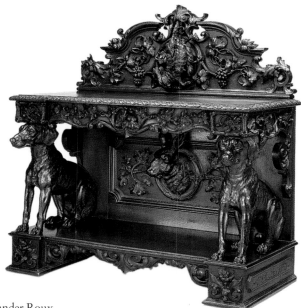

Sideboard

↑ Attributed to Alexander Roux
(American, 1813–1886)
New York, circa 1855
Black walnut, 49 x 49 x 24
(124.5 x 124.5 x 61)

1995.15, GIFT OF BENNO BORDIGA, BY EXCHANGE

By the mid-nineteenth century, furniture for the dining room had developed its own specific iconography. Combining trophies of dead game on the backboard with swags of fruit and nuts, this side table exemplifies objects whose motifs gave expression to the abundance of a nature at the command of man; consequently, in the eyes of the time, its decoration was appropriate to its function. The most unusual feature of this piece, however—the life-size canine atlantes—have older roots. Based on late Roman console tables, the conceit was revived during the Neoclassical period by James "Athenian" Stuart in consoles that he designed for Spencer House in London in 1759. A closer precedent for the dogs on this table can be found in a sideboard exhibited by the Paris cabinetmaker Alexandre-Georges Fourdinois at the Great Exhibition in London in 1851. It is probably this latter object that inspired the French-born Alexander Roux in the design of this piece. Its brilliant naturalistic carving reflects the finest woodworking tradition of midcentury America.

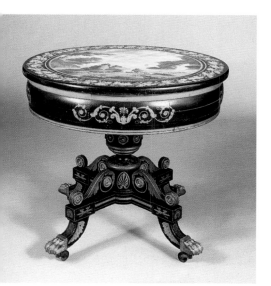

Center Table

◄ Attributed to John Finlay
Baltimore, circa 1825
Wood, brass, gilt, plaster, 30⅜ x 33
(77.1 x 83.3)

88.24, PURCHASED WITH FUNDS GIVEN BY AN ANONYMOUS DONOR, THE AMERICAN ART COUNCIL, AND DESIGNATED PURCHASE FUND

Robust and bold, this painted center table is a superb example of the Neoclassical style in

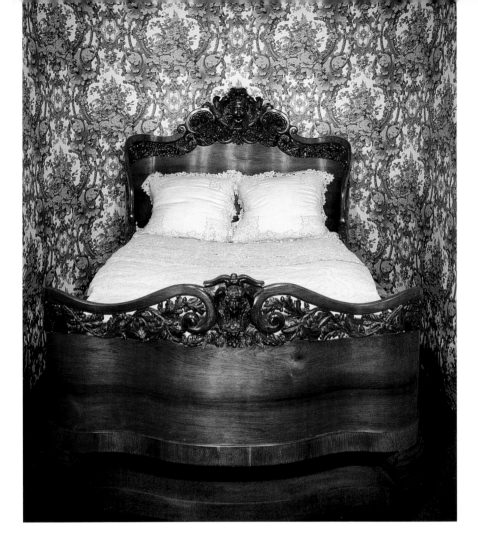

Baltimore. After the American Revolution, Baltimore expanded rapidly, developing as an important port and as a center for the emerging American version of the Neoclassical style. A tradition of painted furniture developed here into a characteristic style unique among American furniture production. Perhaps the most successful practitioners of the late Neoclassical style in Baltimore were Hugh and John Finlay, from whom James Wilson, a prominent shipping merchant, ordered a large suite of furniture, including this table, about 1825. The center table, meant to be placed in the middle of the room, was a new form developed to accommodate changing lifestyles. This table, with its monumental turned pedestal, broad convex apron, and saber legs, reflects the weightiness of the late Neoclassical style. It is ornamented with gilt decoration and brass mounts, and its scagliola top, probably imported from Europe, is richly painted with a maritime scene based on a painting by Carle or Claude Joseph Vernet.

Bed

▮ John Henry Belter (American, b. Germany, 1804–1865)
New York, circa 1856
Rosewood, headboard 65½ x 58½ (166.4 x 148.6); footboard 36 x 58½ (91.4 x 148.6); 83 (210.8) deep

39.30, GIFT OF MRS. ERNEST VIETOR

In both form and decoration, this bed embodies the exuberance of the Rococo Revival style in America. In construction, it reflects the nineteenth-century fascination with technological innovation. Although the bed has its stylistic roots in the Rococo style of the eighteenth century, its manufacture was entirely modern. It was made in the shop of John Henry Belter, a German-born craftsman who began working in New York City in the 1840s. Belter used laminated construction in his furniture, a system of manufacture that allowed a strong and relatively lightweight material to be bent into the elaborate serpentine shapes so much a part of the fashion of the time. Although laminated wood was not his invention, Belter did patent a number of innovations throughout his career. The patent for this bed, dated August 19, 1856, boasts that it can be disassembled easily in case of fire and that its construction eliminates the intricate joints and recesses around the individual parts of ordinary bedsteads, areas "notorious as hiding places for bugs."

Cabinet

❙ Made by Herter Brothers (1865–1905)
New York, circa 1875
Ebonized cherry with painted and inlaid panels, 42⅜ x 66 x 16¾ (107.7 x 167.7 x 42.5)
76.63, H. RANDOLPH LEVER FUND

The preeminent decorating firm in late nineteenth-century America was Herter Brothers of New York City. The firm was founded in 1865 by Gustav Herter (1830–1898) and his half brother, Christian (1840–1883), both of whom had emigrated from Germany. Their name soon became synonymous with the Anglo-Japanese style in America. Made for George Beale Sloane (1831–1904), a prominent Oswego, New York, businessman and New York state senator, this cabinet exhibits the excellent craftsmanship and refined design that made the firm famous. The conventionalized light marquetry on ebonized ground, the painted panels, and the frame-and-panel construction are all within the Herter vocabulary. Other details, as well as the form itself, are adapted from cabinets produced by an English firm. The Herter Brothers, working in the Japanese-inspired idiom with roots in the English Aesthetic Movement, did not just borrow an English idea, but actually improved it.

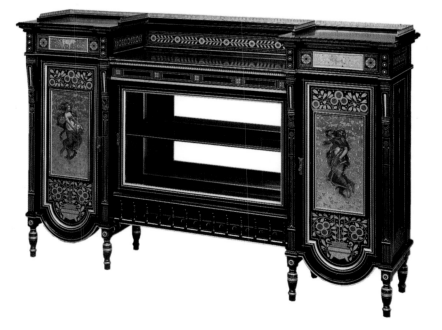

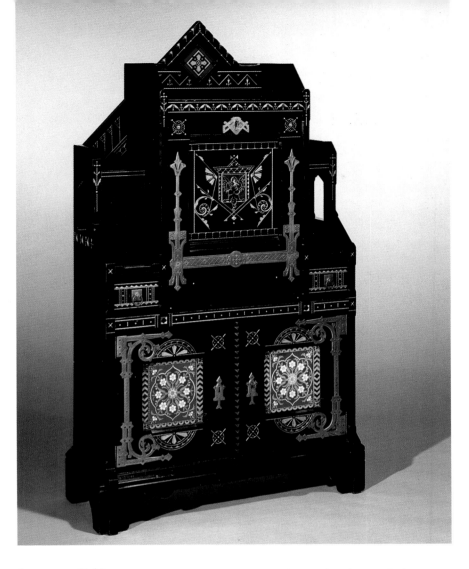

Secretary Cabinet

⬆ Kimbel and Cabus (1863–82)
New York, circa 1876
Ebonized wood, brass, leather, ceramic tile,
59 x 34⅞ x 13⅜ (149.9 x 88.6 x 33.4)
1991.126A-F, BEQUEST OF DELANCEY THORN GRANT IN
MEMORY OF LOUISE FLOYD-JONES THORN, BY EXCHANGE

In both ornament and form, this secretary cabinet exemplifies the Modern Gothic style as adapted in America by Kimbel and Cabus. Anthony Kimbel and Joseph Cabus established a partnership in 1863 that would last for nearly twenty years. Although they worked in many of the styles popular during the period, Kimbel and Cabus are best known for their Modern Gothic objects, which grew out of the English reform movement popularized by designers such as Bruce Talbert, whose *Gothic Forms Applied to Furniture* provided models for Kimbel and Cabus. The cabinet evokes medieval architecture in its form, but its function—the central panel drops to become a writing surface—is a modern one. Likewise, the ornament, while based in part on medieval tradition, reflects nineteenth-century reformist notions, which favored abstract pattern and stylized motifs over realistically carved decoration and demanded that functional elements—such as the prominent exposed strap hinges—be evident, even emphasized.

Side Chair

▮ Frank Lloyd Wright (American,
1867–1959)
Oak Park, Illinois, 1904
Oak with leather upholstery,
40⅛ x 14¾ x 18½ (101.9 x 37.5 x 47)
83.157, DESIGNATED PURCHASE FUND

Frank Lloyd Wright is America's foremost
architect of the twentieth century. He designed
the side chair illustrated here for his own
studio in Oak Park. Like many of his early
designs, the chair adheres to basic conventions
of furniture of the Arts and Crafts Movement:
the material is stained to reveal the natural
characteristics of the wood; the construction is
straightforward, with nothing hidden from
view; and the overall design is uncomplicated.
Yet in terms of subtlety and artistry, the chair
transcends the "simplicity" that Arts and Crafts
furniture was meant to embody. This chair is
more than a mere instrument of seating; it is
a sophisticated architectural
construction in which artistic
intention is more import-
ant than comfort or
practicality. Its forceful
abstract design reveals
the uncompromising
nature of Wright's work
and looks forward to
the geometric abstrac-
tion that was to become
central to modern
architecture and design
in the early twentieth
century.

Corner Cabinet

▮ Émile-Jacques Ruhlmann (French,
1879–1933)
From a room designed for the Weitz family,
Lyon, France, 1923
Kingwood (amaranth wood) veneer on
mahogany with ivory inlay,
49⅞ x 31¾ x 23½ (126.6 x 80.6 x 59.7)
71.150.1, PURCHASED WITH FUNDS GIVEN BY JOSEPH F.
MCCRINDLE, MRS. RICHARD M. PALMER, CHARLES C.
PATERSON, RAYMOND WORGELT, AND ANONYMOUS DONOR

Émile-Jacques Ruhlmann was the foremost
decorator and cabinetmaker in Paris during
the decade following World War I. His luxur-
ious furniture represents the highest achieve-
ment of what is now generally called Art Deco,
a term derived from the name of an important
exhibition held in Paris in 1925—Exposition
Internationale des Arts Décoratifs et Industriels
Modernes. Using costly woods and exotic ma-
terials, Ruhlmann catered strictly to wealthy
clients who were interested in associating them-
selves with the venerable traditions of high-
style French cabinetmaking. The beautifully

proportioned and superbly crafted cabinet pictured here is an exquisitely detailed object whose decorative effect is dependent on the highly figured veneers and the variously treated ivory inlays that cover its surface. The stylized flowers that spill out of the large vase on its center are intricately rendered; the thin lines of white ivory and the dark wood between inlays create a sense of space and turn the flat decoration into a sumptuous and expressive design.

Vanity and Stool

❚ Kem Weber (American, b. Germany, 1889–1963)
Made by Lloyd Manufacturing Company, Menominee, Michigan, 1934
Chrome-plated tubular steel, black-painted wood, glass, and leather,
vanity 55 x 33 x 19½ (139.7 x 83.8 x 49.6); stool 17½ x 21 x 22½ (44.5 x 53.3 x 57.1)

87.123.1-.2, MODERNISM BENEFIT FUND

One of the leading industrial designers of the 1920s and 1930s, Karl Emanuel Martin Weber brought an innovative modernist style to American furniture and interior design in the Depression era. Born and trained in Berlin, Weber came to the United States in 1913 to install the German section of the Panama-Pacific Exposition in San Francisco. When World War I broke out, he was unable to return home and remained in the United States. After the war he settled in Santa Barbara, and in 1921 he relocated to Hollywood, where he maintained a flourishing business as a designer of furniture, decorative objects, interiors, and movie sets. The vanity and stool illustrated here are characteristic of the sleek, modernist designs that Weber produced in the 1930s. The gleaming surfaces and parallel bands of tubular steel were symbolic of the new Machine Age, while the circular mirror and off-center supports captured the glamour and sophistication reflected in contemporary Hollywood movie sets.

Sweetmeat Dish

↑ Gouse Bonnin and George Anthony Morris (American, active 1770–72)
Philadelphia, 1770–72
Soft-paste porcelain painted in underglaze blue, 5¼ x 7¼ (13.3 x 18.4)
45.174, MUSEUM COLLECTION FUND

In 1770 Gouse Bonnin and George Anthony Morris founded a company to produce porcelain tablewares in Philadelphia. Although the company failed after just two years, it was the earliest American attempt at porcelain production to meet with even modest success. Of the handful of Bonnin and Morris wares still in existence, this sweetmeat dish is one of the finest examples. In order to compete with relatively inexpensive imported English ceramics, Bonnin and Morris closely imitated the production of major English factories. Thus this sweetmeat dish bears a strong similarity to related objects made by the Bow factory in England. Its form, comprising three scallop-shell-shaped dishes and a shell-encrusted central pedestal supporting a circular dish, embodies the Rococo spirit in its use of sources from nature to form an object of complex outline.

Standish

▼ Henry Will (American, active 1761–93)
New York or Albany, circa 1761–93
Pewter, 7⅞ x 4¹¹⁄₁₆ x 2¼ (20 x 11.9 x 5.7)
45.10.142, DESIGNATED PURCHASE FUND

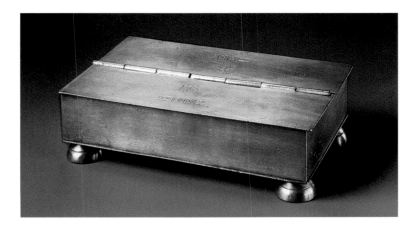

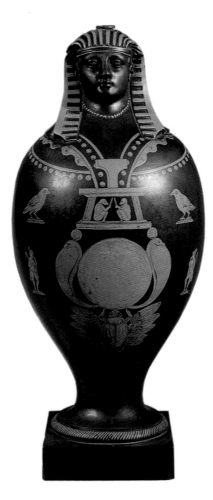

The well-to-do businessman of late eighteenth-century America would have stored his pens, ink, and sander (to dry the ink) in what was then referred to as a standish. This example is the only American one known to exist in pewter. During the eighteenth century, pewter objects were used in nearly every American household that could afford them. Most people in homes and taverns ate and drank from pewter; porcelain was rare and expensive. Pewterers like Henry Will were skilled craftsmen who poured molten tin mixed with small amounts of copper, antimony, and bismuth into brass molds to create their wares. The object was then allowed to cool and harden before being finished to a smooth surface pleasing to the eye and touch.

Canopic Jar

↑ Wedgwood & Bentley (1768–80)
Etruria, Staffordshire, England, circa 1773
Earthenware, encaustic, 13⅝ x 5½ (34.6 x 14)
56.192.33, Gift of Emily Winthrop Miles

The evocation of dynastic Egypt in this vase reflects the interest in the ancient world prevalent in the late 1700s among manufacturers such as Josiah Wedgwood and Thomas Bentley when catering to clientele educated in the classics. Wedgwood had revolutionized ceramics production in England with the introduction of relatively inexpensive creamware, called Queensware, for the table. At the same time he perfected the coarse black stoneware produced in Staffordshire, making

it smoother and finer grained; this new ware he called black basalt. Black basalt was a perfect medium for vases in the classical style, and between 1770 and 1773 objects in the Egyptian taste were added to the repertory of classical forms. In fact, the model for this vase is not Egyptian, but an Egyptian-style vase produced in Hadrian's Rome and illustrated in Bernard de Montfaucon's *L'Antiquité expliquée* (1719), which was in Wedgwood's library. The romance of ancient Egypt, not an accurate replica, was desired. Unlike the originals, this object does not open; it probably had a nozzle on top of the head and served as a candlestick.

Pitcher and Goblet

❘ Zalmon Bostwick (American, active 1846–52)
New York, circa 1845
Silver, pitcher 11 (28) high; goblet 7¾ (19.5) high

81.179.1 AND 81.179.2, GIFT OF THE ESTATE OF MAY S. KELLEY, BY EXCHANGE

This pitcher and goblet are extremely rare examples of Gothic Revival silver. Although the Gothic style was a popular one in American architecture and furniture design during the 1840s, and publication of A. J. Downing's *Architecture of Country Houses* in 1851 further spread the influence of the style, the Gothic Revival was, surprisingly, never widespread among American silversmiths. The pieces were made by the New York silversmith Zalmon Bostwick, and an inscription on the base of the pitcher indicates that they were presented by John W. Livingston, a descendant of an old New York family, to his son-in-law Joseph Sampson in 1845. The pitcher is closely modeled on an English prototype produced in stoneware by Charles Meigh beginning in 1842. These English stoneware pitchers were no doubt popular in America, for they were copied not only by Bostwick, but also by ceramists like Daniel Greatbach, who modeled a similar pitcher for the American Pottery Company of Jersey City, New Jersey, in the early 1840s.

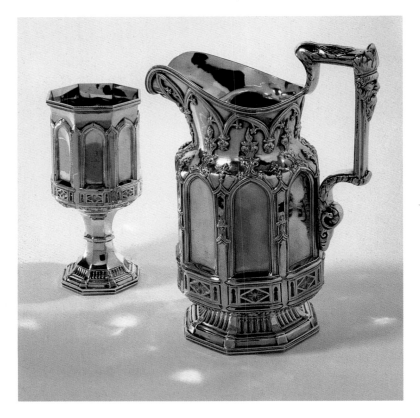

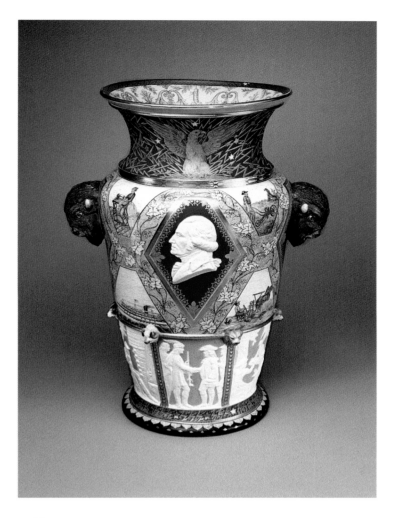

Century Vase

▲ Union Porcelain Works (1863–circa 1922)
Greenpoint, Brooklyn, 1876
Hard paste porcelain, 24¼ x 10 (56.5 x 25.4)

43.25, GIFT OF CARLL AND FRANKLIN CHASE, IN MEMORY OF THEIR MOTHER, PASTORA FOREST SMITH CHASE, DAUGHTER OF THOMAS CARLL SMITH, THE FOUNDER OF THE UNION PORCELAIN WORKS

Conceived by Thomas C. Smith, owner of the Union Porcelain Works, and designed by Karl L. H. Mueller, the company's chief designer, the Century Vase celebrated the optimism and national pride of America at the time of the country's centennial. The vase, which was exhibited in the Union Porcelain Works booth at the Centennial Exhibition in Philadelphia in 1876, is replete with American symbolism. Examples of native animals appear as trophy heads around the midband of the vase, and the handles are in the form of bison heads. On the neck, an American eagle clutches bolts of lightning in its talons. Below the midband of the piece are scenes from American history in white bisque, while above, surrounding a profile of Washington, the marvels of progress are depicted in color—the telegraph, the steamer, the sewing machine, and the reaper among them. The Union Porcelain Works was one of the most important manufacturers of ceramics in America in the late nineteenth century. This monumental vase displays the eclectic vigor seen in the artistic production of the age.

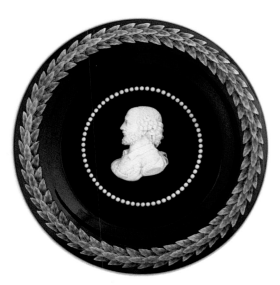

Tazza

John Northwood (English, 1836–1902)
England, 1881
Glass, 4 x 9½ x 9½ (10.2 x 24.1 x 24.1)
1994.203, GIFT OF DR. AND MRS. THEODORE KAMHOLTZ

The delicate, carefully carved profile portrait of William Shakespeare, surrounded by a wreath on this tazza (footed dish; illustrated from above), represents the result of nineteenth-century efforts to raise glassmaking to an art and to revive lost ancient methods of making cameo glass. Two men, cousins, were central to perfecting the technique that led to this object. Philip Pargeter, whose family had long been connected with the glass industry in England, carried out costly experiments to develop the technique of overlaying white opaque glass onto transparent blue glass, and John Northwood accomplished the pains-taking carving. Their first test was in the production of a copy of the most famous piece of ancient glass—the Portland vase. After successfully completing that object, they again collaborated on a vase dedicated to Milton (designed by Pargeter) and then three tazzas representing Art, Science, and Literature, personified by busts of Flaxman, Newton, and Shakespeare. The Shakespeare tazza in the Brooklyn Museum of Art collection is a version of the signed Shakespeare tazza in The Corning Museum of Glass, Corning, New York.

Bottle with Stopper

◄ Gio Ponti (Italian, 1891–1979)
Made by Venini & Company (founded 1921)
Murano, Italy, circa 1950
Glass, 14½ x 3¼ (36.8 x 8.3)
54.64.92, GIFT OF THE ITALIAN GOVERNMENT

In the decade following World War II, Italian
designers led the way in the production of
innovative and original glassware. Venini &
Company, the glasshouse founded in 1921 by
Paolo Venini, was the most important and
progressive. Drawing on centuries-old tra-
ditions, Venini breathed new life into the
Venetian glass industry through the develop-
ment of an extensive program of collabora-
tions with notable artists and designers such as
Carlo Scarpa, Fulvio Bianconi, and Gio Ponti,
and by encouraging a freer, more experimental
approach to design. Beginning in the late
1940s, Venini introduced a series of stoppered
bottles and decanters designed by Gio Ponti
and Fulvio Bianconi. These sculptural, long-
necked vessels captured the fluidity of the
medium in their use of expressive forms and
decoration. The decanter illustrated here is
typical of the anthropomorphic designs created
by Gio Ponti. Its shape, that of a stylized female
figure, is accentuated by the bold horizontal
bands and stripes of color, and by the exag-
gerated tear-shaped stopper.

"Normandie" Pitcher

► Peter Müller-Munk (American,
b. Germany, 1904–1967)
Manufactured by Revere Copper and Brass
Co., Rome, New York, 1935
Chrome-plated brass, 12 x 3 x 9½
(30.5 x 7.6 x 24.2)
84.67, H. RANDOLPH LEVER FUND

During the 1930s American industrial designers
seized on the principles of aerodynamic stream-
lining as the perfect aesthetic expression of
optimism for the forward-looking period in
which they were living. The shiny, chrome-
plated surfaces of objects like this pitcher em-
bodied faith in the symbol of the machine and
the processes of mass production as a panacea
for what had been, in economic terms, hard
times. Though streamlining was a mode of
design most suitable for vehicles of transpor-
tation—airplanes, ships, and automobiles—its
symbolism was so potent that it came to be
applied to all manner of stationary domestic
objects. In the case of this pitcher, the designer
was inspired by the imposing smokestacks of
the famous ocean liner *Normandie,* which had
just completed its maiden voyage. Like the
liner itself, the pitcher's form was sleek, wind-
swept, and elegant, and was evocative of the
speed and luxury associated with transatlantic
travel.

Spaces II

↑ Jaroslava Brychtova (Czech, b.1924) and
Stanislav Libensky (Czech, b.1921)
1991–92
Cast glass, 32½ x 29½ x 4¾ (83 x 75 x 12)

1993.32, PURCHASED WITH FUNDS GIVEN BY PHYLLIS AND
DAVE ROTH, ADELE AND LEONARD LEIGHT, AND JULIUS
KRAMER IN LOVING MEMORY OF THEIR PARENTS, ETTA AND
JAMES MARKOWITZ

Glass as a creative medium has experienced
tremendous growth as part of the modern craft
movement in the post–World War II decades.
Jaroslava Brychtova and Stanislav Libensky,
husband and wife collaborators, are masters in
studio glass. Their sophisticated, highly sculp-
tural work bridges decorative and fine arts.
Working together since 1954, Brychtova and
Libensky have created glass sculptures that
explore the optical qualities of the material.
Spaces II reflects the mastery of form and
medium gained through a lifetime of experi-
menting with the techniques of casting,
molding, and internal hollow modeling. In this
piece, a rectangular channel runs diagonally
through a prismatic form of cast glass. By
taking advantage of the reflective and the
translucent qualities of the material as well as
the gradation in color caused by its varying
thickness, Brychtova and Libensky create a
play between solid and void, and between real
and illusionary space.

Costumes and
Textiles

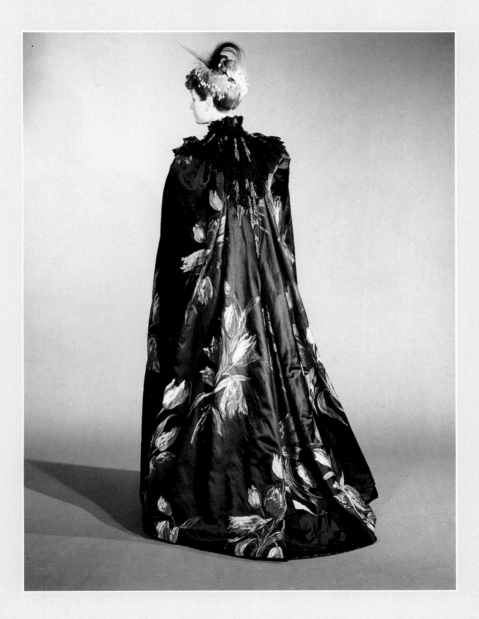

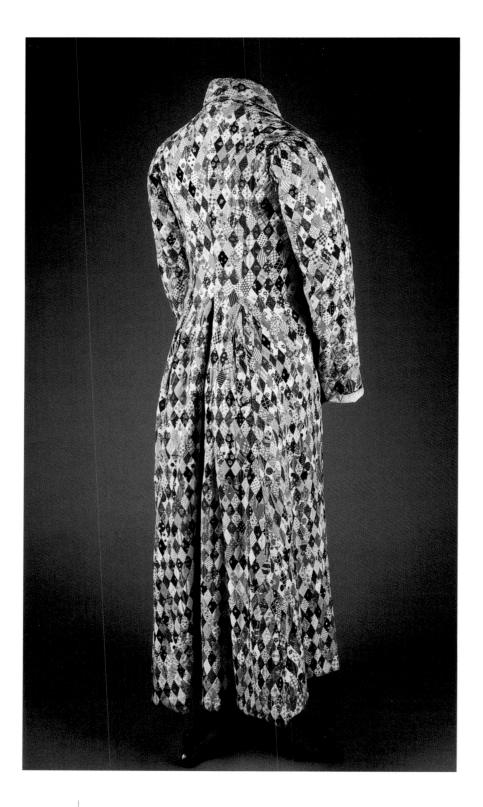

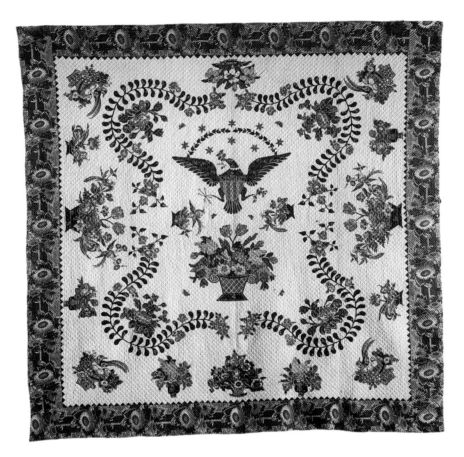

Man's Banyan

◂ England, circa 1820
Printed cotton
83.23.2, DESIGNATED PURCHASE FUND

A garment derived from Japanese, Indian, and Turkish costume, the banyan, or men's dressing gown, was a popular and informal item of dress that gave men a rare chance to wear colorful clothing in the nineteenth century. Most banyans were made of silks or woolens and reflected the eclectic and exotic tastes of the Romantic era. This banyan departs from the typical dressing gown in its remarkable fabrication from hundreds of tiny, diamond-shaped fragments of printed cotton pieced together by hand, indicating that the wearer's wife or a close family member may have created the mosaic-like cloth. The garment itself may have been tailored by a professional, as indicated by the highly stylish silhouette,

formed by the fullness of the upper sleeves; the slim, double-breasted bodice, cut to accentuate a barrel-shaped chest; and the ankle-length skirt, with its volume gathered at the back. This combination of amateur and professional talents was not uncommon in the creation of nineteenth-century garments.

Quilt

▲ Attributed to Elizabeth Welsh
United States, circa 1825
Appliquéd cottons, 110¼ x 109
(280.7 x 267.8)
78.36, GIFT OF THE ROEBLING SOCIETY

One of the most remarkable patchwork quilts in the Brooklyn Museum of Art collection is the "liberty quilt" attributed to Elizabeth Welsh of Warren County, Virginia (now part of West Virginia). While unique in neither design nor

execution, the quilt makes vivid statements about both. It shows an American eagle sporting a shield and clutching two floral sprays and three arrows. Although this republican motif was probably adapted from the Presidential or Great Seal, in this instance the eagle is surrounded by eight stars rather than thirteen and holds in its beak a branch rather than a banner. Such a prominent political statement suggests that the quilt may have been made in celebration of fifty years of American independence in 1826. Except for the sawtooth piecework border, the quilt is executed primarily in the appliqué technique. The quilting itself is a simple crosshatch or diamond design. Of special note are the leaves of the flowering corner garlands, which are worked in a complicated reverse appliqué technique in which the white ground fabric is cut away and colored pattern pieces are stitched in from the back. These patterned cotton materials are suitable for either garment or household items. Some, as in the sunflower border, even retain their original glaze.

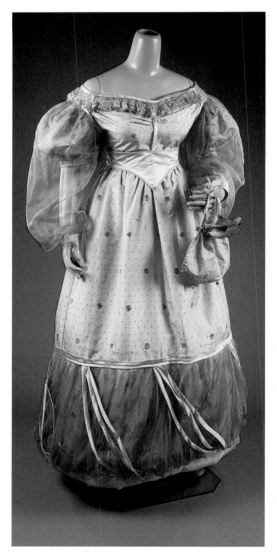

Ball Gown

◄ England, circa 1828
Silk brocaded taffeta, satin, gauze
71.76A-C, H. RANDOLPH LEVER FUND

Sir Walter Scott and other writers of Romantic tales attracted an avid readership in the early nineteenth century. Although stories of medieval chivalry aroused in female readers a desire to imitate their heroines in dress, the Romantic gowns that they wore took current modes into account. Fashionable short puffed sleeves were left intact, but long pendant cuffs were added, and a hemline might be caught up to expose another layer. For this period, sleeves were the important feature. Since about 1820 they had been growing fuller by the year, until they reached "gigot" (leg of mutton) or "imbecile" (the fullness is lower than "gigot" and more evenly distributed) proportions. To support these ballooning sleeves, special down-filled pads or plumpers were worn; they were tied by tapes to the gown at the shoulder and looked not unlike the full puffsleeves of this gown as seen through transparent gauze oversleeves. This sleeve treatment, padded and transparent, was modish between 1825 and 1835. Our ball gown of sprigged pink silk taffeta has a deep hemline "rouleau" with satin trim applied in the manner of Renaissance slashes. The reticule purse (formerly known as "ridicule") matches the gown.

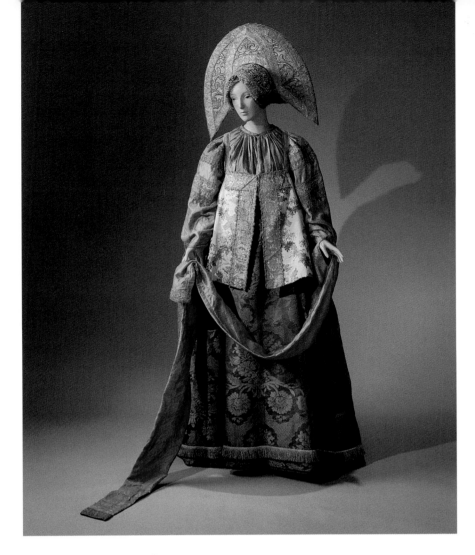

Woman's Festive Outfit

Russia, Vladimir region, early 19th century
Various materials

31.449-.453, GIFT OF MRS. EDWARD S. HARKNESS IN MEMORY OF HER MOTHER, ELIZABETH GREENMAN STILLMAN

In 1930 an exiled Russian count traveled around the eastern United States exhibiting a collection of old Russian costumes and textiles and selling to museums as much of the collection as he could. Through purchases, the Brooklyn Museum of Art came to share parts of an important collection of Russian textile arts that had been assembled in the 1880s and 1890s by a Russian noblewoman named Natalie de Shabelsky. Selections from this collection were considered of such importance during Mme de Shabelsky's lifetime that they were routinely included in World's Fairs—at Chicago in 1893, Brussels in 1894, and Paris in 1900. They also decorated the Saint Petersburg Palace of the Grand Duke Nicholas in 1890–91 and were featured as part of the coronation festivities when Nicholas was crowned tsar in 1896. This outfit from the Shabelsky collection is the festive attire of a moneyed peasant, not one who tilled the soil. It is characterized by an exotically shaped headdress *(kokoshnik)*, a shirt *(rubakha)*, and a long, loose-fitting tunic *(sarafan)*. Made of Russian-produced silk, the ensemble is embellished with freshwater pearls, paste, semiprecious stones, and an abundance of metallic embroidery and lace.

Shawl

◄ ↑ Possibly designed by Anthony Berrus
or Amédée Courder
France, circa 1855
Wool wrapped silk, 158 x 64¼ (395 x 161)
85.142, GIFT OF THE ROEBLING SOCIETY

When the punch-card system of the Jacquard loom was perfected in the early nineteenth century, one of the primary jobs to which it was applied was the weaving of paisley or cashmere shawls, some of which were made for exhibition. Such exhibition shawls frequently had little to do with common examples, which carried the "cone" or "buta" motif; rather, they depicted naturalistic botanical subjects or exotic motifs populated with animal and human forms. The composition and complexity of this shawl point to its having been conceived as an exhibition piece,

possibly (as the harlequin banded border would indicate) the 1855 Exposition Universelle in Paris. In weaving this chinoiserie fantasy, a three-by-one twill, approximately sixty wefts per centimeter, was used. The Jacquard loom would have been fitted with about 200,000 punch cards to direct the weave of the pattern, an image that covers over two-thirds of the shawl. The central subject is a lake over which hang varieties of exotic vegetation; it is populated by a diverse collection of equally fanciful beasts, fishes, and birds, some of which are drawn from Chinese mythology. Miniature people can be observed plucking fruit from trees, enjoying tea, hunting, or going about other daily activities. At either end of the shawl is a splendidly outfitted pleasure barge. All the motifs are set among intermingling architectural elements of both Chinese and Persian influence.

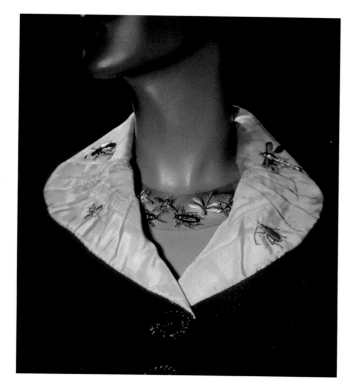

Woman's Opera Cape

◄ Designed by the House of Worth
France, 1890
Silk lampas, velvet, silk lace, glass beads,
and metallic thread
31.22.19, GIFT OF THE PRINCESS VIGGO

Masterful employment of lavish textiles was
characteristic in the work of Charles Frederick
Worth (1825–1895), the father of French
couture. The silk lampas used in this cape
made for the Americans Sarah and Eleanor
Hewitt is perhaps one of the most remarkable
fabrics ever used by the House of Worth.
Woven in 1889 by A. Gourd & Cie of
Lyon, the fabric was distributed in Paris by
Morel, Poeckes & Baumlin. Entitled "Tulipes
Hollandaises," it was included in the section of
Lyonnaise textiles at the Exposition Univer-
selle of 1889, garnering a Grand Prix for
Maison Gourd. With its thirty-one-inch spread
between tulip sprays, it displays Worth's skill
at employing large-scale woven fabrics that
might otherwise be considered suitable as
furnishing fabric.

Necklet

▮ Designed by Elsa Schiaparelli (French,
b. Italy, 1890–1973)
France, Autumn 1938
Perspex plastic and metal, 8¼ x 7½
(21 x 19.1)
55.26.247, GIFT OF PAUL AND ARTURO PERALTA-RAMOS

One of the most stylish American women of
her day was the Standard Oil heiress Millicent
Huttleston Rogers. She was dressed by some
of the twentieth century's most creative
designers. The Museum holds many items
from Rogers's wardrobe, including this rather
astonishing neckpiece, on which nineteen
embossed and polychromed insects chase one
another. Because the insects are applied to
clear plastic, from a distance they seem to
wander at will over flesh. Along with a
similarly decorated jacket of an afternoon suit
now owned by the Museum, the piece was
part of Schiaparelli's 1938 autumn-winter
collection, entitled "Païen," or "Pagan." That
collection, which was based on the theme of
a primordial forest, reflected Schiaparelli's

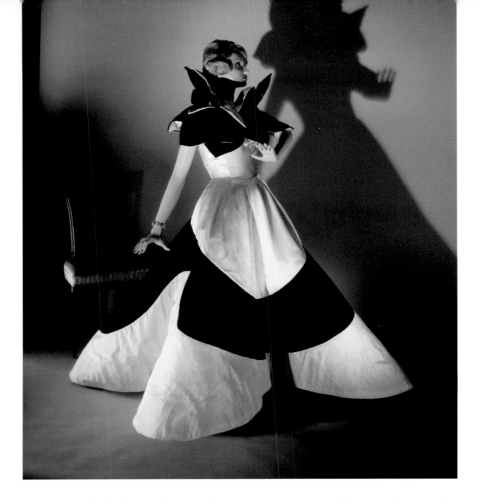

interaction with the day's leading Surrealists, Jean Cocteau and Salvador Dali.

Abstract or Four-Leaf-Clover Ball Gown and Petal Stole

▮ Designed by Charles James (American, 1906–1978)
United States, 1953 and 1956
Silk satin, velvet, faille

53.169.1, GIFT OF MRS. CORNELIUS VANDERBILT WHITNEY AND 64.254, GIFT OF MRS. WILLIAM RANDOLPH HEARST, JR.

For the Eisenhower Inaugural Ball of 1953, Austine Hearst, the wife of William Randolph Hearst, Jr., commissioned the Anglo-American fashion designer Charles James to create something for her to wear. Although the resulting garment was not, in typical Jamesian manner, completed in time for the function, it has since become one of the icons of mid-century couture and, by James's own evaluation, his pinnacle in dressmaking. Reworking a lobed hemline design of the 1930s and melding it with a quatrefoil millinery model of 1948, James fabricated a gown of four layers —an inner taffeta slip, a structured under-petticoat, a matching petticoat flare, and an overdress. The garment expresses James's fascination with geometry and mathematics: while the four lobes are not of equal dimension, they readily fit within a circle. His eye for line and texture is demonstrated by the application of the costliest silks: white duchess satin, black velours de Lyon, and ivory silk faille. The garment was constructed from thirty pattern pieces, twenty-eight of which were cut in duplicate, the remaining two singly. The stole, with its petal outline, is of black silk velvet and white satin. It was adapted from the hipline yoke of a ball gown that James had created in 1949.

Prints, Drawings, and Photographs

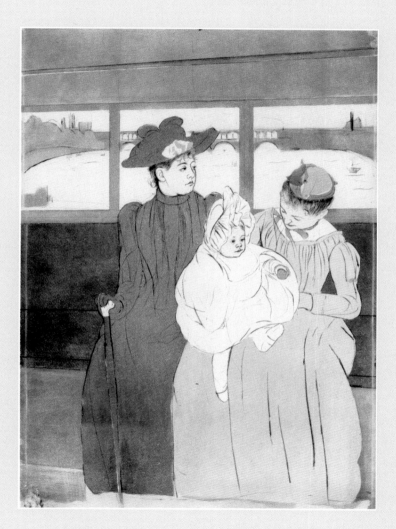

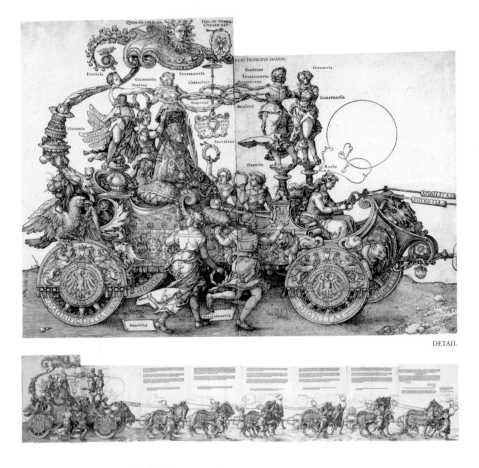

DETAIL

The Great Triumphal Chariot of the Emperor Maximilian I, 1522

Albrecht Dürer (German, 1471–1528)
Woodcut from eight blocks on eight sheets,
approximately 16 x 95 (40.5 x 241.3)
83.43, Gift of The Roebling Society

Albrecht Dürer completed his first drawing for *The Great Triumphal Chariot of the Emperor Maximilian I* (Albertina, Vienna) in 1512–13. It was originally intended to form the climax of a sixty-yard collaborative frieze in woodcut commissioned by Maximilian. As the leading artist of the humanistic court surrounding the emperor, Dürer was entrusted with the depiction of the emperor's chariot. A revised design became far more allegorical than the earlier drawing by the addition of a regalia of emblems and twenty-two women personifying the Virtues. With the death of Maximilian in 1519, realization of the project seemed unlikely and Dürer withdrew his drawing and published it himself as a woodcut in 1522. The Brooklyn Museum of Art's *Great Triumphal Chariot of the Emperor Maximilian I* is one of eight known impressions of the first of seven editions, the only edition printed by Dürer himself. It is a superb example of Dürer's "decorative style" (1512–22), which is characterized by elegant and ornate surface pattern. The Museum's set was formerly in the collection of Count York von Wartenburg of Klein-Oels in Silesia, whose Dürer collection was considered among the most eminent in prewar Germany.

The Round Tower, plate III
from Invenzioni Capric di Carceri,
circa 1749

Giovanni Battista Piranesi
(Italian, 1720–1778)
Etching, 21⅛ x 16¼ (54.61 x 41.27)

37.356.2, Frank L. Babbott Fund and the Carll H. de
Silver Fund

Piranesi, probably the greatest architectural
etcher of all time, was best known throughout
the eighteenth and early nineteenth centuries
for his scenic Roman views, which were
prized and collected by visitors to Italy. In
1749 a publisher named Bouchard released
a series of fourteen etchings by Piranesi that
were far more fantastical and imaginative
than his images of classical ruins. While
scholarly opinion varies on the meaning of the
Carceri, as this series is popularly called, a
current theory is that the images are related
to stage sets. Connoisseurs of prints have
considered these *capricci* Piranesi's greatest
achievement and one of the most important
series in eighteenth-century printmaking.
Bouchard released three issues of the first
states between 1749 and 1760, all of which
are considered first edition and are character-
ized by light biting of the plate and a linear
treatment of the image.

the first edition begin to show signs of wear. The quality of impressions in the Museum's set is unsurpassed.

Mary Cassatt at the Louvre: The Paintings Gallery, 1879–80

❚ Edgar Degas (French, 1834–1917)
Etching, aquatint, and drypoint, 12 x 5
(30.5 x 12.6)
36.955, MUSEUM COLLECTION FUND

The Paintings Gallery is based on a pastel that Degas made of his good friend, the American painter Mary Cassatt and her sister Lydia. The verticality of the print, as well as its oblique

El de la Rollona (Nanny's Boy), plate 4 from Los Caprichos, 1799

❙ Francisco Goya y Lucientes (Spanish, 1746–1828)
Etching and aquatint, 7¾ x 5¼ (19.3 x 13.7)
37.33.4, A. AUGUSTUS HEALY FUND, FRANK L. BABBOTT FUND, AND THE CARLL H. DE SILVER FUND

Goya's famous series of satirical etchings and aquatints, Los Caprichos, consists of eighty plates with text. "Since the artist is convinced that the censure of human errors and vices . . . may also be the object of painting," he wrote in 1799, "he has chosen as subjects adequate for his work [Los Caprichos], from the multitude of follies and blunders common in every civil society, as well as from the vulgar prejudices and lies authorized by custom, ignorance, or interest, those that he has thought most suitable for ridicule as well as for exercising the artificer's fancy." Of *El de la Rollona* Goya commented: "Negligence, tolerance, and spoiling make children capricious, naughty, vain, greedy, lazy, and insufferable. They grow up and yet remain childish. Thus is nanny's little boy." Considered the earliest proof set extant, the Museum's Los Caprichos is from the first and second states prior to the first edition. Because of the delicacy of aquatint, even later impressions of any given plate within

bird's-eye view and irregular cropping, reflects the broad influence of Japanese woodcuts, which were extremely popular in France at the time. The format also accentuates the slim elegance of Mary Cassatt in a languid pose, leaning on the tapered vertical line of her tightly furled umbrella. Degas often worked his plates through numerous states. He rarely editioned his prints, considering etching a private activity, and pulled only a few impressions of each state. Rather than selling his prints, he usually gave them to his friends, keeping a few impressions in his studio. The Brooklyn Museum of Art's impression of *The Paintings Gallery* is one of six known of the twentieth (and final) state found during the inventory of Degas's studio after his death.

In the Omnibus (The Tramway), 1891

► Mary Cassatt (American, 1845–1926)
Drypoint and soft-ground etching,
14⅜ x 10⅜ (36.5 x 26.5)
41.685, DICK S. RAMSAY FUND

At the invitation of her friend and mentor Edgar Degas, Cassatt exhibited her paintings and pastels with the Impressionists, thus becoming one of the few women and the only American to be prominently connected with the Impressionist movement. With Degas, she visited the great Japanese exhibition of 1890 at the École des Beaux-Arts, where she was profoundly influenced by the color woodcuts of Utamaro and Toyokuni. In 1891 she began a series of ten color prints in which she combined her longtime study of Old Masters with her newfound enthusiasm for the simplified areas of flat, bold color and asymmetrical compositions of Japanese woodblock prints. Since she was not conversant with woodblock technique, Cassatt devised a method of intaglio printing that approximated the layers of transparent colors of Japanese prints and, in the process, created some of the most striking and beautiful color prints of Western tradition.

Le Jockey, 1899

►► Henri de Toulouse-Lautrec (French, 1864–1901)
Lithograph, 20¼ x 14⅛ (51.5 x 36)
37.20, BROOKLYN MUSEUM OF ART COLLECTION

More than any other graphic artist of the period, Henri de Toulouse-Lautrec was responsible for the great popular revival of lithography in France in the 1890s. He was a superb draftsman with a particular interest in capturing scenes of popular entertainment and the demimonde of Paris. *Le Jockey*, sometimes known as *Le Gallop d'Essai*, is one of Lautrec's last lithographs. In the final productive year of his life, he concentrated on animals, particularly horses, one of his childhood passions. *Le Jockey* was intended to be part of a series on the races proposed by Pierrefort, a young Parisian print publisher, but was the only image realized. One hundred impressions of the keystone were printed in black and white, and another one hundred executed in color. Lautrec's vantage point and his cropping of the horse on the left are of special interest. The horse is viewed from the rear, with a

37.20

foreshortened body, and its head appears particularly elegant and graceful. The Brooklyn Museum of Art has both the black-and-white and the color versions of *Le Jockey* in its permanent collection.

Woman with Black Hat, 1910

► Ernst Ludwig Kirchner (German, 1880–1938)
Lithograph, 23½ x 17 (59.7 x 43.2)
57.194.1, CARLL H. DE SILVER FUND

Ernst Ludwig Kirchner was a founding member of Die Brücke (The Bridge), a group of German artists that was active in Dresden from 1905 until 1913. Die Brücke was the first distinctly German Expressionist movement in twentieth-century art. All members of the group were deeply involved in printmaking, and Kirchner, like other Die Brücke artists, preferred to print his own work, often in only a few impressions. His graphic output consisted of almost 1,000 woodcuts, more than 650 etchings and drypoints, and more than 450 lithographs. *Woman with Black Hat*, which is printed in black on slightly greenish yellow paper, is one of Kirchner's most impressive early portraits. The massed areas of black in the hat and hair create visual weight at the top of the composition and are juxtaposed with the mainly negative space at the lower half. The expressiveness of the thick, somewhat jagged lines describing the neck and shoulders imparts energy to the lower half, creating significant tension within the composition.

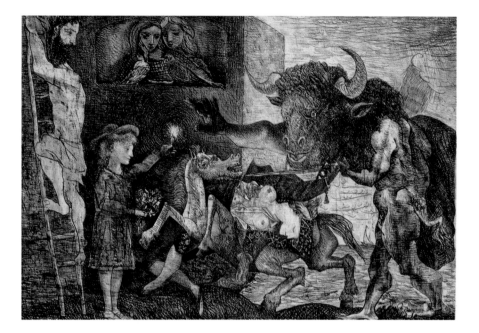

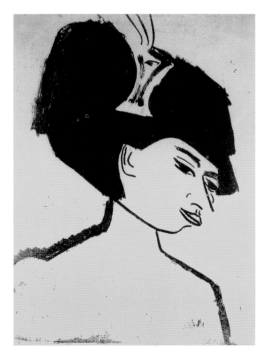

The Minotauromachia, 1935

↑ Pablo Picasso (Spanish, 1881–1973)
Etching, scraper and burring, 19½ x 27¼
(49.8 x 69.3)

59.30, FRANK L. BABBOTT FUND, FREDERICK LOESER ART FUND, AND THE MUSEUM COLLECTION FUND

Picasso created *The Minotauromachia*, arguably his most important single etching, when not only the European political situation, but his personal life as well were in a state of upheaval. At the time that he was working on this image, Picasso was contemplating a break from his mistress Marie-Thérèse Walter, one of the inspirations for his Classical Period, who was then pregnant. She is depicted five times: as the two spectators in the tower, as the innocent young girl leading the Minotaur, as the wounded mare, and as the *torera* holding the sword of her own destruction. Half man, half beast, Picasso's Minotaur was a symbol not only of man's unconscious and of sexual passion, but also of the artist's vision, because he could see in the darkness of his labyrinth but was blinded by the natural light of the

human world. While an edition of fifty was proposed, only fifteen were numbered, although fifty-five impressions have been located. The Museum's impression of *The Minotauromachia* is a particularly beautiful impression proof dedicated in Picasso's hand to the American artist Man Ray.

Folgen (Obey/Follow), plate 4 from Café Deutschland Gut, 1983

▌Jorg Immendorf (German, b.1945)
Linoleum cut with overpainting, 62¼ x 79 (159 x 218)
84.241, DESIGNATED PURCHASE FUND

Of the new generation of German Expressionists, Jorg Immendorf incorporates universally recognizable symbols of Germany with portraiture of some of the shapers of radical twentieth-century thought. In his series of paintings Café Deutschland, Immendorf depicted a revolutionary café that represents postwar-preunification Germany. The print series Café Deutschland Gut is based on one of the paintings in the series, *Adlerhälfte (Half-Eagle)*. The print is divided vertically by a central pole that symbolizes the division between East and West Germany. The rest of the composition revolves circularly around this bisecting device. The presence of the German eagle in the lower left, the Brandenburg Gate in the center, the busts of Stalin and Marx in the upper right, and George Washington, who peers out from behind in the lower right, represent recognizable symbols of a divided world. Café Deutschland consists of ten linoleum cuts, each printed in editions of ten. The Museum's *Folgen* is one of the landmarks of renewed German activity in block printing.

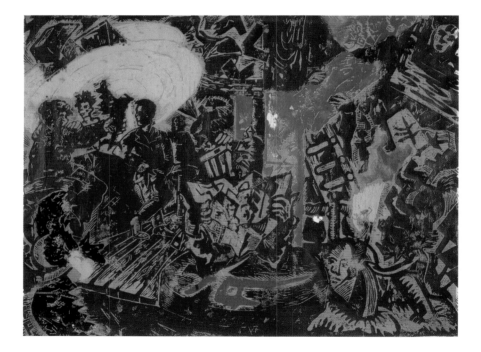

The First Riding Lesson (La Première Leçon d'équitation), circa 1778

► Jean Honoré Fragonard (French, 1732–1806)
Graphite and brown wash, 13⅛ x 17¼ (34.8 x 45.2)
57.189, GIFT OF MR. AND MRS. ALASTAIR B. MARTIN

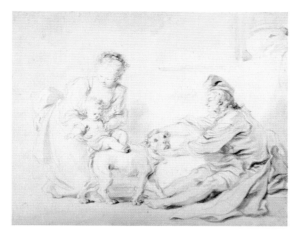

Fragonard is considered one of the best and most versatile draftsmen of the eighteenth century. His drawings are particularly appealing to the modern sensibility because they are neither overly intellectual nor academic. Although he was François Boucher's student, his vibrant, natural figures are distinctly different from the elegant, formal studies of his teacher. He worked from memory or direct observation in a loose, fluid style. Originally thought to have been a depiction of the artist's family caught at a relaxed and intimate moment, the drawing has recently been dated to circa 1778, before Fragonard's son, Alexandre-Évariste, was born. Therefore, rather than being a rendition of Fragonard's family as previously believed, this is probably an imaginary scene intended as a statement about human nature and family relationships.

Portrait of Mme Monnerot, 1839

❚ Théodore Chassériau (French, 1819–1856)
Graphite, 10¼ x 8¼ (26 x 21)
Inscribed, signed, and dated center right: "à mon ami/Jules/TH. Chassériau/1839"
58.163, GIFT OF JOHN S. NEWBERRY

Théodore Chassériau was a student of Ingres's who broke away from his Neoclassical master to favor the Romantic mode of Delacroix. Théodore Chassériau's style of finely modeled heads and looser, more relaxed lines forming the rest of the figure lies between Ingres's cold, delicate lines and Delacroix's more intense, looser style. Among Chassériau's most admired works are those from his large legacy of pencil portraits. Considered an early mature work, *Portrait of Mme Monnerot* dates to 1839. While this rendition of Mme Monnerot has a certain naiveté of style, the charm and directness of this rather severe but kindly woman as she stares full face at the artist reflect the hand of a young artist with promising talent. The Monnerot family became acquainted with the Chassériaus in the 1830s. Jules Monnerot was a close friend

of Théodore Chassériau, while Clemence Monnerot was an intimate of Théodore's two sisters. From 1837 to 1840 Théodore Chassériau spent every evening at the Monnerot house. The Brooklyn Museum of Art's drawing *Portrait of Mme Monnerot*, done during this period, was a gift from the artist to the sitter's son, Jules.

Forest Interior, 1865

❙ William Trost Richards (American, 1833–1905)
Charcoal and chalk, 23⁵⁄₁₆ x 29½
(59.2 x 74.9)
72.32.3, Gift of Edith Balllinger Price

Born in 1833, William Trost Richards was a self-taught artist whose early training as a designer of explicitly detailed lighting fixtures and his later trip to study the linear art of Germany's Düsseldorf artists is evident in this meticulously rendered forest scene. *Forest Interior* was done at the end of the first part of Richards's career and represents his affinity with John Ruskin's dictum to observe and record the intricacies of nature as created by

a higher being. Additionally, the drawing is a splendid manifestation of the mid-nineteenth-century American landscape tradition as originated by Thomas Cole and Asher B. Durand, two artists whose work Richards regarded highly. William Trost Richards is well represented in the Museum's collection with more than fifty-three drawings, twenty-seven sketchbooks, and seventeen paintings.

Illustration for "Mr. Neelus Peeler's Conditions," 1879

► Thomas Eakins (American, 1844–1916)
Ink and Chinese white, 10½ x 12¼
(26.5 x 31.2)
30.1452, Brooklyn Museum of Art Collection

Eakins is known for his insistence not only on realism of the human body, but on a psychological realism as well. His ability to capture the essence of his sitters' emotional being remains legendary in the history of American painting. Neelus Peeler sits opposite the table from his wife as he tells her that he has decided to enter the clergy, yet his motives for doing so are questionable. "Thar's such a thing as CALLS

in this world," he remarks to her. The table that separates them depicts a psychological as well as physical distance between husband and wife. Note the contrast between Mr. Peeler's slouched and somewhat sloppy attitude and that of Mrs. Peeler, who is depicted as a stable pyramidal figure, diligently attending to the task at hand. Brooklyn's drawing, made for *Scribner's Monthly* in 1879, is among the few original designs that Eakins did for inclusion in the journal. (Most of his contributions were conceived originally as paintings.)

L'Amour en Plâtre, 1890–95

◄ Paul Cézanne (French, 1839–1906)
Graphite, 19¼ x 12¾ (48.9 x 32.4)
39.623, FRANK L. BABBOTT FUND

This drawing from Cézanne's late period is after a plaster of a Baroque statuette traditionally attributed to Pierre Puget but now thought to be by François Duquesnoy. The plaster is still preserved in Cézanne's studio on the hill of Les Lauves in Aix-en-Provence. He made about eleven pencil drawings, four watercolors, and four oil paintings of the statuette in the 1890s, studying it from many different angles. The Brooklyn Museum of Art's is one of the most beautiful and finished studies of the sculpture, and it appears to be the one used for a painting in the National Museum in Stockholm. The angle and position of the sculpture are the same in both works, and even the shadows correspond. Paul Cézanne's late work has come to be recognized as the source of his most

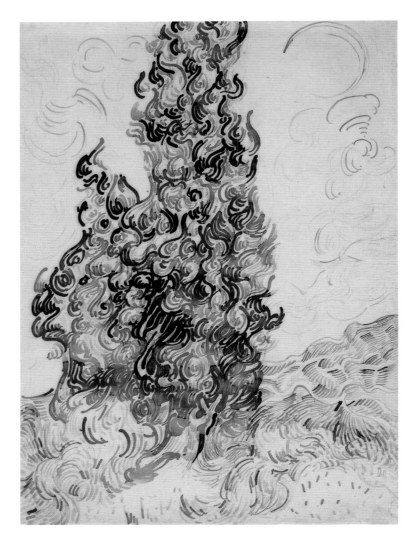

innovative and significant contributions to twentieth-century art. The Symbolists, the Fauves, and the Cubists all based their modern styles on the late art of Cézanne.

Cypresses, 1889

⬩ Vincent van Gogh (Dutch, 1853–1890)
Reed pen, graphite, quill, and brown and black ink, 24½ x 18 (62.3 x 46.8)

38.123, FRANK L. BABBOTT FUND AND THE A. AUGUSTUS HEALY FUND

This drawing was made after a painting of the same subject (The Metropolitan Museum of Art, New York). In a letter to his brother Theo, van Gogh expressed his intense feelings about these trees: "The cypresses are always occupying my thoughts; I should like to make something of them like the canvases of the sunflowers, because it astonishes me that they have not been done as I see them. It is as beautiful in lines and proportions as an Egyptian obelisk, and the green is of so distinguished a quality. It is a splash of *black* in a sunny landscape, but it is one of the most interesting black notes, and the most difficult to hit off exactly that I can imagine." The monumentality and free style of the drawing place it among the artist's finest works on paper.

Nude Standing in Profile, 1906

► Pablo Picasso (Spanish, 1881–1973)
Charcoal, 21⅛ x 14¼ (53.6 x 36.2)
43.178, GIFT OF ARTHUR WIESENBERGER

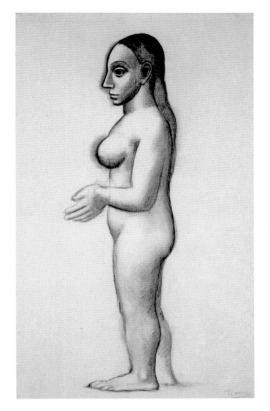

The geometric simplicity of Picasso's *Nude Standing in Profile* documents the artist's path to Cubism, manifesting a radical change from the *saltimbanques* of Picasso's Rose Period that immediately preceded it. Picasso had been impressed by the monumentality of the figures that he saw in Cézanne's *Bathers* at the October 1905 Salon d'Automne and also by the recently excavated Iberian sculpture that he saw at the Louvre in spring 1906. The sculptural form and stylized features of the figure in this drawing, made in the autumn of 1906, show how quickly he absorbed and reconstituted sources. *Nude Standing in Profile* is a study for the painting *Two Nudes* (The Museum of Modern Art, New York), which immediately preceded Picasso's 1907 masterpiece *Les Demoiselles d'Avignon*. Indeed, the standing nude on the far left of *Les Demoiselles d'Avignon* is closely related to this drawing. Apart from its value as a study, this drawing is a powerful rendition of a female in profile—an image to which Picasso returned in almost every phase of his long career.

Bildnis Einer Schwangeren Frau (Portrait of a Pregnant Woman), 1907

► Paul Klee (Swiss, 1879–1940)
Pastel, watercolor wash, and brown ink, 9⅝ x 13⁷⁄₁₆ (24.5 x 34.2)
Signed and dated lower right: "Paul Klee 1907"
38.110, MUSEUM COLLECTION FUND

Early in his career Paul Klee made satiric and poetic etchings in an expressive and decorative Art Nouveau style. About 1905 in Munich he became interested in folk art, especially Bavarian glass painting. This drawing, one of the earliest works by Klee in an American collection, is a preliminary sketch for a painting of the same subject. A sensitive and charming study of the artist's wife, Lily, it was executed shortly before their son Felix was born. *Bildnis Einer Schwangeren Frau* represents a transition from Art Nouveau to a greater naturalism based on Impressionist sources. Color was just entering Klee's work, and he wrote in his diary: "Tonality is beginning to mean something to me, in contrast to the past when I seemed to have almost no use for it." In addition to its delicate color, this work's warmth, wit, and evocative use of line all became trademarks of Klee's mature style.

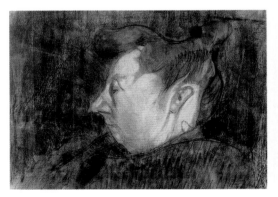

Composition with Four Figures, 1910

❚ Max Weber (American, 1881–1961)
Charcoal, 24½ x 18 (62.2 x 46)
Signed and dated lower right:
"Max Weber 1910"
57.17, DICK S. RAMSAY FUND

In 1891 Max Weber came with his family to the United States from Russia. Several years after graduating from Brooklyn's Pratt Institute in 1905, he went to Paris, where he continued his artistic education. Weber returned to New York in 1908 and associated himself with Alfred Stieglitz's Little Galleries of the Photo-Secession, which was a gathering place for the American avant-garde. *Composition with Four Figures* (actually three) was produced in this period. Having absorbed the Fauvist color and simplified abstract figures of Matisse, whom he had befriended in Paris, Weber was already moving toward Cubism. The masklike features, mechanical distortions, flattened space, and angular geometric masses of the three female nudes in this drawing relate to his love of African, Mayan, and Aztec sculpture as well as the Cubist art of Picasso, with which Weber was definitely acquainted.

Study for "They Will Take My Island," 1944

► Arshile Gorky (American, 1904–1948)
Crayon, 22 x 30 (56 x 76.2)
Signed and dated in graphite, lower right:
"Arshile Gorky 1944"
57.16, DICK S. RAMSAY FUND

Arshile Gorky was born in 1904 in Armenia and arrived in America in 1920 and began to study art. By 1930 he was an accomplished painter, having studied, absorbed, and copied the masters of modern art from Impressionism through Cézanne to Cubism and finally Surrealism. The drawing *They Will Take My Island* was made in the summer of 1944 at a farm owned by Gorky's wife's parents in Virginia. The drawings of this period reflect the flowers and fields as well as the bright colors of nature seen through a Surrealist imagination. As with a number of other highly finished drawings of this period, it became the basis for a closely related painting of the following winter that addressed issues of war, political upheaval, and the loss of homeland. This drawing, a major work of Gorky's final years, exemplifies how the logic of Cubism, the irrationality of Surrealism, and his own

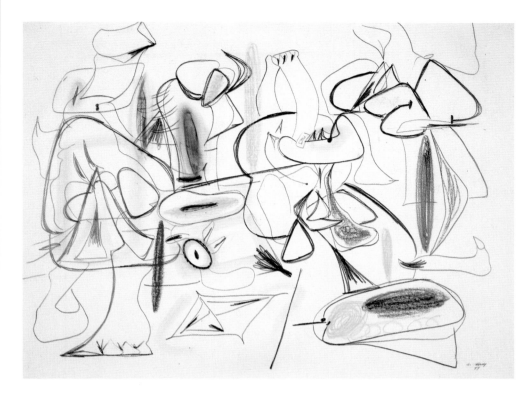

expressive passion were consolidated to form a personal and influential style that anticipated the formation of Abstract Expressionism.

Tête de Jeune Homme, 1923

◄ Pablo Picasso (Spanish, 1881–1973)
Grease crayon, 24½ x 18⅝ (62.1 x 47.4)
39.18, CARLL H. DE SILVER FUND

Although Picasso looked to his Mediterranean heritage for inspiration throughout his career, the years 1918–24 are specifically referred to as his Classical Period. Picasso's break from Cubism was caused by a number of factors, including the xenophobic French mood during World War I, which fostered a preference for traditional French art; Picasso's marriage to Olga Kaklova, a traditional ballerina who tried to lead him from bohemian tendencies to a more refined lifestyle; his friendship with Jean Cocteau, who was advocating a return to classical tradition; and an Italian sojourn in 1917, where he saw Roman marbles and Pompeian paintings. The soft, heavy strokes and serene introspective look of *Tête de Jeune Homme* are found in other works of the same year. The great beauty of this drawing captures the essence of the ideal classical youth in simple forms and solidly modeled contours. Its extraordinary quality is enhanced by the soft pink paper on which it was created.

Coney Island Beach:
A Double-Sided Drawing
(Recto: *The Artist Sketching,*
Verso: *Acrobats*), circa 1951

↓ ► Reginald Marsh (American,
1898–1954)
Chinese ink wash, 22½ x 30⅞ (57.2 x 78.6)
Stamped in red, lower right verso:
"R. Marsh Collection"; in graphite, lower
right: "Ch 2294"

79.99.1, GIFT OF THE ESTATE OF FELICIA MEYER MARSH

Born in 1898, Reginald Marsh went to New
York City after his graduation from Yale in
1920 to work as an illustrator. Sometime
during the 1920s, *Vanity Fair* assigned him to
make sketches of Coney Island. So taken was
he with the scene at the beach and amusement
park that Marsh returned three or four times a
week every summer to sketch and photograph
the mass of humanity that populated the sea-
shore. Indeed, in a 1944 article Marsh said,
"I go to Coney Island because of the sea, the
open air and the crowds—crowds of people
in all directions, in all positions, without
clothing, moving—like the great compositions
of Michelangelo and Rubens." The Museum's
double-sided drawing is a superb example
of Marsh's ability to re-create the view of
the masses as they spend leisure time at
Coney Island.

TOP : RECTO; ABOVE : DETAIL OF VERSO

Climbing into the Promised Land, Ellis Island, 1908

► Lewis Wick Hine (American, 1874–1940)
Gelatin silver print, 14 x 10½ (33 x 26.8)
84.237.1, Gift of Mr. and Mrs. Walter Rosenblum

Lewis Wick Hine began his career in 1905 as a social photographer while experimenting with a camera at Ellis Island. In this extraordinary photograph of immigrants being shoved while going through the process of becoming American citizens, Hine managed to juggle a huge and awkward camera while manipulating a crude device loaded with flash powder in order to compose a gripping picture of hope, confusion, and excitement. Probably one of his best-known images, it prefaced a career of formidable accomplishment until the late 1930s. When he died in 1940, his pioneering achievements were all but forgotten until his first major retrospective nearly forty years later. He left behind a legacy of several thousand images of dazzling quality and social import.

Francis with a Flower, circa 1930

◄ Consuelo Kanaga (American, 1894–1978)
Gelatin silver print, 10¼ x 8⅞ (26 x 22.2)
82.65.10, Gift of Wallace B. Putnam from the estate of Consuelo Kanaga

Consuelo Kanaga, one of the pioneers of American photography, began as a photojournalist in 1915 in San Francisco. A trip to Europe in 1928 awakened her lifelong preoccupation with European modernist painters and the degree to which they were influenced by the sculpture of Africa. In *Francis with a Flower,* which appeared in an exhibition in 1932 in San Francisco, the focus is so sharp that the slightly rough texture of the skin, shiny

with perspiration at the hairline, seems palpable. The forehead, nose, and cheeks, highlighted by flash and dodged in the developing, contrast with the deep-set eyes lost in shadow, thus producing a sculptural dimension that turns the photograph into hills and valleys of light. The stark, white blossom pressed to the woman's nose serves only to emphasize the sensuality of her face.

Untitled, circa 1930–31

❚ Margaret Bourke-White (American, 1903–1971)
Gelatin silver print, 9⅜ x 13¼ (23.7 x 33.7)
79.299.1, GIFT OF SAMUEL GOLDBERG IN MEMORY OF HIS PARENTS, SOPHIE AND JACOB, AND HIS BROTHER HYMAN GOLDBERG

Margaret Bourke-White was for much of her career the quintessential photojournalist. A major contributor to *Life* magazine starting with her photograph in its inaugural edition, Bourke-White was the first of dozens of female photojournalists who appeared and then disappeared during the golden age of news magazines. Her strong sense of precision and design was formed when she began her work as an industrial photographer glamorizing the steel industry and urban architecture. She never

lost her precisionist technique, as is seen in this beautifully lit and perfectly composed photograph of infants at mealtime in a Russian orphanage. The play of light on the identically shaved heads of the sexually indeterminate three-year-olds solemnly sharing milk and bread at a child-sized table with a spotless white tablecloth leaves the viewer curiously disturbed. Bourke-White conveys her social message within a lovely yet artfully arranged image.

Mulberry and Prince Streets, Manhattan, 1935

► Berenice Abbott (American, 1898–1992)
Gelatin silver print, 7 x 9⅜ (17.8 x 23.8)
X858.3, BROOKLYN MUSEUM OF ART COLLECTION

As a young artist, in 1918, Berenice Abbott left New York and moved to Paris to pursue her studies in sculpture, never dreaming that she would become a photographer. She learned photography as an assistant to the Surrealist Man Ray. By 1925 she had become a professional portrait photographer of such literary and artistic figures as Marcel Duchamp, André Gide, and James Joyce. No matter what her subject, her photographs never lost the precise,

natural, carefully lit quality of her early portraits. Just as Atget documented the streets, storefronts, and country lanes of Paris and its environs, so Abbott photographed New York City, beginning in 1929 in a project for the Works Progress Administration. The picture *Mulberry and Prince Streets, Manhattan* is one of the few that Abbott photographed with people in it.

Untitled (Eleanor), circa 1941

► Harry Callahan (American, b.1912)
Vintage gelatin silver print on Kodak paper, 4½ x 3½ (11.4 x 8.9)
1995.76.2, PURCHASED WITH FUNDS GIVEN BY THE HORACE W. GOLDSMITH FOUNDATION, ARDIAN GILL, THE COLER FOUNDATION, HARRY KAHN, AND MRS. CARL L. SELDEN

Harry Callahan has been taking photographs since 1938. Without formal training, he has become one of the most influential photographers through his investigation of light, shadow, texture, multiple exposure, and portraiture (mostly confined to his wife, Eleanor, and his daughter, Barbara). This early portrait of his wife combines his exploration of light with abstract form. The flatness of this image and the importance of shadow emphasize his debt

to Abstract Expressionism. Callahan is a bridge between formal representation and abstraction in photography. Throughout his career he has hoped to create a body of work that is a "continuous piece of a life." His work constitutes a significant portion of the Brooklyn Museum of Art's collection.

Sheik Ali Gournah, Egypt, 1959

▲ Paul Strand (American, 1890–1976)
Gelatin silver print, 13⅜ x 10⅝ (34 x 27)
85.193.2, Gift of Naomi and Walter Rosenblum

Paul Strand was a pupil of Lewis Hine's, who encouraged Strand to turn his hobby into his life's work. After a visit to Alfred Stieglitz's Gallery 291 in New York, Strand confirmed his dedication to precisionism and the modernist aesthetic. Although Strand's photographs of urban sites and machinery were the focus of his early interests, he eventually turned to nature and portraiture as subjects in his search for purity of vision in the last years of his career. His portraits are expressions of simple, straight-forward imagery, which he gradually turned into a quest for ideal beauty as expressed through the inherent dignity of his subjects. In his portrait *Sheik Ali Gournah*, Strand sought a precise vision of character through contrast, texture, and light. This technique best expresses what Strand termed "an aesthetic based on the objective nature of reality."

European Painting
and Sculpture

Madonna and Child Enthroned with Saints Zenobius, John the Baptist, Reparata, and John the Evangelist, circa 1360

▲ Nardo di Cione (Italian, Florentine, active 1343–65/66)
Gold ground and tempera on panel, 77½ x 39½ (196.9 x 100.3)

1995.2, Healy Purchase Fund B, Gift of Mrs. S. S. Auchincloss, James A. H. Bell, Mrs. Tunis G. Bergen, Mrs. Arthur Blake, Leonard Block, Mary A. Brackett, Mrs. Charles Bull in memory of Noel Joseph Becar, Sidney Curtis, Mrs. Watson B. Dickerman, Forrest Dryden, Estate of George M. Dunaif, Marion Gans, Francis Gottsberger in memory of his wife, Eliza, Bequest of Anne Halstead, Mrs. William H. Haupt, A. Augustus Healy, William H. Herriman, Mrs. Alexander Howe, Julian Clarence Levi, The Martin Estate, Estate of Emilie Henriette Mayr through Oscar J. Heig in memory of her brother and sister-in-law, Mr. and Mrs. Mayr, Mrs. Richard Norsam Meade in memory of Miss Margery Moyca Newell, Mr. Bernard Palitz, Richman Proskauer, Charles A. Schieren, Estate of Isabel Shults, Mr. and Mrs. Daniel H. Silberberg, Austin Wolf, Mrs. Hamilton Wolf, and Mrs. Henry Wolf, by exchange

In the years surrounding the Black Death in Florence and Siena (1348), which took the lives of two-thirds of the population, artists reacted against the humanistic inroads pioneered by Giotto earlier in the century. A more hierarchical, gothicizing style came to the fore among painters after the Black Death; this altarpiece is a good example. In the panel, Nardo combines the weightiness of Giotto's figures with the delicate gold tooling identified with the *trecento*. While depicted within the strict conventions of its period, the figures nonetheless display a sensitivity of expression and a three-dimensional tactility rare at this time. The size of the panel, and the fact that the saints are gathered alongside the Madonna and Child in a single-panel altarpiece, indicates that it might originally have been intended to decorate a pier of the Duomo in Florence. This picture was given to The New-York Historical Society in 1867 by Thomas Jefferson Bryan, whose collection introduced Italian religious painting to America. The Brooklyn Museum of Art purchased the altarpiece at the sale of works from that collection in 1995.

Saint James Major, 1472

► Carlo Crivelli (Italian, School of Venice and the Marches, active 1457–94/95)
Gold ground and tempera on panel,
38¼ x 12⅝ (97.1 x 32.1)
78.151.10, BEQUEST OF HELEN BABBOTT SANDERS

Saint James Major was one of Christ's apostles and became the patron saint of pilgrims, devoted and adventurous Christians who made their way across hundreds of miles to the Holy Land or to the chief pilgrimage churches. This connection arose from the belief that as an apostle he traveled across the Mediterranean as far as Spain to found the famous pilgrimage church at Santiago de Compostela. The cockleshell symbolizing this voyage is the saint's usual attribute, together with the pilgrim staff. Although Crivelli painted toward the end of the fifteenth century, his linear style aligns his work with earlier tendencies. In this panel, he treats the figure of Saint James sculpturally and endows it with great intensity through the clearly drawn details in the saint's face and fine spiraling curls of hair, as well as in the long and knobby fingers.

The Adoration of the Magi, circa 1480

❡ Bernardo Butinone (Italian, Milanese, circa 1450–circa 1507)
Tempera on panel, 9¾ x 8½ (24.8 x 21.6)
78.151.6, Bequest of Helen Babbott Sanders

This little painting is one of a series of panels of roughly the same size by Butinone that represent scenes from the life of Christ. The scene is one of the most significant of the Christian stories centering around the Nativity: the moment at which the most learned and powerful men of the ancient Near Eastern world, symbolized by a black King, a young King, and an old King, come to pay homage to a newborn infant. This paradox is often emphasized, as it is here, by the act of the oldest King taking off his crown (which he would do for no one else) and, in all the dignity of his bearded age, kneeling humbly before a little child. Butinone has presented this theme with the combination of seriousness and charm that is one of the great attractions of *quattrocento* painting. Particularly delightful are the brilliance of color, the costume details, and the presence of the Virgin's little cat, sitting comfortably beneath her stool.

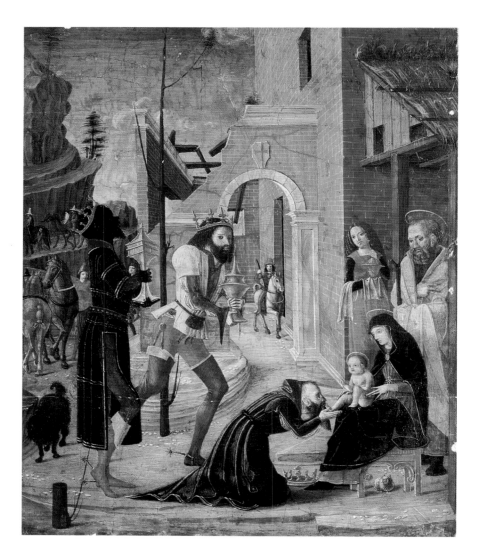

Portrait of Jan Carondelet,
circa 1528–30

Jan Cornelisz. Vermeyen (Netherlandish, 1500–1559)
Oil on panel, 30¾ x 24½ (78.1 x 62.2)
47.76, GIFT OF HORACE O. HAVEMEYER

Jan Carondelet, a noted cleric and statesman, served, among other posts, as Archbishop of Palermo, Primate of Sicily, and Chancellor of Flanders. He was also provost of the Church of Saint Donation in Bruges, where he was buried. It has recently been suggested that the portrait originally hung in the choir of that church. The type of portrait exemplified here is characteristic for the period: a dark-clothed figure silhouetted against a medium-tone ground, with an evenly lit face and naturalistically detailed costume treatment. Working within this convention, Vermeyen has given us a painting of great penetration and finesse. The

texture of the sitter's hair and his fur collar are masterfully portrayed, as are the gray gloves he grasps so firmly in one hand. The open gesture of his other hand is a counterpoint to the massiveness of the figure and to the strength of the face with its steady, comprehending gaze.

Young Woman Overtaken by a Storm, 1799

Féréol de Bonnemaison (French, circa 1770–1827)
Oil on canvas, 39⅜ x 31⅝ (100 x 80.3)
71.138.1, GIFT OF LOUIS B. THOMAS

Critics at the Paris Salon of 1799 were as intrigued by this image as are today's museum visitors, though they were primarily interested in the ways in which the young woman's gauzy garment revealed her "ravishing form" and did not raise the practical question of what

71.138.1

such a creature was doing out in the country-side at night. They knew that there was no intended or implied narrative content in such an image beyond the presentation of a young female figure in a state of distress and undress. The painting juxtaposes the different styles and cultural ideas that were both in conflict and in the process of synthesis at the time. The figure is pure turn-of-the-century Neoclassical, a rounded and porcelained version of the Greek ideal, with the "wet" draperies derived from Classical reliefs beautifully rendered as they both cling to the figure and create patterns flying in the wind. Her setting, on the other hand, is filled with the Romantic attributes of a stormy night, a broken tree stump, and the threat of danger.

Taddeo Bravo de Rivero, 1806

► Francisco Goya y Lucientes (Spanish, 1746–1828)
Oil on canvas, 82 x 49 (208.3 x 124.5)
34.490, Gift of the Executors of the Estate of Colonel Michael Friedsam

Goya painted portraits throughout his career, and in the early years of the nineteenth century he portrayed a number of military officers. Taddeo Bravo de Rivero was a native of the Spanish dominion of Lima who later moved to Madrid, where he served as an officer of the army and as a municipal deputy. In these official portraits Goya employed traditional portraiture conventions to emphasize the stature of his sitters through details such as scale and attributes worn or held. Depicted against a darkened sky, Taddeo Bravo towers over the surrounding landscape, and his jacket glitters with gold and silver detailing and military decorations, including the important insignia of the knights of the Order of Santiago. Taddeo Bravo's canine companion represents the virtue of fidelity, while also referring to the hounds traditionally represented in portraits of the royal family. *Taddeo Bravo* was heralded as one of Goya's greatest military portraits from this group, and he lavished extra attention on it. He inscribed the portrait at the lower left "a su amigo" (to his friend).

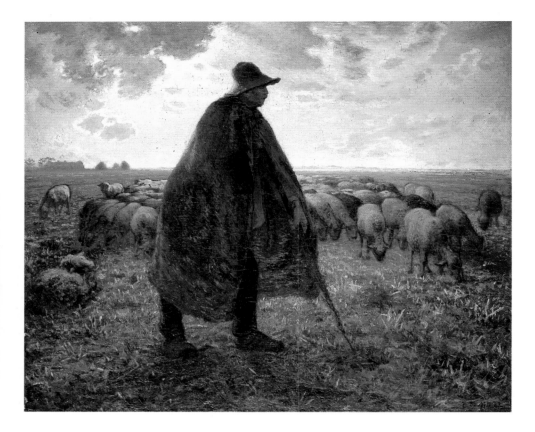

A Shepherd Tending His Flock, mid-1860s

⏐ Jean-François Millet (French, 1814–1875)
Oil on canvas, 32 x 39½ (81.3 x 100)
21.31, BEQUEST OF WILLIAM H. HERRIMAN

This emblematic painting of a peasant at work in rural France is one of a group that Millet made during the years after 1848, when he settled in Barbizon, the village at the edge of the Forest of Fontainebleau that gave its name to the group of artists who began to work in the region about 1830. Among these paintings are such well-known images as *The Sower, The Angelus,* and *The Man with a Hoe.* They have in common a composition that features large single figures silhouetted against the sky or an empty field, engaged in the act of labor or rest from labor. In this painting the shepherd figure is both active, in that he is watching over his sheep as they graze on the recently cut stalks of hay, and passive, as he leans forward to rest his weight upon his staff. The resulting massive pyramidal shape emphasizes the heroic nature of his enduring task. Millet made these paintings as a representation of his ideas and feelings about the life of the rural peasantry in France, a class that was still very much present but which in Millet's time was rapidly disappearing in its ancient form. Hitherto caricatured, prettified, or ignored in pictorial art, peasant figures assume a new dignity in Millet's work. Buyers, often American, were attracted to them and brought a welcome degree of success to the artist; ironically, the extent of idealization in the figures permitted many of them to read a specifically Christian message into the imagery, which Millet, a nonbeliever, had never intended.

The Edge of the Pool, circa 1867

▮ Gustave Courbet (French, 1819–1877)
Oil on canvas, 31½ x 34¾ (80 x 88.3)

1992.17, Gift of Mrs. Horace Havemeyer and Mrs.
Frederic B. Pratt, by exchange

The setting of this cool and somewhat mysterious summer landscape is recognizably that of Courbet's native region of the Doubs in Franche-Comté in eastern France, an area characterized by rough, steep rock formations, tall, leafy oak trees, and numerous streams and pools. A pastoral element is provided by the two small figures: a woman on the bank and a man in a boat, whether mooring or pushing off we do not know. These figures represent not an explicit genre scene, but rather the inclusion of a somewhat enigmatic pair as a secondary motif within the major theme of landscape. In the mid-nineteenth century, the painting of landscape was a statement of artistic independence, an assertion of personal experience and choice against the established hierarchies of the Academy, which granted little status to landscape. Courbet began quite early to paint landscape in a powerfully personal way. He established the use of the palette knife as an alternative to the brush, inventing as he does in this painting a remarkable range of strokes and touches with which to construct form, especially that of the vegetation. This emphasis on an active, expressive paint surface enabled him to distinguish the quality of his own Realist vision from the smooth, literalist surfaces of the academic realists of his time.

Mlle Fiocre in the Ballet "La Source," circa 1867–68

❙ Edgar Degas (French, 1834–1917)
Oil on canvas, 51½ x 57⅛ (130.8 x 145.1)
21.111, Gift of James H. Post, John T. Underwood, and A. Augustus Healy

This painting depicts the renowned Parisian ballerina and demimondaine Eugénie Fiocre as the star of the ballet *La Source*. The elaborate ballet was such a success that an excerpt was chosen for performance at the inaugural celebration of Garnier's opera house in January 1875. The picture is at once a summation of Degas's work of the 1860s, which he had devoted to history painting, and a foreshadowing of his paintings of the ballet that were to become such a central theme in his work. This is Degas's first portrayal of the ballet. Although in many of his later portrayals of

dancers, Degas would display an obsessive fascination with their highly disciplined poses and movements, here he catches Eugénie in a moment of stillness and introspection. In many of his portraits Degas captures his sitters in such moments of inactivity. As its title makes clear, this painting is as much a portrait of an individual as a painting of a performance.

The Climbing Path, L'Hermitage, Pontoise, 1875

► Camille Pissarro (French, 1830–1903)
Oil on canvas, 21⅛ x 25¾ (54 x 65)
22.60, Purchased with funds given by Dikran G. Kelekian

In late 1873 Pissarro began a decade-long stay in Pontoise, the village to the northwest of Paris where he had lived and painted a series of

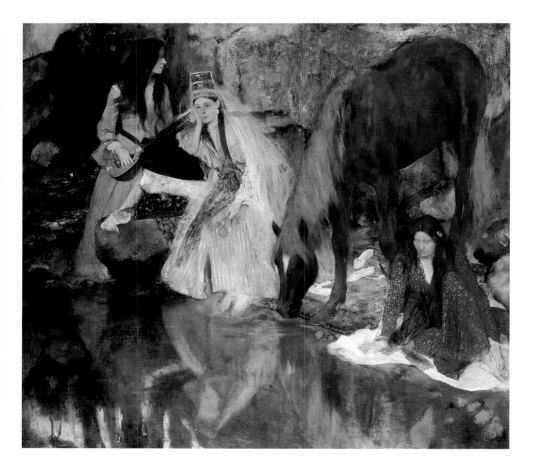

innovative landscapes in the 1860s. A favorite site at both periods was a district at the edge of town called l'Hermitage, where a hill climbed steeply behind the houses that lay along the river. While Pissarro's earlier paintings had shown the topography clearly, here a more complex and daring point of view is taken. On the left, the viewer is looking down the hill into woods with a stretch of wall, and up across to a group of houses; on the right, one looks up a steep footpath that gives the painting its title. These widely different spatial experiences are integrated by structure, color, and handling of paint. The strong, stabilizing verticals of the screen of trees through which the house is seen are a motif that may have become of interest to Pissarro while he was painting with Cézanne in the early 1870s. Cézanne was the student, but Pissarro was, throughout his life, open to ideas from the best of his colleagues. The whole surface of the canvas is unified by the complex patterning of pale earth colors, creams, and shades of green, laid down in a variety of strokes and touches that create the effect of dappled sunshine coming through foliage. A notable feature of the painting is the use of the palette knife, a practice first established by Courbet, whose work was an important model for Pissarro.

The Village of Gardanne, 1885–86

►► Paul Cézanne (French, 1839–1906)
Oil on canvas, 36¼ x 29⅛ (92.1 x 74.5)

23.105, Ella C. Woodward Memorial Fund and the Alfred T. White Memorial Fund

In the autumn of 1885 and most of the following year, Cézanne painted in Gardanne, a village near his native Aix-en-Provence. By this time Cézanne's quest for a disciplined form of painting led him to pursue the underlying structure of nature. The geometric forms of Gardanne's houses stacked steeply up the hill, culminating in the fortresslike church, were particularly suited to his purpose. Cézanne here also seems to be exploring, whether consciously or unconsciously, a tension between three-dimensional form and flatness. The solidity of the characteristically Mediterranean buildings is denied, to some extent, by the way that their densely interlocked forms rise vertically up the canvas and by our awareness of the flat surface of the canvas itself, which is especially apparent here, owing to the unfinished, unpainted area at the lower right. This sense of an ambiguous relationship between the objects depicted and the space that they inhabit was to lead, in the early twentieth century, to the Cubists' revolutionary analysis of space.

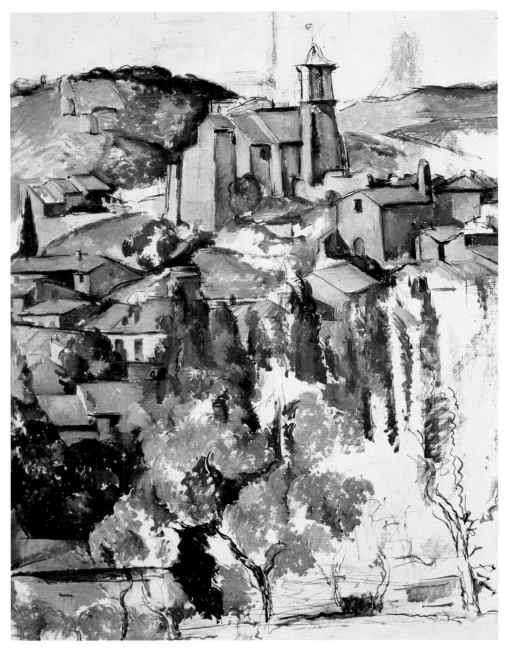

23.105

Pierre de Wiessant, circa 1886–87, cast 1979

► Auguste Rodin (French, 1840–1917)
Bronze, 84⅛ x 46 x 39
(214.9 x 116.9 x 99.1)
84.243, Gift of Iris and B. Gerald Cantor

After France's defeat in the Franco-Prussian War in 1871, government officials sought to raise both the morale and the national consciousness of its citizenry by the commissioning of public monuments. In 1884 the Municipal Council of Calais opened a national subscription for a monument to commemorate the hero who had defended their city against the siege by Edward III of England during the Hundred Years' War. Eustache de St. Pierre, along with five of the town's most prominent citizens, offered himself in exchange for the freedom of the city. They were ultimately spared at the behest of the queen. Rodin was eager to win the commission and offered to create a monument to all six burghers for the price of the single one specified in the subscription. The sculptor used several models to make numerous studies of the heads and bodies, both nude and clothed, intending the final result to contain six separate freestanding figures at eye level. The larger-than-life sculpture of Pierre de Wiessant represents the final version of the undraped form, whose pose evinces the tension of the figure's gesture of sacrifice. Rodin retained the accidental gash in Wiessant's chest; it evokes images of violence and sacrifice while asserting the primacy of the sculptural process.

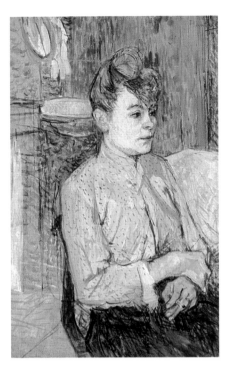

Woman Smoking a Cigarette, 1890

◄ Henri de Toulouse-Lautrec (French, 1864–1901)
Black chalk, *peinture à l'essence*, and gouache on cardboard, 18½ x 11¾ (47 x 30)
22.67, MUSEUM SURPLUS FUND AND PURCHASED WITH FUNDS GIVEN BY DIKRAN G. KELEKIAN

Well known for his depictions of the seedier side of turn-of-the-century Parisian life, Henri de Toulouse-Lautrec focused about 1890 on pictures of lower-class women in interiors, of which *Woman Smoking a Cigarette* is a prime example. Lautrec demonstrates his mastery of graphic technique in the tightly juxtaposed strokes of intense, at times contrasting, color. In its compelling portrayal of a woman in a down-and-out though unspecified setting, staring into the distance with a cigarette in her rough hands, the composition evokes a sense of fin-de-siècle despair. Lautrec often depicted prostitutes in brothels or women in dance halls, but in this small, though complete, composition, he hints at the spare interiors of the working class. The artist leaves both the woman's identity and her profession unspecified, however, encouraging the viewer to ponder her fatigue, isolation, and malaise, not in terms of reportage, but rather as a statement of the human condition.

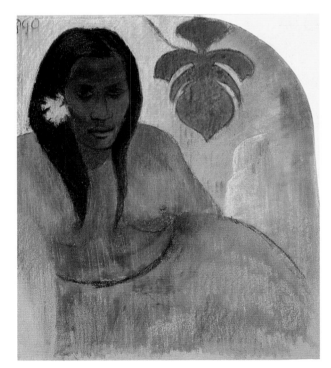

Tahitian Woman, 1894(?)

◄ Paul Gauguin (French, 1848–1903)
Charcoal and pastel on paper, glued to yellow wove paper and mounted on gray millboard, 22¼ x 19¼ (56.5 x 48.9)
21.125, MUSEUM COLLECTION FUND

Gauguin succeeds in this pastel in combining exotic subject matter with an intensity of color that makes the image appear truly of another realm. The background, unlike those of the pictures he painted in Tahiti, is abstract, implied only by the

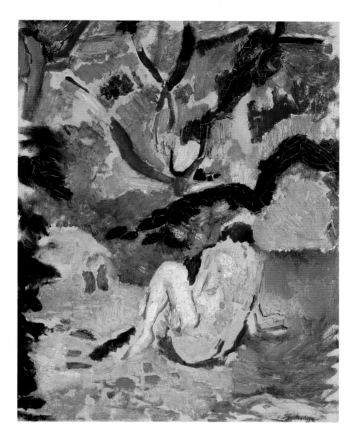

sinuous forms of the breadfruit leaf at the top of the composition, indicating that the painting was probably done upon his temporary return to Paris in 1894. Gauguin's own desire to be freed from the traditional, academic strictures of art is successfully realized in this composition; its subject, staring dreamily into the distance in an undefined space, is depicted with colors so intense that they come more from the imagination than from observed reality. In this way, the figure evokes to a greater degree the idea of the exotic than mere reportage would have.

Nude in a Wood, 1906

Henri Matisse (French, 1869–1954)
Oil on panel, 16 x 12¾ (40.6 x 32.4)
52.150, GIFT OF GEORGE F. OF

Matisse painted *Nude in a Wood* at the decisive moment in his career, when he was continuing to push the boundaries of artistic possibilities while searching for an ever more personal means of expression. In this picture, Matisse allowed color and form to exist independently; lozenges of color highlight the figure, the landscape, and the spaces in between without graphic distinction. The lack of primacy of the figure scandalized critics at the time. Matisse sought a greater compositional harmony here, however, linking the rhythms of the body to those of the surrounding landscape, without the constrictions even of definitional lines. The model was probably Matisse's wife, who posed in the woods of the mountains behind their house in Collioure; the artist made quick sketches on small panels that he placed in the top of his paint box. This small canvas is thought to be the first Matisse to enter an American collection, having been bought in 1907 by Michael and Sarah Stein for the noted Brooklyn frame maker George F. Of.

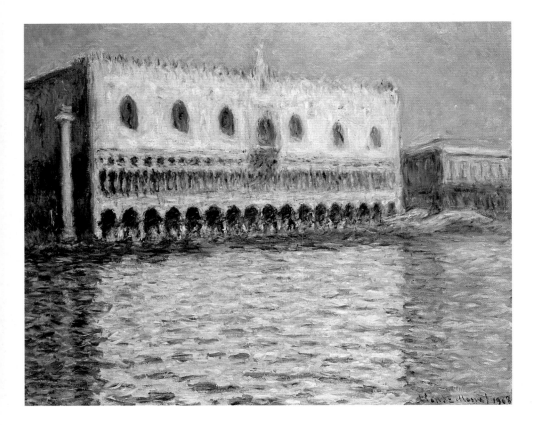

The Ducal Palace at Venice, 1908

▮ Claude Monet (French, 1840–1926)
Oil on canvas, 32 x 39⁹⁄₁₆ (81.3 x 100.5)
20.634, GIFT OF A. AUGUSTUS HEALY

By the beginning of the twentieth century, Monet was completely immersed in his garden and grounds at Giverny. In 1908 he succumbed, for the first time, to an invitation to Venice. Captivated by the magical light and its colorful play on the picturesque monuments surrounded by water, Monet produced twenty-nine canvases. He continued to work on the unfinished pictures back in Giverny, creating an overall harmony between the canvases somewhat akin to a series. Monet painted *The Ducal Palace* from the water, constructing in the vibrant reflection of the building an image as strong as that of the palace itself. The combined building and reflection, built up with interwoven thick strokes of pinks, blues, and violets, creates a dramatic vertical slice through the horizontal canvas, at once affirming the beauty of the monument and dematerializing it to a compositional abstraction.

American Painting
and Sculpture

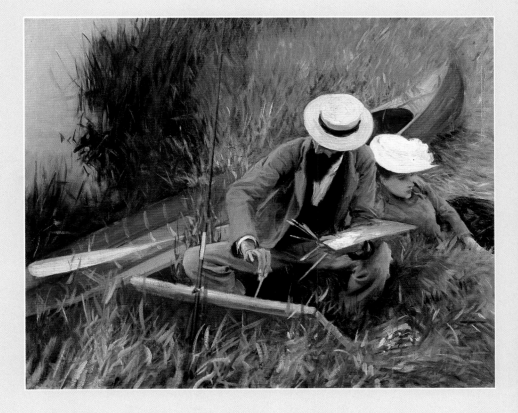

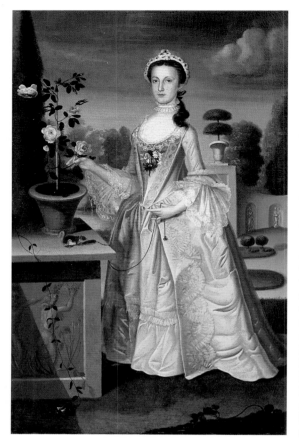

Deborah Hall, 1766

◄ William Williams (American, 1727–1791)
Oil on canvas, 71⅜ x 46⅜
(181.3 x 117.8)
42.45, DICK S. RAMSAY FUND

Williams's portrait of Deborah Hall (1751–1770) is often noted as one of the most iconographically complex full-length portraits of the colonial era. Presumably commissioned by the sitter's father, David Hall, a Philadelphia printer and former partner of Benjamin Franklin, the painting is filled with a richly calculated array of symbols that establish the fifteen-year-old as the personification of a carefully cultivated rose, a metaphor of love and beauty. Deborah herself calls attention to this meaning by appearing ready to pluck the rose at her right. The concepts of romantic love and chastity are central themes, inasmuch as the sculpted relief at the lower left illustrates the Greek myth of Apollo's pursuit of Daphne, wherein she escapes Apollo's amorous advances by changing into a laurel

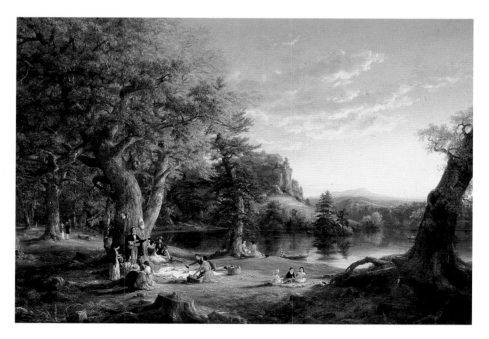

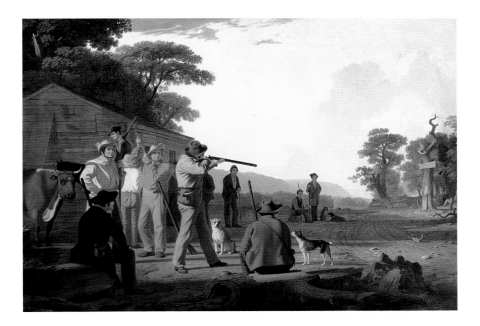

tree, in itself a symbol of chastity. With these and other traditional symbols, Williams constructed a web of meanings that defines Deborah Hall's place within society as a young woman whose impeccable upbringing has prepared her for a life of marital propriety and duty.

The Pic-Nic, 1846

◄ Thomas Cole (American, 1801–1848)
Oil on canvas, 44⅞ x 71⅞ (121.6 x 182.6)
67.205.2, A. Augustus Healy Fund B

Thomas Cole, America's first great landscape painter, earned his reputation with romanticized views of the American Northeast as well as with grand moralizing allegories and European scenes. English-born, Cole arrived in the United States in 1818 and by 1825 had received recognition in New York City for his landscape subjects. His art matured under the influence of European travels, which impressed upon him the allegorical potential of landscape. Cole was at the height of his career when he received a commission from James Brown, a wealthy New York banker, who expressed a preference for landscapes with interesting figure groups. The artist fulfilled the commission with *The Pic-Nic*, using the motif of the popular outdoor pastime to describe the ideal coexistence of nature and civilization, and thus creating one of his most important American pastoral subjects.

Shooting for the Beef, 1850

↑ George Caleb Bingham (American, 1811–1879)
Oil on canvas, 33⅜ x 49⅜ (85.4 x 125.4)
40.342, Dick S. Ramsay Fund

With the exception of a brief period of study in Philadelphia in 1838 and a sojourn in Washington, D.C., from 1841 to 1844, Bingham spent most of his career as a portraitist in Missouri. About 1845 he began to paint genre subjects that provided vivid descriptions of American frontier life. These paintings gained national attention through distribution by the New York–based American Art-Union. *Shooting for the Beef* is the last of twenty works he submitted to the Art-Union before its dissolution in 1851. The narrative content (which centers on the marksmanship contest for the bull tethered at the left) and the far-ranging view of the frontier landscape combine to make this work an icon of the era of Manifest Destiny in its suggestion of limitless opportunity for those possessed of the pioneering, competitive spirit.

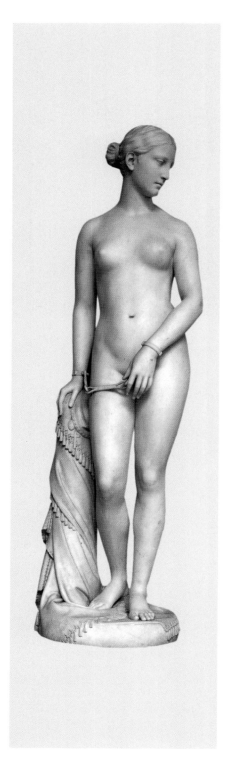

The Greek Slave, 1869

◄ Hiram Powers (American, 1805–1873)
Marble, 66 x 19¾ x 18⅜ (167.6 x 50.2 x 46.7)
55.14, GIFT OF CHARLES F. BOUND

The Greek Slave is a masterwork in the history of American Neoclassical sculpture. Daring in its depiction of the female nude, it contains many historical, religious, and political associations that served to mitigate the long-standing public resistance to images of the nude in American art. Although the form is based on classical prototypes, Powers (who by 1837 had expatriated to Italy) placed the work within the context of the Greek War of Independence (1821–30) and thus referred to the many Christian Greeks taken prisoner by the Turks and later sold as slaves. With subsequent versions created in the 1860s, the sculpture came to be interpreted as an allusion to anti-slavery sentiments then at issue in America. The last of six full-scale versions by Powers (the first was finished in 1844), the Brooklyn Museum of Art's marble differs from its predecessors in the substitution of bar-manacles for chains as restraints. By 1869, the year that this piece was carved, its meaning had entered the American consciousness through the many variants available through Powers's studio and through countless reproductions.

A Storm in the Rocky Mountains, Mt. Rosalie, 1866

► Albert Bierstadt (American, 1830–1902)
Oil on canvas, 83 x 142½ (210.8 x 361.3)
76.79, DICK S. RAMSAY FUND, HEALY PURCHASE FUND B, FRANK L. BABBOTT FUND, A. AUGUSTUS HEALY FUND, ELLA C. WOODWARD MEMORIAL FUND, FUNDS GIVEN BY DANIEL M. KELLY AND CHARLES SIMON, CHARLES STEWART SMITH MEMORIAL FUND, CAROLINE A. L. PRATT FUND, FREDERICK LOESER ART FUND, AUGUSTUS GRAHAM SCHOOL OF DESIGN FUND, MUSEUM COLLECTION FUND, SPECIAL SUBSCRIPTION, JOHN B. WOODWARD MEMORIAL FUND, BEQUEST OF MRS. WILLIAM T. BREWSTER, GIFT OF MRS. W. WOODWARD PHELPS, GIFT OF SEYMOUR BARNARD, BEQUEST OF LAURA L. BARNES, GIFT OF J. A. H. BELL, BEQUEST OF MARK FINLEY, BY EXCHANGE

Bierstadt returned to the United States in 1857 from four years of study in Europe to begin his career as a landscape painter. A trip to the Rocky Mountains in 1859 established him as the

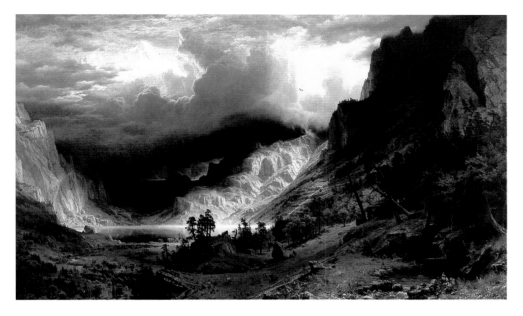

primary interpreter of the western wilderness landscape. *A Storm in the Rocky Mountains, Mt. Rosalie* was inspired by Bierstadt's 1863 overland expedition to California. En route he made numerous on-the-spot sketches and studies in the mountains north of Denver, Colorado. Upon returning to his New York studio, he incorporated them into this panoramic vista. For all its careful detail, the painting is not a literal rendering of a specific site. It is a highly subjective visual essay on the natural wonders of the New World executed on a scale commensurate with the vastness of the land. Bierstadt's use of such large canvases invites comparison of his work to that of Frederic Church as well as to the then-popular theatrical attractions of moving panoramas and dioramas. Mount Rosalie (now Mount Evans) was named by the artist in honor of the woman he would marry in 1866. This monumental landscape dropped from public view after purchase by an Englishman in 1867. Until its rediscovery in 1974, it was known only by a chromolithograph.

A Ride for Liberty—The Fugitive Slaves, circa 1863

❙ Eastman Johnson (American, 1824–1906)
Oil on board, 22 x 26¼ (55.8 x 66.6)
40.59.a, Gift of Gwendolyn O. L. Conkling

The young American genre painter Eastman Johnson based this dramatic image on a scene of fleeing slaves that he witnessed on March 2, 1862, while traveling with Union troops at

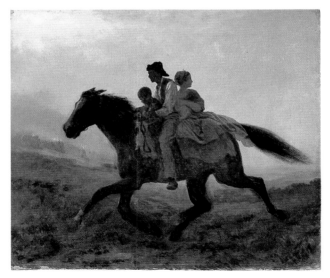

Centerville, Virginia. Although a number of American painters spent time with Civil War regiments, few recast their observations and sketches as finished paintings. Johnson's work is all the more unusual for the manner in which the artist chose the flight of the mounted slave family as his primary focus, representing them as a powerful and dynamic silhouette against the smoky chaos of the battlefield. The painting demonstrates Johnson's own sympathy for the abolitionist cause, notably at a moment in the early months of 1862 when Union troops were beset by serious losses, and it remains one of the most moving images created by any American artist during the Civil War.

Lake George, 1870

▲ John Frederick Kensett (American, 1816–1872)
Oil on canvas, 14 x 24⅛ (35.5 x 61.2)
33.219, GIFT OF MRS. W. W. PHELPS IN MEMORY OF HER MOTHER AND FATHER, ELLA M. AND JOHN C. SOUTHWICK

John Frederick Kensett first visited Lake George in northern New York State in 1853, and the popular locale would be the subject of at least four major oils by the artist over the next two decades. This painting is unusual in his work and may indicate that he was in the process of reorienting his aesthetic approach. Although he portrayed a site traditionally linked with the Hudson River School style (which by 1870 was becoming outmoded), he refrained from reiterating the pantheistic sentiments inherent in the work of the previous generation of landscape painters. What is more, he exchanged the fixed calm and mirror-smooth surfaces characterizing many of his mature works (often aligned with a tendency called Luminism) for a sensibility residing in the transitory. The signs of impending atmospheric change—swiftly moving clouds and agitated water—reinforce the idea of transition, as does the artist's uncharacteristic depiction of the lake as it appeared in late autumn.

June (A Day in June), 1882

◄ George Inness (American, 1825–1894)
Oil on canvas, 30¼ x 45 (77 x 114.3)
41.776, BEQUEST OF MRS. WILLIAM A. PUTNAM

Inness, who was born in Newburgh, New York, began his art training when the Hudson River School style was approaching the zenith of its popularity. While his early paintings reflect his use of the Hudson River School aesthetic, he gradually rejected the topographical specificity and moralizing content often associated with that mode. This tendency grew stronger following his second trip to Europe in 1853, for direct contact with the work of the Barbizon painters introduced a looser facture and greater naturalism to his art. Inness painted *June* at a time when his art was beginning to achieve popular as well as critical admiration. The placid summer scene seems enclosed in an almost palpable atmosphere and exudes a serenity that induces the subjective, emotional responses to which he aspired in his art.

Letitia Wilson Jordan, 1888

↓ Thomas Eakins (American, 1844–1916)
Oil on canvas, 60 x 40 (152.4 x 101.6)
27.50, DICK S. RAMSAY FUND

While most of Thomas Eakins's artistic energies were devoted to portraiture, only a small portion of his production in the genre was commissioned. Most—largely portraits of his family and close friends—were given away or kept in his Philadelphia studio. Letitia Wilson Jordan (1852–1931) was the sister of Eakins's friend and pupil David Wilson Jordan, to whom the artist gave the painting on its completion. Eakins's portrayal of this handsome woman stands apart from contemporaneous aesthetic norms. In an era primarily disposed to the idealization of women, Eakins expressed his fascination with the sitter in an unconventional manner. Much of this was accomplished through the synthesis of his French academic training and his study of the

great Spanish masters Velázquez and Ribera. The meshing of the two strong European traditions allowed Eakins to create complex amalgams of physical and psychological realities unique to each subject.

An Out-of-Doors Study (Paul Helleu Sketching with His Wife), 1889

❙ John Singer Sargent (American, 1856–1925)
Oil on canvas, 26⅛ x 32⅛ (66.3 x 81.5)
20.640, MUSEUM COLLECTION FUND

The summers of 1885 to 1889 that he spent in or near the rural English village of Broadway mark the period of Sargent's most intense experiments with plein-air painting. *An Out-of-Doors Study* was painted at Fladbury, where in 1889 the Sargent family had rented the rectory. Among Sargent's visitors that summer were his friend Paul Helleu, the French painter, and his wife, Alice. Although the painting functions mainly as an informal portrait of the

Helleus, its title clearly indicates Sargent's overriding concern with issues of technique by focusing on the method of its production—plein-air painting. Indeed, this is a painting about painting, as Paul Helleu is portrayed in the act of creating a plein-air study that is perhaps a study of Sargent himself pursuing the same activity.

Poppies on the Isles of Shoals, 1890

► Childe Hassam (American, 1859–1935)
Oil on canvas, 18⅛ x 22⅛ (46 x 56)

85.286, GIFT OF MARY PRATT BARRINGER AND RICHARDSON PRATT, JR., IN MEMORY OF RICHARDSON AND LAURA PRATT

Childe Hassam, one of the best-known American practitioners of Impressionism, was a frequent visitor to Appledore, a small island located off the coast of New Hampshire, where the family of his former student Celia Thaxter owned a hotel. Hassam painted many views of Thaxter's garden on the island, the beauty of which was widely celebrated in contemporary

literature and was the subject of Thaxter's own book, *An Island Garden*, published in 1894, for which Hassam provided illustrations. *Poppies on the Isles of Shoals* belongs to a series of canvases in which the artist focused on the wild poppies that carpeted the grassy hills edging the island's rocky shore. The painting displays Hassam's attention to such Impressionist concerns as pleinairism, broken brushstrokes, and brilliant color, which, with the strong, reductive composition, establish this as one of the artist's most memorable works.

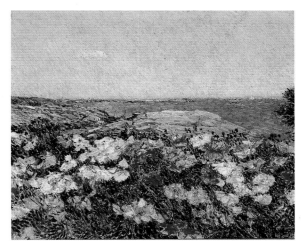

The Turtle Pound, 1898

▌ Winslow Homer (American, 1836–1910)
Watercolor over pencil, 14¹⁵⁄₁₆ x 21⅜ (38 x 54.2)

23.98, SUSTAINING MEMBERSHIP FUND, ALFRED T. WHITE MEMORIAL FUND, AND THE A. AUGUSTUS HEALY FUND

For the most part Winslow Homer, one of America's greatest painters, employed watercolor during his many trips, concentrating on a particular theme or subject inspired by the locale he visited. Such is the case with *The Turtle Pound*, one of twenty-five watercolors

he is known to have painted over a two-month stay in the Bahamas during the winter of 1898–99. Here, within the simple but dynamic construct of sea and sky, Homer presents a dignified portrayal of the islanders' way of life, one that he perceived as being closely attuned to nature. While providing a truthful record of a routine task (that of capturing a young sea turtle to be confined in the wooden pound for fattening before going to market), he transcends the level of mere documentation by imbuing his subject with a conceptual monumentality. The universal issue of man's place in nature and the struggle for life as embodied in the captive turtle are given immediacy and physicality through the artist's brilliant handling of the watercolor medium.

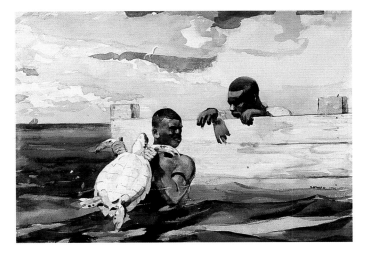

Michelangelo's Sistine Chapel sibyls. The hooded, androgynous face with its closed eyes suggests a state of spiritual containment beyond what is possible in the earthly sphere, and the sculpture evokes the timelessness that Saint-Gaudens and Adams sought to capture.

A Morning Snow—Hudson River,
1910
► George Bellows (American, 1882–1925)
Oil on canvas, 45⅜ x 63¼ (115.2 x 160.7)
51.96, GIFT OF MRS. DANIEL CATLIN

George Bellows left his native Ohio in 1904 for New York, where he soon began attending classes taught by Robert Henri at the New York School of Art. Although he was never a member of the group of realists headed by Henri (later known as The Eight and still later considered part of the Ashcan School), he was deeply influenced by Henri's call to create an art based on life. *A Morning Snow—Hudson River* shows the Upper West Side of Manhattan overlooking the Hudson River and the New Jersey Palisades. With the assured, broad strokes of a heavily loaded brush, Bellows captured the effects of morning light reflected from the freshly fallen snow while conveying the sense of the city's awakening energies by including small but important narrative elements: the figure shoveling snow, men walking to work, and boats plying the river. The urban landscape punctuated by such narrative vignettes certainly aligns this painting with Henri's dictum for realism. Yet perhaps more than any other of Henri's followers, Bellows had a keen eye for abstract relationships, seen here in the ordered system of horizontal and vertical elements that are relieved by a subtle series of diagonals.

Night, circa 1910
► Adolph A. Weinman (American, b. Germany, 1870–1952)
Pink granite, 120 x 75 x 41 (304.8 x 185.4 x 104.1)
66.250.1, GIFT OF LIPSETT DEMOLITION CO. AND YOUNGSTOWN CARTAGE

Born in Karlsruhe, Germany, in 1870, Adolph A. Weinman emigrated to New York in 1880.

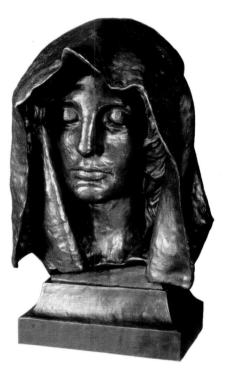

Head from the Adams Memorial,
1908
▮ Augustus Saint-Gaudens (American, 1848–1907)
Bronze, 19⁹⁄₁₆ x 12 x 7½ (49 x 30.5 x 19)
23.256, ROBERT B. WOODWARD BEQUEST FUND

This enigmatic sculpture is one of four known bronze versions of a head based on that of the figure that Saint-Gaudens created for the *Adams Memorial*, 1886–91 (Rock Creek Church Cemetery, Washington, D.C.). Commissioned in 1886 by writer-philosopher Henry Adams as a grave monument for his wife, Marion, whose tragic suicide the year before had left him devastated, the Memorial bears witness to the shared tastes of Adams, Saint-Gaudens, and their friend, the artist John La Farge. Saint-Gaudens drew upon Adams's and La Farge's studies of Far Eastern religion and philosophy to create a sculpture that reflected (in his words) "Mental repose—Calm reflection in contrast with the violence or force in nature." The result was a figure of solemn monumentality that blended the spiritual calm of Buddhism with the formal weight of

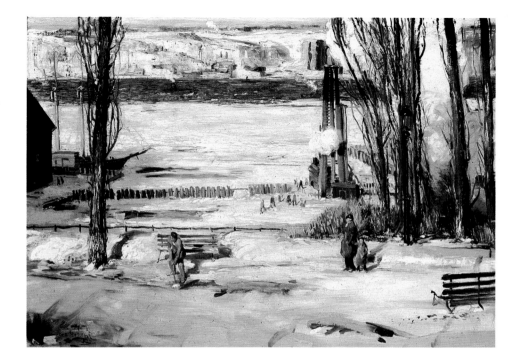

A pupil of Augustus Saint-Gaudens and Phillip Martiny, Weinman opened his own studio in 1904. Weinman flourished as a civic sculptor and was at the height of his career when he completed eight heroic female figures of *Day* and *Night* for New York's Pennsylvania Station, a monumental building designed by Charles Follen McKim in the style of the Roman Baths of Caracalla. The figures flanked four clocks over the four entrances to the building. The allegorical depiction of *Night* in the style of the American Renaissance was completed in 1910. The figure is draped in the enveloping cloak of night, with eyes closed and an oriental poppy symbolic of the opiate that brings sleep (the statue of *Day* held sunflowers) drooping from her hand. Four sets of figures were installed but only two were saved when the building was demolished in 1963. The statue of *Day* has not been reassembled but was salvaged and moved to Ringwood Manor in northern New Jersey.

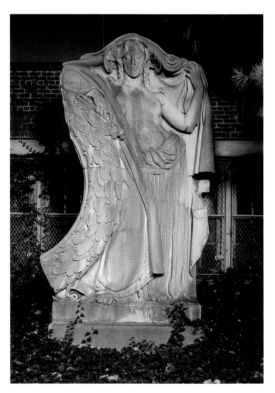

Painting No. 48, Berlin, 1913

▌ Marsden Hartley (American, 1877–1943)
Oil on canvas, 47¾₁₆ x 47¾₁₆ (119.8 x 119.8)
58.158, DICK S. RAMSAY FUND

Marsden Hartley was among the first American artists to incorporate the effects of European modernism in his work. One of the most important paintings of his early career, *Painting No. 48, Berlin* reveals the impact of the considerable time that he spent in Germany in 1913, where the canvas was executed. Typical of his work of this period, it reveals his assimilation of Picasso's Cubist style, which he expanded to embrace an iconography incorporating the military atmosphere of Berlin and the mystical associations of numbers, colors, and shapes generated by his understanding of the writings of Wassily Kandinsky and the French philosopher Henri Bergson. In a letter to the photographer Alfred Stieglitz, Hartley noted that the painting represented the mystical embodiment of the number eight (a number generally associated with transcendence from the material to the spiritual), but he denied further explanations of his art.

Ram's Head, White Hollyhock–Hills (Ram's Head and White Hollyhock, New Mexico), 1935

► Georgia O'Keeffe (American, 1887–1986)
Oil on canvas, 30 x 36 (76.2 x 91.44)
1992.11.28, BEQUEST OF EDITH AND MILTON LOWENTHAL

From 1916 Georgia O'Keeffe's artistic activity was based in New York and most closely associated with the artistic circle of her husband, the important photographer and gallery owner Alfred Stieglitz (1864–1946). However, her sphere of activity broadened suddenly with a 1929 trip to Taos, New Mexico. There memories of her much earlier experiences of vast American spaces were reawakened as she became enthralled with the stark, dramatic vistas surrounding Taos,

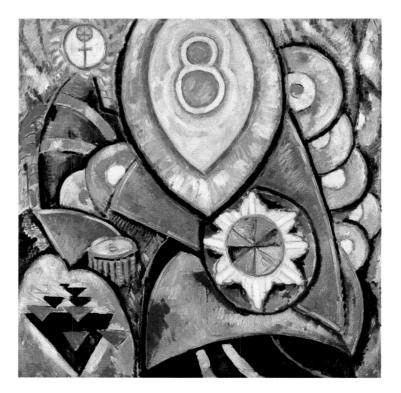

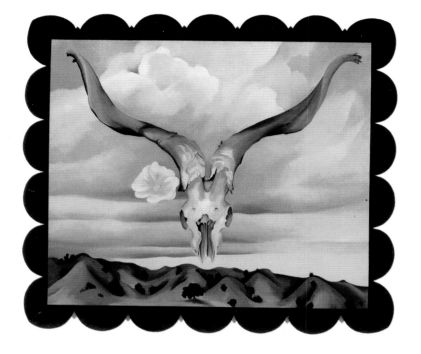

which she later came to call the "faraway." From 1929 on, much of O'Keeffe's output reflected her fascination with the Southwest. Her stays there fostered new thematic concerns: the famed bone paintings and works featuring the severe beauty of the land. *Ram's Head, White Hollyhock—Hills* captures the spare purity that O'Keeffe discovered in the natural forms of the desert. Far from being a morbid token of death, the sun-bleached ram's skull hovers in concert with the flower in full bloom as a visionary symbol of the constantly renewed life force even within the harsh extremes of the desert environment.

Jonah and the Whale: Rebirth Motif, 1937

► John B. Flannagan (American, 1895–1942)
Bluestone, 30¼ x 11 x 2⅕
(76.8 x 27.9 x 5.6) (irregular)

1992.11.12, BEQUEST OF EDITH AND MILTON LOWENTHAL

About 1928 John Flannagan began to work almost exclusively in stone with the direct carving method, a technique that lent itself

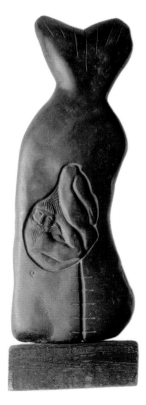

well to the elemental themes of birth, death, and rebirth—both physical and spiritual—that flow throughout the content of his art. *Jonah and the Whale: Rebirth Motif* is one of the most remarkable expressions of Flannagan's aesthetic, wherein he melds the concept of the biblical Jonah's spiritual rebirth with the idea of physical gestation (as indicated by Jonah's fetal position within the belly of the whale). The elegant simplicity of his artistic approach, which centered on his notion of the sculptor's goal as that of "freeing" already existing forms from the stone in a birthlike process, brings the formal and thematic aspects of the work into a delicate, almost mystical equilibrium.

The Mellow Pad, 1945–51

⬆ Stuart Davis (American, 1892–1964)
Oil on canvas, 26 x 42 (66 x 106.7)
1992.11.6, BEQUEST OF EDITH AND MILTON LOWENTHAL

The Mellow Pad, one of Davis's most important works, occupied the artist intermittently from 1945 to 1951. Davis almost obliterated the original composition, based on one of his paintings from the previous decade, with a complex layering of bold shapes and colors in a pattern that invokes the energetic variations and movement of the jazz music that he loved. Embedded in the seemingly random scheme are the words of the painting's title that are reminders not only of the Cubist collage aesthetic that inspired him, but also of his intent to emphasize the flat, two-dimensional surface of the painting (by referring to drawing pads) and his desire to capture the hip sensibility associated with American jazz by using two potent buzz words, "mellow" and "pad." Davis's art addressed even deeper issues regarding the relationships between color and design, and form and content; in many ways his art reflected the formal values of Abstract Expressionism, yet Davis retained an approach rooted in the objective realities of American life and interpreted by a personal and highly intellectualized set of aesthetic criteria.

Contemporary
Painting and
Sculpture

Vessels of Magic, 1946

▲ Mark Rothko (American, b. Russia,
1903–1970)
Watercolor on paper, 38¾ x 25¾
(98.4 x 65.4)
47.106, MUSEUM COLLECTION FUND

By 1940 Mark Rothko, deeply impressed by
the European Surrealists, some of whom
came to this country during World War II,
integrated their technique of automatic draw-
ing and interest in myth in his own work and
moved away from the representationalism of
his earlier art. Reflecting on this time, Rothko
later said: "It was with utmost reluctance that

I found that the figure could not serve my
purposes . . . but a time came when none of
us could use the figure without mutilating it."
Rothko's work of the mid-1940s is an
amalgam of Surrealism and abstraction,
with the latter foreshadowing the painted,
hovering, or blurred areas of color for which
the artist is best known. *Vessels of Magic*
anticipates these works with horizontal
registers on the paper's surface broken only
by passages of imagery and gesture. The
apparition of vessel forms may suggest the
artist's interest in classical mythology by
evoking a simplified classical vestment and
the power of magic.

The Hero, 1952

► David Smith (American, 1906–1965)
Steel, 73¹¹⁄₁₆ x 25½ x 11¾ (187.2 x 64.8 x 29.8)
57.185, DICK S. RAMSAY FUND

David Smith's *The Hero* conflates the abstract and the figurative, for discernible in this geometric steel sculpture is an almost life-size female figure. She is revealed frontally, balanced on a pedestal, with a rectangle for a torso, two triangular forms for breasts, and a tank lid for a head. *The Hero* is a forerunner of more than ten sculptures produced between 1952 and 1960 that Smith entitled his Tanktotem series. "Tank" refers to the industrial tank lids or boiler tops that he used to construct his pieces, while "totem" may reflect the influence of Sigmund Freud's book *Totem and Taboo*.

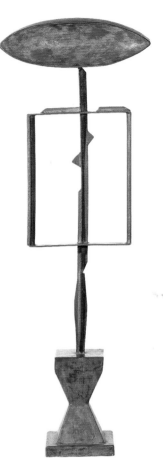

Untitled (Composition #104), 1954–60

◄ Ad Reinhardt (American, 1913–1967)
Oil on canvas, 108¼ x 40⅛ (274.9 x 101.9)
67.59, GIFT OF THE ARTIST

Although Ad Reinhardt was a contemporary of the Abstract Expressionists, his mature works were geometric abstractions formally unrelated to the expressive gesture of the New York School. In *Untitled (Composition #104)*, the artist's control over his canvas is apparent in the solid rectangles of blues and blacks and velvety color that form a compositional grid. Although Reinhardt denied that his paintings carried any content, contemporary critics have sought to find additional meaning in his work.

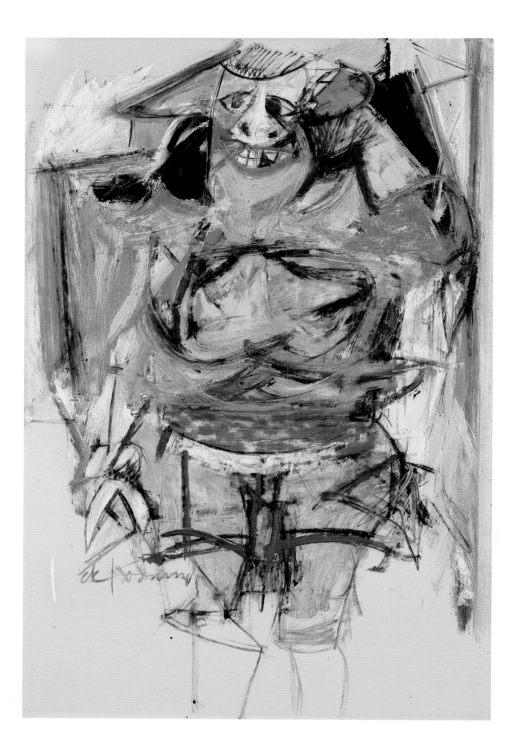

Woman, 1953–54

◄ Willem de Kooning (American,
b. Holland, 1904)
Oil on paper, 35¾ x 24⅜
(90.8 x 61.9)

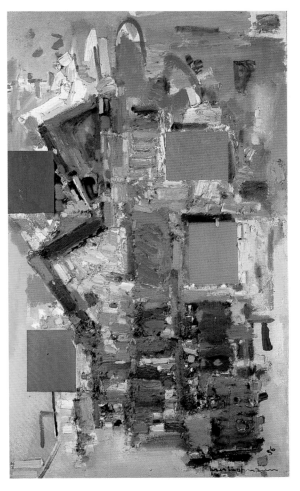

The female figure was predominant
in the Abstract Expressionist Willem
de Kooning's work from the time of
his arrival in America from Holland
in 1926 until the 1950s. In the 1930s
and 1940s, his paintings of women
were realistic and lifelike. He finally
abandoned strict attention to detail,
maintaining that "you could lose
your mind" drawing objects so
closely resembling nature. In this
work, facial features are the artist's
concession to an identifiable figure.
He knew Picasso's *Desmoiselles
d'Avignon* of 1907, then on view at
The Museum of Modern Art, New
York, and its influence is clear in
Woman: the masklike face, flattened
forms, and almond-shaped eyes all
recall the Picasso painting. In
addition, de Kooning endowed his
subject with ferocity. Fanglike teeth,
among the few recognizable forms
in the image, dominate the face. A
dozen years after he completed his
Woman series, the artist found humor in
such horrifics: "I look at them [the Woman
paintings] now and they seem vociferous and
ferocious. I think it had to do with the idea
of the idol, the oracle, and above all, the
hilariousness of it."

Towering Spaciousness, 1956

► Hans Hofmann (American, b. Bavaria,
1880–1966)
Oil on canvas, 84¼ x 50 (214 x 127)

Hans Hofmann was born in Bavaria and settled
in New York in the late 1930s. He is known as
a devoted and influential teacher, especially of
the first and second generation of Abstract
Expressionists, with a student roster including
Lee Krasner, George McNeil, Louise Nevelson,
and Larry Rivers. Not until 1958, when Hof-
mann closed his Eighth Street, Manhattan, art
school, could he focus fully on his own work.
Hofmann's oeuvre assimilated the Fauvism,
Cubism, and Surrealism that he studied during
his European years and the vibrancy and vigor
of New York School painting. In *Towering
Spaciousness*, the artist abides by Cubism's
and de Stijl's geometric forms while imposing
in the surround thickly impastoed gestural
areas of oranges, blues, yellows, and pinks.
Blocks of color are built into towering, spatial
intervals. Indeed, this painting well represents
the artist's "push-and-pull" theory. In consider-
ing the spatial relations he created on the
picture plane, Hofmann wrote in 1948, "*Push*
and *pull* are expanding and contracting forces
which are activated by carriers in visual motion.
Planes are the most important carriers, lines
and points less so."

First Personage, 1956

▌ Louise Nevelson (American, b. Russia, 1900–1988)
Painted wood, two pieces: 94 x 37⅟₁₆ x 11¼
(238.8 x 94.1 x 28.6); 73¹¹⁄₁₆ x 24⁹⁄₁₆ x 7¼
(187.2 x 61.4 x 18.4)
57.23, GIFT OF MR. AND MRS. NATHAN BERLIAWSKY

Louise Nevelson is best known for her mono-chromatic boxes and wooden wall constructions of found objects. *First Personage*, a part of the artist's 1957 installation *The Forest* at New York's Grand Central Moderns gallery, pre-figured her wall environments. Nevelson wrote of *First Personage* as "one of the first major pieces" that she created. The large, subtly undulating frontal slab recalls a composed or outer persona, and the spiky column behind, our inner and agitated self. Nevelson later recalled that the work's persona came forth in the process of creation: "While I was filing and

working away at it there was a knot where the mouth was supposed to be, just a plain knot, and I, being so concentrated, all of a sudden I saw this knot, mouth moving. And the whole thing was black by then and it frightened me."

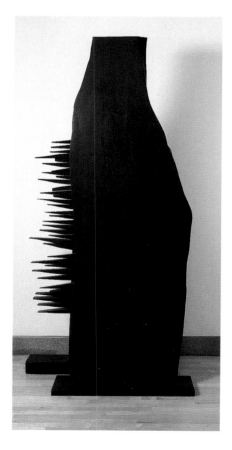

Stonewall, 1956

▌ Leon Polk Smith (American, 1906–1996)
Oil on canvas, 35½ (90.2) diameter
TL1992.275.5, BEQUEST OF LEON POLK SMITH

Leon Polk Smith was born in Indian Territory (now Oklahoma) in 1906. He has cited his upbringing on the plains of Oklahoma as an influence in his geometric, abstract art. In 1936 he came to New York to pursue a teaching career. That same year, he saw nonobjective art by Jean Arp, Constantin Brancusi, and Piet Mondrian on view at New York University's A. E. Gallatin Collection, and he there found ideas that he would use as the basis for his own work from that moment on. It was Mondrian's cool, geometric style that challenged the young Smith the most, but by the mid-1940s his work had departed from Mondrian's. In working to break from Mondrian's grid, Smith was a trailblazer with the tondo format, at first adapting the grid onto a circular format, and then forming curvilinear spaces on a curvi-linear canvas. The movement of spatial planes and bold interaction of color passages forge a unique artistic vocabulary in Smith's dynamic visual language. His circular paintings, like *Stonewall* (named for Stonewall, Oklahoma), put him at the forefront of geometric inno-vation in our time.

The Judgment, 1963

⬙ Bob Thompson (American, 1937–1966)
Oil on canvas, 60 x 84 (152.4 x 213.4)
81.214, A. Augustus Healy Fund

Bob Thompson was a noted African-American artist whose career was cut short by his early death at age twenty-eight. Thompson was born near Louisville, Kentucky, and studied at Boston University and the University of Louisville. In the early and mid-1960s, he traveled throughout Europe and found Renaissance paintings of great interest. He fused the vigor and vibrancy of Expressionism with themes of Old Master compositions and the vivid palette of Fauve painting toward an original visual vocabulary, exemplified in *The Judgment*. Recalling the subjects in classical works like *The Last Judgment* or *The Judgment of Paris*, a nude male trio sits before faceless winged female angels. Two figures at left await judgment. The planar, flattened figures and compositional contours in a gestural background are all equally emphasized in the painting.

Ocean Park No. 27, 1970

►► Richard Diebenkorn (American, 1922–1993)
Oil on canvas, 100 x 81 (254 x 205.7)
72.7, Gift of The Roebling Society, Mr. and Mrs. Charles H. Blatt, and Mr. and Mrs. William K. Jacobs, Jr.

In 1967 Richard Diebenkorn began a series of paintings named Ocean Park after the section of Santa Monica, California, where his studio was located. In contrast to Diebenkorn's early, figurative works, the Ocean Park paintings were nonobjective, a change that the artist found to permit "an allover light which wasn't possible for me in the representational works, which seem somehow dingy by comparison." In *Ocean Park No. 27*, Diebenkorn reduces a scene to planes and fragments of color not unlike Matisse's, building up layers of paint to signify the Ocean Park landscape. Depth and spatial illusion are suggested by the advance and recession of color. Using a low-key palette devoid of harsh tones, the artist accomplished his stated goal of communicating "a feeling of strength in reserve, tension beneath calm."

72.7

Riot IV, 1983

↑ Leon Golub (American, b.1922)
Acrylic on canvas, 120 x 186 (304.8 x 472.4)
1991.272, GIFT OF SUSAN CALDWELL

Leon Golub's main subject matter, political power and its abuses, is derived from world events refracted through the lens of the media. In the late 1960s and early 1970s, for example, he painted a series on the Vietnam War. In the late 1940s and 1950s, as a young painter in Chicago, Golub was deeply influenced by the art of classical antiquity, and he concentrated on the human form. At the time of the pre-dominance of Abstract Expressionism, Golub chose to work on the periphery of the New York art world because of his allegiance to the figure. Golub lived in Paris from 1959 to 1964, when he returned to New York and worked in a figurative mode against the backdrop of Pop Art, Minimalism, and Conceptualism. More recently, Golub's work has been notable for its pertinent subject matter and consistency of vision and impact. The artist depicts a victim and victimizers in *Riot IV*, from a group of seven in the Riot series that the artist began in 1983 and continued through 1991. A brutalized figure is dragged across the ground

as his form is pushed forward in the picture plane and forced into the viewer's space.

Head, 1984

◄ Tom Otterness (American, b.1952)
Bronze, 35½ x 33 x 25 (90.2 x 83.8 x 63.5)
85.176, GIFT OF HENRY AND CHERYL WELT

Though Tom Otterness's *Head* lies within the tradition of bust-length portrait sculpture, it confounds that identification upon first gaze, for the artist has no interest in capturing a sitter's likeness. Rather, *Head* recalls mass-produced, machine-made imagery in which carbon copies predominate and distinction disappears. Much of Otterness's work is humorous; *Head*, however, has a content apart from humor. About five times the size of a human head, it recalls the ancient head of Constantine, a colossal sculpture of the fourth century that also denies personal character and concentrates on a sculptural statement of size and anonymity. The resemblance is possibly no coincidence, for Otterness's travels through Europe, the Middle East, and Asia have influenced his work, as have mythology, folklore, and pop culture.

No Nature, 1985–86

◄ Carroll Dunham (American, b.1949)
Mixed media on wood veneer, 58 x 34
(147.3 x 87.7)

86.91, Purchased with funds given by Arthur Cohen
in memory of Ben Cohen, and the John B. Woodward
Memorial Fund

No Nature, painted between June 1985 and
April 1986, is the opening statement in a series
of paintings in which Carroll Dunham dealt
with the artificiality of the so-called natural
while exploring the hierarchic arrangements of
dominant and subordinate forms. The work's
surface consists of three different kinds of
wood veneer, a material that the artist started
to use about 1980. These veneers are dyed so
as to obscure the wood's natural color and
imply new relationships between the natural
and the man-made. The entire surface is
painted, drawn on with pencil, sanded,
stained, and overpainted. The vividly colored,
sharply outlined shapes floating through the
painting are reminiscent of cartoon images.
Always interested in the powerful presence of
line, Dunham stresses the graphic qualities of

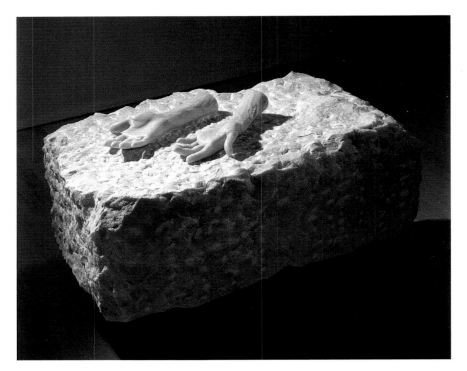

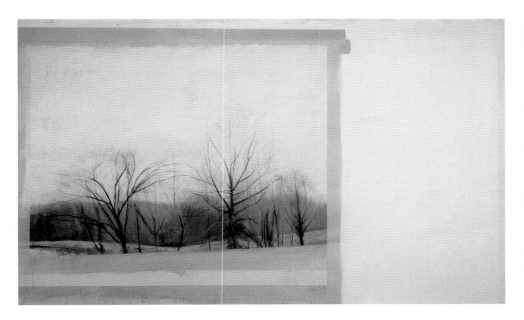

his work, using linear elements to structure space, outline shapes, and carry the viewer into an illusion of depth.

Décontractée, 1990

◄ Louise Bourgeois (American, b. France, 1911)

Pink marble and steel base, 28½ x 36 x 23 (72.4 x 91.4 x 58.4)

1994.124, PURCHASED WITH FUNDS GIVEN BY THE MARY SMITH DORWARD FUND, THE CONTEMPORARY ART COUNCIL, THE DAVID H. COGAN FOUNDATION, INC., HARRY KAHN, MRS. CARL L. SELDEN, AND GIFT OF EDWARD A. BRAGALINE, BY EXCHANGE

Throughout her long career, Louise Bourgeois has experimented with various methods of composing the fragmented parts of the body in her sculptures, yet none are more brilliant than the series of marble pieces from the last decade. Most of them employ roughly finished marble blocks with the body parts seemingly growing from the inanimate substance of the stone. While some works comprise numerous organic elements, others feature a single part of the body isolated and decontextualized. Hands appear frequently in these pieces. They are also the most important tool of the artist and as such are celebrated in many forms. They are expressive of character and mood and serve in the communication process. The two hands carved in *Décontractée* masterfully suggest not only the arrested tension of pain and exaltation, but also total relaxation and release.

The Inversion, 1984

▲ Sylvia Plimack Mangold (American, b.1938)

Oil on linen, 60 x 100 (152.4 x 254)

86.200, GIFT OF HENRY, CHERYL, DANIEL, MICHAEL, AND WILLIE WELT IN MEMORY OF ABRAHAM JOSEPH WELT

Sylvia Plimack Mangold's *The Inversion* is a work full of polarities: images compete with a void, geometry conflicts with nature, traditional landscape painting faces off with abstraction. The canvas forms a narrative about the painting process. The artist began *The Inversion* as a larger work. "The landscape originally stretched horizontally from left to right, side to side," she wrote. "I cropped it because it didn't work—the negation of some areas becomes a positive element in the support of the total picture." Until the mid-1970s Plimack Mangold depicted fragments of flooring or domestic space realistically. Although she switched to landscape painting after moving from New York City to the Catskills, she never completely abandoned her early subjects. Remnants of those interiors are found in the tape frame that wraps around this landscape, forcing the viewer to peer through an imaginary opening. The color of the tape is repeated in the landscape: hence, the title of the painting.

276. (On Color Blue), 1990

↑ Joseph Kosuth (American, b.1945)
Neon tubing, transformer, and electrical
wires, 30 x 162 (76.2 x 411.5)
1992.215, MARY SMITH DORWARD FUND

Joseph Kosuth has been credited with the
coining of the term Conceptual Art, whereby
the importance of an idea, a concept, is seen as
primary, and language in the form of short text
is often brought into an artwork to illuminate
its content. Consequently, Kosuth's work is
centered around "making a meaning" rather
than making an object, and he frequently uses
text. An excellent example of this approach,
276. (On Color Blue) uses a quotation from
the brilliant Viennese philosopher Ludwig Witt-
genstein. It describes the viewer's ability to
perceive a color as a part of an object and
simultaneously to contemplate its own signifi-
cance: "276. But don't we at least *mean* some-
thing quite definite when we look at a colour
and name our colour-impression? It is as if we
detached the colour-*impression* from the object,
like a membrane. (This ought to arouse our
suspicions.)" Kosuth uses the text as a ready-
made device, and it serves to carry a new mean-
ing and to stimulate our intellectual curiosity.

Brooklyn Museum of Art:
A Chronology

1823

A group of concerned citizens of the Village of Brooklyn begins to organize the Brooklyn Apprentices' Library Association for the purpose of "establishing a library, for collecting and for forming a repository of books, maps, drawing apparatus, models of machinery, tools, and implements."

1825

Plans are made for a Library building. On July 4, General Lafayette, on his triumphal tour of the United States, lays the cornerstone for the new building in Brooklyn Heights.

1831

Art joins the book collection when the Library acquires its first painting, a portrait of Robert Snow, one of the founders and first president of the Library Association.

1841

The Library moves to quarters in the Lyceum Building on Washington Street, housing collections previously reported by librarian Walt Whitman to have reached 1,200 volumes.

1842

The Library begins a program of exhibitions including painting, sculpture, models of machinery, and curiosities of nature.

1843

The Apprentices' Library and the Brooklyn Lyceum are legally consolidated and renamed The Brooklyn Institute.

1846

The Institute announces plans for a permanent gallery of fine arts "containing specimens of the finest European artists, with productions of the best painters of our own country."

1851

Augustus Graham, one of the original founders of the Apprentices' Library, dies and leaves an endowment fund to the Institute for the acquisition of books, natural history specimens, and paintings by American artists, as well as for support of free lectures and a school of design. This donation is in addition to his payment of the mortgage of the Institute building.

1867

The Washington Street building of the Brooklyn Institute undergoes major renovation to accommodate growing collections and educational activities.

1888

An Institute committee begins plans for a new building that would be a unique museum combining the arts and sciences. Legislation is passed to set aside land adjacent to Prospect Park for art and educational institutions.

1890

The Institute is reorganized into The Brooklyn Institute of Arts and Sciences, with departments ranging from anthropology to zoology. The new Institute eventually becomes the parent of the Brooklyn Academy of Music, the Brooklyn Botanic Garden, and the Brooklyn Children's Museum, as well as the Brooklyn Museum of Art.

The Institute's art museum becomes the first in North America to have a Department of Photography.

1893

The Institute's Department of Architecture organizes an architectural competition to provide a design for the Museum building. The firm of McKim, Mead & White is selected.

1895

Brooklyn Mayor Charles Schieren lays the cornerstone for the Museum building and construction begins.

1897

The West Wing is completed, collections are installed, and the building is opened to the public.

1899

The first children's museum in the world is established as a division of The Brooklyn Institute of Arts and Sciences.

1903

The organization and growth of the collections are regulated by three departments: Fine Arts, Natural History, and the newly established department of Ethnology.

1905

The Institute Board of Trustees sets up an acquisition fund to encourage contributions from the membership.

1906

The Museum begins to support excavations in Egypt, which continue today in the Precinct of the Goddess Mut at South Karnak.

1907

The East Wing, Central Pavilion, and Grand Staircase of the Museum are completed.

The art collection is composed of 532 paintings, watercolors, and photographs as well as plaster casts and decorative arts. Great quantities of archaeological, ethnographic, and natural history materials are collected through Museum expeditions.

1909

Thirty statues of famous philosophers and other historical figures, designed under the direction of Daniel Chester French, are mounted on the exterior façade of the Museum building.

Notable acquisitions include eighty-three John Singer Sargent watercolors, Egyptian antiquities, a model of a humpback whale, and ninety-three Chinese enamel vases.

1915

Colonel Robert Woodward, Institute trustee for twenty-five years, leaves the Museum his estate, which includes a collection of jades along with endowment funds. The Woodward family made major contributions to the growth of the Museum.

1916

The Museum initiates a major international exhibition program with the *Exhibition of Contemporary Swedish Art.*

The heirs of Charles Edwin Wilbour, a pioneer American Egyptologist, begin to donate his collection of art objects and his library to the Museum. Wilbour's collection becomes the cornerstone of the Museum's world-renowned Egyptian collection and is later augmented by an endowment fund given in Wilbour's honor.

William H. Fox, the Institute's Director of Museums from 1914 to 1933, shortens the title of the Central Museum of The Brooklyn Institute of Arts and Sciences to The Brooklyn Museum.

1920

A subway stop opens in front of the Museum, and attendance increases markedly.

1922

Augustus Healy, President of The Brooklyn Institute for twenty-five years, leaves the Museum his private art collection as well as endowment funds.

1923

The Museum holds a precedent-setting exhibition of objects from its African collection, interpreting them as fine art rather than ethnographic specimens.

1926

The Museum hosts the *International Exhibition of Modern Art*, one of the largest and most comprehensive showings of modern art yet held in America.

1927

The last two sections of the Museum are completed according to the original McKim, Mead & White plan.

1929

The Museum opens twenty-one American period rooms; in time there are twenty-eight rooms ranging in date from 1675 to 1928. The Museum is the first American art museum to open a series of nineteenth-century period rooms.

1934

The Museum establishes a new collecting policy emphasizing the fine arts, and the social and industrial aspects of art. The natural history collections are discontinued and dispersed to several institutions, including the Brooklyn Children's Museum, the Brooklyn Botanic Garden, and the American Museum of Natural History.

The Grand Staircase is removed and a new entry hall created.

1935

The collections are rearranged in "chronological" order, beginning with the prehistoric period on the main floor and continuing up to the Gallery of Living Artists on the top floor.

1941

The Brooklyn Museum Art School, jointly organized by The Brooklyn Institute and the Brooklyn Art Association in 1891, and previously housed in the Brooklyn Academy of Music, is moved to the Museum.

1948

The Museum purchases the Egyptian holdings of The New-York Historical Society.

The Edward C. Blum Design Laboratory is opened to encourage the study of design. Later, in the 1960s, the Design Laboratory is transferred to the Fashion Institute of Technology.

1950

Plans for major renovation of the entire Museum are begun with the architectural firm of Brown, Lawford and Forbes.

1964

Daniel Chester French's allegorical figures of Brooklyn and Manhattan are removed from the Manhattan Bridge and placed on either side of the Museum's main entrance.

1966

The Frieda Schiff Warburg Memorial Sculpture Garden, containing architectural fragments from demolished New York buildings, is opened in the rear of the Museum.

The Brooklyn Museum is designated a landmark by the New York City Landmarks Preservation Commission.

1970

The Brooklyn Academy of Music becomes the first of the departments in The Brooklyn Institute of Arts and Sciences to be reorganized as an independent institution.

1976

The New York City Landmarks Preservation Commission approves the addition to the rear of the Museum of a new service extension designed by Prentice & Chan, Ohlhausen.

The Brooklyn Museum is added to the National Register of Historic Places.

1985

The size of The Brooklyn Museum collections is estimated at more than a million objects. The organizational structure of the Museum includes curatorial departments devoted to art of Africa, the Pacific, and the Americas; Costumes and Textiles; Decorative Arts; Egyptian, Classical, and Ancient Middle Eastern Art; Asian Art; Painting and Sculpture; and Prints, Drawings, and Photography. Two research libraries—the Art Reference Library and the Wilbour Library of Egyptology—are merged into one department with the newly established Museum Archives.

The Art School is closed and the adult classes transferred to Pratt Institute to join a long-established fine arts program.

1986

A Master Plan Competition Jury selects Arata Isozaki & Associates/James Stewart Polshek and Partners to devise a new master plan to improve existing conditions and provide for the Museum's growth into the next century.

1987

A gift of fifty-eight Rodin sculptures donated to the Museum in 1983 by Iris and B. Gerald Cantor is installed in the Iris and B. Gerald Cantor Gallery.

To celebrate the gift of nearly five hundred objects from the collection of the late trustee Ernest Erickson, a major exhibition and catalogue are produced. The gift included fine examples of Andean, Native American, Egyptian, Iranian, Indian, and Islamic art.

1990

Some ten thousand works of art are transferred to a newly built, centralized, and climatized art storage facility in the Museum created as a part of the renovation phase of the master plan.

1991

The Iris and B. Gerald Cantor Auditorium designed by Arata Isozaki and James Stewart Polshek is dedicated on April 9.

1992

The majority of the Edith (a trustee) and Milton Lowenthal Collection, important private holdings of modern American painting and sculpture, is bequeathed to The Brooklyn Museum along with the Lowenthals' personal library.

A bequest of fifty-nine objects including modern paintings, sculpture, and decorative arts from the estate of the trustee William K. Jacobs is received.

1993

All three floors of renovated gallery space in the West Wing, redesigned by Arata Isozaki and James Stewart Polshek, reopen to the public in December. The highlight of the reopening is a major reinstall-ation of the Museum's collection of ancient Egyptian art. For the first time since the 1930s, the West Wing space of the original McKim, Mead & White design is made available for exhibition.

Centralized climatized storage is completed and some fifty thousand works of art are transferred and inventoried.

1994

The renovated West Wing is renamed the Morris A. and Meyer Schapiro Wing.

The New York City Museum School, a collaboration with several museums and the New York City public school system, is established for students in the 6th–12th grades. The Brooklyn Museum provides a classroom for students to study the collections under the supervision of teachers and Museum staff.

1995

The Arts of Africa Galleries are reinstalled, highlighting one of the oldest collections of African art in the country.

Several paintings are acquired from The New-York Historical Society sales, including a mid-eighteenth-century set of portraits of the fourteen Inca kings painted by artists of the Cuzco school and Nardo di Cione's *Madonna and Child Enthroned with Saints Zenobius, John the Baptist, Reparata, and John the Evangelist* (circa 1360).

1997–98

The Museum celebrates the 175th anniversary of the founding of the Apprentices' Library and the centennial of the present McKim, Mead & White landmark building. The Trustees approve a change of name to the Brooklyn Museum of Art.

Index of
Artists and Makers

PHOTO CREDITS

Unless otherwise specified, photography is by
Photography Department, Brooklyn Museum
of Art.
Justin Kerr: cover, 28, 32 (below), 45, 48 (below),
73, 76 (above), 78 (below), 79 (below), 80 (above),
83 (below), 84, 85, 100, 101 (below).
Schecter Lee: 95, 111.
Peter Muscato: 180 (below).
Philip Pocock: 43 (below), 132, 185.
Paul Warchol: 96, 99.